INDIANA
UNIVERSITY

INDIANA

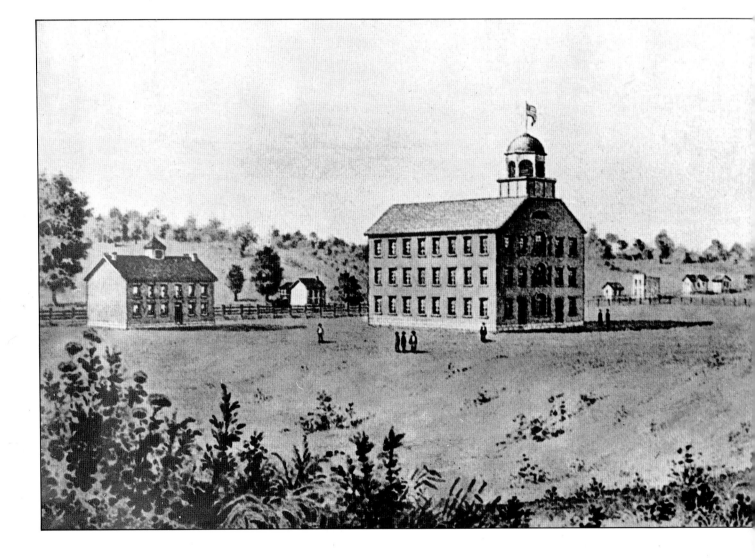

UNIVERSITY

A PICTORIAL HISTORY

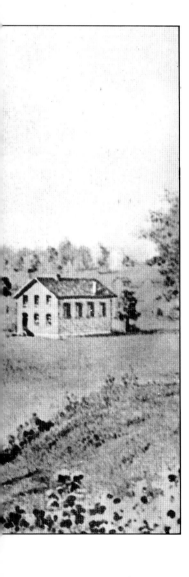

Dorothy C. Collins and Cecil K. Byrd

Foreword by Thomas Ehrlich

INDIANA UNIVERSITY PRESS · BLOOMINGTON AND INDIANAPOLIS

Collins, Dorothy C.
 Indiana University : a pictorial history / Dorothy C. Collins and
Cecil K. Byrd : foreword by Thomas Ehrlich.
 p. cm.
 ISBN 0-253-31397-X (alk. paper)
 1. Indiana University—History. 2. Indiana University,
Bloomington—History. 3. Indiana University, Bloomington—Pictorial
works. 4. Indiana University–Purdue University at Indianapolis—
History. 5. Indiana University–Purdue University at Indianapolis—
Pictorial works. I. Byrd, Cecil K. II. Title.
LD2518.C65 1992
378.772'255—dc20 92-6142

1 2 3 4 5 96 95 94 93 92

Contents

Foreword by Thomas Ehrlich

As I write, I am sitting in the wonderful home built by Charlotte and William Lowe Bryan on the Bloomington campus. In one direction is the old: the first buildings, Owen and Wylie Halls, built in 1884, and the other seven that make a quadrangle to frame Dunn's Woods—a "precious island of green," in the words of Herman B Wells. In the other direction is the new: the spectacular Musical Arts Center, housing the finest university opera house in the world; the residence halls; and the almost completed new School of Education building. Yet there is much new in the old and old in the new. Renovation of the Student Building and Lindley Hall is already complete, and the other quadrangle facilities are scheduled for remodeling over the next few years. No less important, the new buildings maintain the style and the character that make the campus a special place.

In *The Campus as a Work of Art,* Thomas A. Gaines recently named the Bloomington campus one of the five most beautiful in the country:

> Indiana University is exciting. You never know what is coming up next. You must walk through hilly gardens and woods to get to classes, to dorms, to the Library, to the Union. Surprise is surely a worthy goal of design. It is more difficult, I believe, to develop an interesting cohesive campus without the traditional axes or quads on which planners hang their hats. And it is more dangerous to try. Indiana succeeds, because its visual quality is largely based on the unexpected.

Unexpected, but not unplanned. Over the years since coming to IU, I have listened to Herman B Wells describe his vision for expanding the university even in the depths of the Depression. He kept the expansion plans in his desk, realizing that the time would come when new structures would be needed. He knew that unless careful plans were made and followed, IU would suffer the fate of other campuses where, when pressures came to expand, new buildings often bore no architectural relation to earlier ones.

The architecture of many American universities is marked by "a little bit of this, and a little bit of that." But fortunately for IU, since the turn of the century Presidents William Lowe Bryan, Herman B Wells, Elvis J. Stahr, and John W. Ryan held the ground, literally and figuratively. The result is beauty and grace in almost every corner. As just one example,

newcomers often assume that the beautiful Sample Gates were constructed as part of the original campus design. They are surprised to learn the gates were added in 1987—the old and the new in harmonious blend.

The beauty of our university is revealed in the spectacular photographs chosen by Dottie Collins, longtime friend and assistant of Herman Wells, with sparkling captions by Cecil Byrd. Looking at the cover picture, you can almost hear "Chimes of Indiana" ringing forth from the Student Building carillon. As you turn the pages you will be caught up in the magic of your own experiences at Indiana University, reliving good times and rekindling old memories.

Indiana University is one university with eight front doors. All of those doors are opened in the pages of this book. Each campus has a character of its own consistent with its setting. All have grown dramatically in the years since they were extensions of IU Bloomington.

The Indianapolis campus is the largest, a striking illustration of how well an urban campus can function to serve commuting students from throughout the region, and serve the whole state as a center of excellence in teaching and research. The campus has been transformed in the two decades since IU and Purdue joined forces—and the transformation continues. At this moment, $160 million in construction is underway—the third phase of the Science, Engineering, and Technology Building is about to begin; the Ambulatory Care Center and the new library are almost completed; plans are approved to renovate and expand the Van Nuys Medical Science Building; and new facilities for the Herron School of Art are on the drawing boards.

The Indianapolis campus began as a collection of independent buildings, but in 1975 the university trustees hired Edward Larrabee Barnes to devise a master plan to ensure integrity as new facilities were added. Barnes developed a design that is simple and functional, and that works extremely well for the campus's 30,000 students. The new library will be a focal point for the whole campus as development continues.

The Fort Wayne campus is the next in size, with close to 12,000 students. Under an arrangement concluded in 1985, Purdue is fiscal agent with administrative responsibilities, but IU is an equal partner, just as is Purdue at Indianapolis. The pictures here of the Fort Wayne campus over the past twenty-five years show its remarkable growth.

IU East at Richmond has the smallest student body. Set in a lovely woodland, the campus reflects the beauty of its surroundings. IU Southeast at New Albany is perhaps the most beautiful, with striking red brick buildings in rolling countryside that give the sense of a small college. IU Northwest at the other end of the state in Gary is, like Indianapolis, an urban campus. A dynamic place, IUN underscores the reality that each IU campus is a vital set of facilities for its region. The campus at South Bend, also urban, has been expanded in recent years, through superb architectural and landscape planning, into a handsome and coherent environment.

Those who built Indiana University have believed strongly that learners—students and faculty—live up to their environment, that the physical standards of a campus help set the academic standards. That is my own conviction as well. A campus should be not just a collection of buildings, but an environment for learning. This beautiful book reflects that ideal. With pleasure and pride, I join in presenting *Indiana University: A Pictorial History*.

Preface

Written chronicles of Indiana University date from the first, published in 1890, to the most recent, the four-volume sesquicentennial history written by Thomas D. Clark, 1970-77. But this album is the first major pictorial history of IU. As the university grew and its campuses multiplied, its visual image became altered and enlarged. This changing image, captured by the camera, parallels the word accounts, making vivid the aspects and stages of this progression.

Only such narrative as is necessary to provide a framework for the kaleidoscope of illustrations relates this book to the chronicles that preceded it. The introduction is a skeletal presentation of the administrations from Wylie's to Ehrlich's that form the lifeline of Indiana University's being. The pictures and captions flesh out the whole.

Our quest for photographs covering 170 years of the institution's history inevitably encountered barriers. The early years of the university—its seminary and college stages— were for the most part antecedent to the development of photography and particularly to the invention of time exposures. There were few photographers and even fewer amateur photographers, and survival of their pictures was haphazard. The preponderance of pictures of more recent periods in this album reflects not only the factor of availability but even more the contrast between the infant institution and its present vast scope and infinite variety. In fact, the very abundance of photographs in recent years seems to have been an impediment, for with their rarity diminished they became expendable. Not just families but also institutions destroyed their pictorial records. We hunted in vain for the originals of many pictures used in the *Arbutus* yearbook; they were thrown away several years ago by a staff that needed more office space.

All of the early work on this jointly produced book—the gathering of pictures, data, interviews, historical information, and so forth—as well as the Introductory Chronicle are attributable to Dorothy Collins. The captions and linkages are for the most part the contribution of Cecil Byrd. Byrd and John Gallman made the final selection of the pictures. Selection criteria gave preference to the aesthetic over particulars of coverage, to life over stone and mortar.

There are many, known and unknown, to whom we owe acknowledgment for photographs/pictures in this volume. Whenever possible, we have tried to include the photographer's name or the source of the photograph in this broad statement of indebtedness, but in more cases than not, there has simply been no clue to attribution.

Jerry Mitchell, who was originally associated with this project as a photographer for the IU News Bureau, had an extensive photographic archive. Many of his pictures, though taken for their news value, have a distinctively aesthetic quality. Complications of scheduling and interpretation eventually led to an end to the association. No small number of the photographs in this book are Jerry's work.

Annalese Poorman, also a former employee of the News Bureau, took some of the pictures for us; her touch too is often aesthetic. Larry Crewell of the Bloomington *Herald-Times* shot the 1987 NCAA championship photo.

Photographs taken by Cynthia DeGrand (News Bureau) and Kevin Hutchinson (Center for Media and Teaching Resources) represent an important portion of the color photographs. Other color photographs are by Beverly Simpson, Paul Helfrich (Musical Arts Center), Barrett Ewald (Northwest), Rick Baughn (IUPUI), and Gabriel R. Delobbe (Fort Wayne). Kate Robinson Sturgeon took the picture of the three IU presidents in the Federal Room of the Union Building.

John Gallman, director of the Indiana University Press, assembled a small group of knowledgeable persons to advise on the photo gathering and selection process. Members included Claude Rich, Donald Carmony, Dolores Lahrman, and Jeannette Matthew. Their contribution was of great value.

Help and offers of help came from many people. A notice in the *Alumni Magazine* produced photographs, memorabilia, and miscellaneous offers. Others responded after simply hearing of the project. Quite early we realized that there needed to be a ruthless selection policy to observe the guidelines set by the publishers and at the same time maintain a balance in the presentation.

Principal sources of photographs were the IU Archives, the IU News Bureau, the IU Alumni Office, the IU Center for Media and Teaching Resources (formerly the Audiovisual Department), the IU Sports Information Office, and the archives of Indiana University-Purdue University at Indianapolis. James Capshew furnished pictures of President William Lowe Bryan, and Mrs. Edward Von Tress contributed the photograph of the three alumni secretaries. To all of these sources we are deeply indebted.

The former university archivist, Dolores Lahrman, and her successor, Bruce Harrah-Conforth, were helpful, as were members of their staff, William Baus and Elizabeth Jacobs.

Jeannette Matthew, archivist at IUPUI, now retired, and John Shawn, her assistant, combed their files for photographs of historical interest, helped in making selections, and provided invaluable background information on each photograph chosen. We are indebted to them for almost the whole of the IUPUI section.

The regional campuses have come on the scene relatively recently in the university's life span, with the result that photographs of them reflect the importance of moves from temporary to permanent buildings and the development of student activities on the commuter campuses. Among the persons who contributed photographs were Olivia Maddox (Kokomo), Mary Grove (South Bend), and Renee Shawn Lee (Southeast). We are pleased to acknowledge their assistance.

Dr. Byrd is pleased to acknowledge the valuable assistance of Faye Ellen Mark (IU Archives), Judith Schroeder (*Alumni Magazine*), Charles D. Stepp (Kokomo), Ellen K. Mathia (South Bend), James E. Stammerman (Southeast), and, for her secretarial aid, Esther S. Byrd.

And there doubtlessly are others, unacknowledged, who lent material, offered useful suggestions, buoyed our spirits, and in general helped us hang in there. For them we hope that this book itself will serve as a silent acknowledgment.

Our modest intent has been to present an album of sightings along the span of Indiana University's life, from its origin to its present age, with certain symbolic inclusions. On this framework, dear reader, you are urged to hang your own memories, a link necessary to the whole.

DOROTHY C. COLLINS
CECIL K. BYRD

Introductory Chronicle

THE EARLY YEARS: 1820-1828

Indiana University is a remote product of legislation by the Confederation Congress in 1785. In defining how western land acquired from the British at the end of the Revolutionary War should be disposed of, the Confederation Congress declared that section sixteen in every township should be reserved for the maintenance of public schools. The new Congress formed under the United States Constitution was even more generous than its predecessor. The enabling act of 1816, permitting Indiana Territory to enter the Union as a state, set aside two townships "for the use of a seminary of learning." One of these townships, in Gibson County, was given in 1806 for Vincennes University. The second township selected was in an area that became Monroe County, named for President James Monroe. The seminary township was named for Oliver Hazard Perry, naval hero of the War of 1812.

The Indiana Constitution of 1816, Article IX, section 2, contained the infant state's promise for education: "It shall be the duty of the general assembly, as soon as circumstances will permit, to provide by law for a general system of education, ascending in a regular gradation from township schools to a state university, wherein tuition shall be gratis, and equally open to all."

The implementation of that section of the constitution, insofar as it relates to the history of Indiana University, began on January 20, 1820, when Governor Jonathan Jennings signed into law "An act to establish a State Seminary." The law named the trustees, instructed them to meet in Bloomington, select a site in Perry Township, sell some land, and erect a seminary building and a "commodious house for a Professor," who was to be hired by the trustees. They selected the Reverend Baynard Rush Hall, a graduate of Union College and an ordained minister of the Presbyterian Church.

The State Seminary, located at the southern edge of Bloomington, opened its doors to students in May 1825. After an examination of the prospective students, ten boys remained for instruction in the Greek and Latin languages. A second teacher, John H. Harney, graduate of Miami University in Oxford, Ohio, and also a Presbyterian, was the successful

applicant to teach mathematics and science, beginning in May 1827. An enrollment that year of twenty-six students almost doubled within a year and the board of visitors reported approvingly the results of its examination of each student. On January 24, 1828, the State Seminary became Indiana College by act of the General Assembly.

THE FIRST PRESIDENT: 1829-1851

With the nominal elevation of the seminary to college status, it was time to seek a president. The trustees issued an invitation to Andrew Wylie, D.D., president of Washington College in Washington, Pennsylvania, and a graduate and former president of Jefferson College in Pennsylvania. Inaugurated president of Indiana College in 1829, Wylie served until his death from a wood-chopping accident in 1851. His length of service has been exceeded by only two IU presidents, William Lowe Bryan and Herman B Wells.

Of particular significance was the first president's extension of the curriculum, which had been appropriate for students generally still in their preparatory studies. Dr. Wylie, who had the additional title of professor of moral and mental philosophy, political economy and polite literature, extended the teaching capabilities of the small faculty from the study of Greek and Latin and pure and applied mathematics to the fields of his own preparation. Another significant action of Dr. Wylie, this one prior to his arrival in Bloomington, was his acquisition by personal solicitation in the East of 235 books to form the nucleus of a library for Indiana College.

President Wylie, whose inaugural address set a high level of intellectual and moral discourse, undertook the teaching of the seniors. His presidency was marred by institutional attacks on issues of curriculum and sectarianism, a "faculty war," a frivolous trial in which he was vindicated, an outbreak of Asian cholera in several Indiana cities from which the college drew students, and an act of the legislature in 1842 that reduced the university's income, with the result that salaries were cut and a highly valued professor resigned. But there were accomplishments also, including growth in enrollment and staff, curricular additions in line with student needs, establishment of a Department of Law, addition of a classroom building, and reorganization of Indiana College as Indiana University by act of the legislature on February 15, 1838.

TRIAL AND ERROR: 1852-1885

In the years between Wylie's death and David Starr Jordan's succession to the presidency in 1885, five men undertook the administration of Indiana University, all of them ministers: Alfred Ryors, 1852-53; William Mitchell Daily, an alumnus, 1853-59; John Hiram Lathrop, 1859-60; Cyrus Nutt, 1860-75; and Lemuel Moss, 1875-84.

The brevity of Ryors's term was the result of political maneuvering by Governor Joseph A. Wright, an alumnus of the university, who forced the resignation of Dr. Ryors and urged the election of the Reverend William M. Daily to succeed him. Dr. Ryors had once been a professor of mathematics at Indiana University and had preached to the Presbyterians of Bloomington. He had resigned to become president of Ohio University, and it was this position he left to become IU's president. Dr. Ryors was an able and respected scholar, and his forced removal caused deep resentment, particularly because his successor was felt to be less qualified than he. Governor Wright's motive, we now know, was to save Indiana University from the likely disastrous consequences of a judgment against it by the Indiana Supreme Court in a suit concerning funds credited to the university by the General Assembly from sale of the lands in Gibson County once given to Vincennes University. Ryors's year as president was afflicted by jealousies and outside pressures that limited his effectiveness, but his travails may have been tempered somewhat in recollection

by a doctor of divinity degree granted him by Indiana University when he went to the presidency of Ohio University.

Unpopular as the choice of Dr. Daily was as successor to Ryors and discredited as he sometimes was by various charges, including plagiarism in his speeches and in his sermons to Methodist congregations, he gained friends for the university through his wide acquaintanceships. Early in his administration he suffered two severe setbacks: the death of Dr. David Maxwell, who had been instrumental in the founding of Indiana University and a guiding spirit in his thirty years as a university trustee, twenty-eight of them as president of the board; and the destruction by fire of the university's main building on the morning of April 9, 1854. Funds for rebuilding were secured with the greatest difficulty, as can be surmised from the decision of the trustees to authorize the president of the board to mortgage the college campus for $6,000 and seek $10,000 in contributions from Bloomington residents toward rebuilding.

Following Dr. Daily's resignation, John H. Lathrop was elected president. Lathrop had been the choice of the trustees to succeed President Wylie, but Lathrop, who was chancellor of the University of Wisconsin at the time, had declined the bid. He had also been president of the University of Missouri before coming to Indiana University. After only a year he returned to the University of Missouri, and five years later he began a second term as its president. The only significant action during his brief administration at Indiana was a decision to establish an agricultural department if the funds for implementation could be secured.

In nine years Indiana University had gone through the disruption of having to accommodate to three different administrations. With the election of Cyrus Nutt in 1860 the university began to enjoy the fruits of what was to be a long tenure. Dr. Nutt had served in the Methodist ministry and in various educational posts, including the presidencies of Fort Wayne Female College and Whitewater College and the acting presidency of Asbury College, now DePauw University. He was to preside over a period of major university developments. In 1867 Indiana University became coeducational and in the same year *The Indiana Student* newspaper was founded. Of equal or greater overall importance was the action of the General Assembly authorizing annual appropriations of $8,000 for current expenses of the university. This sum amounted to an 80 percent increase in the university's income and marked the end of its having to rely on interest from the fund formed by the sale of federal lands. University supporters hoped that the change signified an appreciation of the university's service to the state. Successive legislatures increased the appropriation to $23,000. A Science Building was erected in 1873.

Two notable but short-lived developments during the period were the establishment of military drill and the affiliation of the university with the Indiana Medical College to form the Medical Department of the university. Of more permanency and import was the meeting in 1873 of the superintendents of some of the large high schools in the state with the trustees and faculty of the university to coordinate the requirements of high schools and the university for students preparing for college. The long-envisioned state school system leading from public schools to a state university now had a chance to become reality.

Another relatively long administration succeeded Nutt's when the Reverend Lemuel Moss was elected president after the death of President Nutt in 1875. Moss had been a pastor, an educator, and an editor before assuming the presidency of the University of Chicago in 1874. One year later he was called to Indiana University. An improvement in faculty working arrangements began during his administration, with a reduction of teaching loads and an increase in salaries. Recognition that alumni could be helpful in promoting university interests led to the organization of the alumni. An immediate effect of this collaboration was legislative passage of a bill to tax the assessed valuation of property for the purpose of amassing an endowment fund to support the university.

Once again the university suffered a great loss by fire, on July 12, 1883, when lightning struck the ten-year-old Science Building. This disaster led to relocation of the campus to its present site in Dunn's Woods on Bloomington's eastern border, a decision abetted by an insurance payment of $20,000 and a Monroe County contribution of $50,000. The

construction of Owen and Wylie halls on the new campus had begun when the young David Starr Jordan, not yet thirty-four years old, was elected president of Indiana University in 1885 upon the resignation of Lemuel Moss.

The Jordan Years and Continuing Momentum: 1885-1902

The appointment of Jordan as president represented an historic moment in the life of the university. Severed forever was the cord that bound the trustees to electing a minister as president. A botanist educated at Cornell University, Jordan had come to Indiana University as a professor in 1879 after holding various teaching positions, most recently at Butler University, and with an honorary M.D. degree conferred by Butler. The university was ripe for dynamic leadership, having had such setbacks as a nearly static enrollment and the discontinuance of the departments of law and medicine in the last years of the Moss presidency.

Unfearful of criticism and in a sense wresting the reins from the trustees, Dr. Jordan began immediately to make the changes that he deemed necessary or advisable to bring the university into step with institutions of superior quality. He rejected traditional comparisons with private colleges of Indiana. He did not hesitate to shake off parochialism and ignore previous practices repeated year after year without any evaluation. The *Richmond Palladium* announced: "The friends of Indiana University will be glad to know that under the able presidency of Dr. Jordan it is rapidly rising to the front rank of American Universities. . . . The changes made in the corps of teachers in the last three years make the faculty one which will compare favorably with the best institutions of the kind, either in the east or in the west."

Jordan also operated with some sense of perspective, initiating a policy of promising chairs to certain young alumni if they would prepare themselves appropriately in Europe or at an eastern university, for he had found that professors originally from the East who accepted appointment at IU were often second-rate. How successful this new policy was can be judged by such illustrations as Joseph Swain, William Lowe Bryan, Horace A. Hoffman, James A. Woodburn, and Allan B. Philputt, stalwarts at a later date.

The growth of enrollment (from 157 in 1884 to 300 in 1888, for instance) furnished Jordan an opportunity to increase the size of the faculty. His appointments to the instructor rank included such men as Robert J. Aley, Bryan, Carl H. Eigenmann, Arthur Lee Foley, Rufus Lot Green, and Robert E. Lyons, most of whom had distinguished careers at Indiana University subsequently. Jordan selected David D. Banta to be dean of the reestablished Law School, John C. Branner as head of geology, Charles H. Gilbert as head of zoology, Hoffman as head of the Classics Department, and Woodburn to head the History Department. (Branner and Gilbert, neither of whom was an IU alumnus, were among those faculty members Jordan took with him later to Stanford.) Gilbert collaborated with Jordan afterwards on many of his publications.

Other innovations of this courageous scholar-administrator were the introduction of the major department system and the elective system, the organization of extension courses, the maneuver of taking the university's story to citizens throughout the state and asking for their support with the legislature, the use of noted speakers to replace senior orators at commencements, and the construction of three buildings: a library (Maxwell Hall), Mitchell Hall (called at first Maxwell Hall and used in part as a chapel), and a gymnasium (later converted to a carpenter shop). The campus was now twice the size of the former campus, and there was abundant land for expansion. During Jordan's presidency the number of faculty members increased from eighteen to twenty-nine, and IU's estimated income reached $54,000, compared with the $30,800 at the start of his tenure. Thus, the new campus had a strong beginning, coupled with the new directions given to academic life at Indiana University.

The final decade of the nineteenth century was full of promise, it seemed, only to be

dampened by Dr. Jordan's departure to assist the Leland Stanfords in the establishment of Leland Stanford Junior University as its first president. The blow to Indiana University was especially keen because Jordan took with him six faculty members, five of them department heads, and many students followed. Three other major professors left the university at that time.

Jordan, it should be noted, had a distinguished professional career apart from his successful presidential roles. As an internationally respected scientist and specialist in marine life, he held several federal appointments, conducted explorations in the United States and abroad, and published widely on both scientific and general subjects. He presided over the World's Peace Congress, 1915; the American Association for the Advancement of Science, 1909-10; and the National Education Association, 1915. His connection with Indiana University brought prestige to it on a national scale that set a pattern for future presidents. His onetime presence on the campus has such physical reminders today as Jordan Field, Jordan Hall, Jordan Avenue, and Jordan River. As a footnote to this progressive period, the record shows that in 1891 the Indiana Legislature authorized the election of three trustees by alumni—a practice that still holds today.

John Merle Coulter, a professor of botany at Wabash College in Crawfordsville, accepted the difficult task of succeeding Dr. Jordan and becoming the eighth president of Indiana University. He remained for only two years, then accepting the presidency of Lake Forest University and subsequently an appointment as head of the department and professor of botany at the University of Chicago. Dr. Coulter was, like Jordan, an author of numerous scientific publications and a leader in national professional societies. In his brief stay at Indiana University he had to make appointments to replace the faculty who had left with Jordan; he also added significant impetus to the extension courses and helped establish a Young Men's Christian Association branch on campus that became an influential source of student leadership and volunteer activity.

Coulter's successor, Joseph Swain, was an alumnus of the university and a former faculty member who had followed Jordan to Stanford in the position of professor of mathematics. His alma mater summoned him to its presidency in June 1893. He was swept up in the educational currents of the time: expanding enrollments, building programs, administrative and faculty mobility, and an ever-increasing urgency for the state to respond affirmatively to the university's financial needs. Between the beginning of the Jordan administration and the end of the Swain regime, the student body became eight times larger and the teaching load eight times greater, but the number of faculty increased by only 3.3-fold and the income of the university by a factor of just 4.2.

The construction of Kirkwood Hall, the men's gymnasium (Assembly Hall), and Kirkwood Observatory and the start of Science Hall seem to suggest that the trustees and administration were trying to keep up with expanding needs. Their efforts were supplemented by Mrs. Swain's campaign to secure private funding for a women's building and by the trustees' purchase of additional Dunn land for future building, marking a new stage and outlook in university planning. Off campus, the biological station, erected at Turkey Lake and then removed to Winona Lake, provided a natural laboratory for students in biology, who enjoyed the added benefit of a pleasurable experience among fellow students and faculty members.

THE REMARKABLE IMPACT OF WILLIAM LOWE BRYAN: 1902-1937

When on June 17, 1902, President Swain resigned and William Lowe Bryan was chosen to succeed him, few could have anticipated the almost complete transformation of the university that would take place under Bryan's aegis. A Monroe County native and the son of a minister, Bryan had spent part of his youth in the country and part in Bloomington. Apparently his education was broad, for his teaching included at different times Greek, English, and philosophy; and presumably he had enough command of German to study in

Berlin and Würzburg and enough French to study in Paris. Bryan had published in the fields of psychology and philosophy and had served as vice-president of the university from 1893 to 1902. His preparation and his promise suggested a future of exceptional leadership for Indiana University. The auguries were accurate. For thirty-five years, the longest presidential tenure in the life of the university, Dr. William Lowe Bryan presided over the destiny of Indiana University.

By all reports a master on the dais, Bryan was persuasive as well with scholars of promise or renown whom he encouraged to associate with Indiana University in its strong move forward. He attracted thirty-three deans and department heads and nine nonteaching executives from outside the alumni ranks during his presidency, compared with thirteen and twelve respectively from among alumni. The practice of inbreeding, so smothering to an institution, was losing its grip.

During the Bryan presidency, state support increased more than $2 million from its 1902 level, the university facilities increased by forty buildings, of which a third were the result of private donations, and the university's academic structure took on its basic shape. With few exceptions the foundations of the university's present academic structure were laid by President Bryan.

Thirty-five years of growth and development transfigured the campus, extended the university's presence in the state, and supplied the form and substance for the academic maturation of the university during the twentieth century. The Bloomington campus grew from 50.82 acres to 1,136.89 acres during Bryan's administration. Science Hall and the Student Building were completed, and landmark construction added a powerhouse, a library, Biology Hall, the men's gymnasium, the Commerce Building, the fieldhouse, the Chemistry Building, the Memorial Union, the Administration Building, the Medical Building, a dormitory for men and a dormitory for women, and the President's House as well as extensions of buildings of earlier vintage.

At the same time a campus in Indianapolis took shape, in part through purchase of existing buildings and in part through new construction: Long Hospital, Riley Memorial Hospital, the Medical School Building, and the start of the Clinical Building. To accommodate state needs better, the administration established new schools: the School of Medicine, the Graduate School, the School of Education, the Extension Division, the Training School for Nurses, the School of Commerce and Finance (Business), the School of Music, and the School of Dentistry. Most of them represented an elevation in status rather than wholly new offerings.

As the university grew it gained public respect and financial support, partially demonstrated by an increase of approximately 15 percent in funds from the state and partially by the donation of several large private gifts, such as those of Luther Dana Waterman, William Patten, Mahlon Powell, George A. Ball, Eli Lilly, Carl Fisher, Hugh McK. Landon, and Will Irwin. In the 1920s a wave of patriotism and untapped loyalty to the institution produced a Memorial Campaign to finance a student union building, a stadium, and women's housing facility (the Memorial Student Union, Memorial Stadium, and Memorial Hall, now a part of Agnes Wells Quadrangle).

Emboldened by the success of that endeavor among students, faculty, alumni, and friends, by an invidious comparison of IU's private fund raising with that of rival institutions, and by the example of the James Whitcomb Riley Association in Indianapolis, a small contingent of alumni leaders pushed for the establishment of an IU-connected but independent foundation. The establishment of the IU Foundation in 1936 formalized a conduit of private financial support to the university, supplementing its public support. The initiative served to recognize the reality that the state's allocation of its resources to the university could not allow sufficiently for the educational needs of students seeking postsecondary education at Indiana University; nor could it provide the funding required to elevate the university's academic standing significantly among the ranked institutions in the land. Begun with a $5,000 gift from George A. Ball of Muncie, the IU Foundation's assets have grown in a little over a half-century to $275 million.

Another initiative taken late in the Bryan administration was the funding of a faculty

pension system (now TIAA-CREF) that enabled faculty members to retire with enough income to live respectably. The 1937 General Assembly furnished the lump sum financing to make it possible for Indiana University to become a member of the Teachers Insurance and Annuity Association. In the early years, a percentage of each faculty member's monthly salary was deducted for TIAA, but later during the Wells administration the university assumed all the contributions to TIAA. In the year of the change, minimal salary increases made the new arrangement possible.

Bryan's governance was a benevolent patriarchy. He hired and he fired. His imprint was on every facet of the university. The unusual length of his tenure made possible the implementation of his plans and the generation of a personal mythos that inspired and nurtured a flowering of the university but slowed the emergence of youthful challengers of the status quo. In the thirtieth year of his administration, Dr. Bryan resigned and a young successor, different from him in almost every way except in intellect and in ambition for the university, began the process of directing Bryan's accomplishment into the fullness of a new vision.

The Flowering under Wells: 1937-1962

A native Hoosier, Herman B Wells had attended the University of Illinois before he transferred to IU for his sophomore year. His degrees, B.A. 1924 and M.A. 1927, were in economics, a field that he pursued in graduate study at the University of Wisconsin. He returned to Indiana as secretary of the Indiana Banking Association before associating permanently with Indiana University in 1930, first as an instructor in economics. In his early years as a faculty member he shared his time with the Indiana Department of Financial Institutions in various capacities, but with his appointment to the deanship of business administration in 1935 he became committed to a lifetime of service to the university. In 1937 the trustees appointed him acting president, and before the year was out they elected him president.

Wells stepped into a twenty-five-year tenancy, then capped even the Bryan legend with a more durable legend that survived three presidencies and the beginning of a fourth. By nature masterful in personal and public relations, he initiated a period of unrivaled collegiality. Clark Kerr called him "IU's secret weapon." By his own account Wells had a vision of what the university should become and that vision guided him in his actions and decisions.

Wells began his administration with three major initiatives: an administrative reorganization, a self-survey, and a replenishment of the faculty. The new retirement benefit program that President Bryan and the legislature had made possible gave Wells the opportunity to replace approximately half of the department heads, and he promptly searched the country for the best candidates he could find for the vacancies. At the same time he recruited new faculty members with promising credentials. This move to broaden the geographical and scholarly fields from which faculty members were chosen had a bracing effect throughout the university.

Stimulation came also from the initiation of a self-survey seeking opinions and ideas about the operation of the university from all constituencies. The implementing of the recommendations positioned the university to accommodate the changes that the nation's entry into the Second World War soon necessitated. Meanwhile such innovations as the Administrative Council, a personnel office, the Office of the Dean of Faculties, a Junior Division, a Student Health Center, a student counseling organization, provisions for facilitating faculty research, sabbatical leaves, standardization of admissions, and increased library and other learning resources came about in positive reaction to the self-survey.

The spread of administrative responsibility was of critical benefit when calls to Washington and to military service depleted both the administration and the faculty. The male student enrollment declined, but military training programs assigned to the university

brought thousands of trainees to the campus. These troops required housing and classroom facilities. There were accommodations too to accelerate the fulfillment of degree requirements. In some years there were three commencements.

Foreseeing the problems that a rush of returning veterans would cause, multiplied by the inducements of the GI Bill, Wells began at an early date to plan for increased faculty, student and faculty housing, and auxiliary aids. Wells appealed to all the higher education institutions in Indiana to shoulder their load of responsibility for the GIs so that any qualified Hoosier veteran could reenter civilian life with a college education. A few of the temporary buildings acquired from the military for the Bloomington campus at that time remain, but the trailer villages, Hoosier Courts, and most of the quonset huts have long since become mainly GI memories.

Permanent structures, both for housing and for office and classroom use, were part of a building program, stimulated at first by PWA and WPA funds, that continues to this day. In Bloomington the first of the great student quadrangles—Wright, Teter, and Read—became focal points of student life. As married students were no longer a rarity on campus, building plans had to include married housing. Young faculty members, too, found these accommodations convenient until they could ascertain their future needs. The name of Alice McDonald Nelson has received acclaim and commemoration because she was Wells's strong right arm throughout the development of the student housing program.

Apart from the many changes required by the doubling of enrollment after the war, an unexpected boon to the life of the university resulted from Wells's careful recruiting of faculty who were refugees from Europe. Foreign scholars of note brought not only intellectual stimulation to the university family but also a cosmopolitan presence that profoundly influenced the hitherto largely midwestern social milieu.

As unlikely in mid-America as the internationalization of the Bloomington campus was, an even more unexpectable occurrence in Hoosierland was Wells's stalwart defense of Alfred Kinsey's pioneering research on human sexual behavior. The issue was academic freedom, and Wells's defense, widely hailed in the academic world, was often a contributing factor in recruiting top-notch new faculty.

Of course there were contemporaneous developments in Indianapolis and on the extension campuses as well. Instead of new campus buildings, construction was limited to critically needed additions. Purchase of the Maennerchor Building made room for the new evening division of the School of Law in Indianapolis, and the acquisition of the Indiana Lumbermen's Mutual Insurance Company Building there added classroom space for the Extension Center. Additions to Long Hospital and to Riley Hospital kept the building program from faltering during the period, but the construction of state health-related buildings (the State Board of Health Building, the Veterans Hospital, and LaRue Carter Hospital) adjacent to the Medical Center served to strengthen and increase the resources of the Medical School.

Service clubs in the state—Rotary, Kiwanis, the Lions Clubs of Indiana, the Elks of Indiana—as well as the Indiana Cancer Society, the Indianapolis Junior League, and the Riley Hospital Cheer Guild provided funding for additions to the physical plant, for prohibitively expensive equipment, and for research. The consolidation of medical training in the state under the aegis of Indiana University during this period appeared to have statewide approval.

Essentially a commuter campus, the Medical Center lacked a campus facility for food service, student activities, meeting rooms, public lounges, and other amenities. The Student Union, completed in 1953, answered these needs and added hotel-like accommodations for visitors and relatives of patients in the campus hospitals. More recently, with the addition of a hotel and convention center, the Union Building's function has changed to meet shortages of office space. Gradually filling out the planned development of the Medical Center, new housing (the Alfred S. Warthen Apartments) and instructional and laboratory accommodations (the Medical Science Building and an addition to the School of Dentistry Building) have marked a steady pattern of growth in step with need.

The university's concern for provision of real opportunities in public higher education

throughout the state received attention too as the administration sought to improve physical facilities at the various extension centers by remodeling, purchase of buildings, and new construction. This was a period in the establishment of a multicampus system that proved to be preliminary to the solid advances made during the presidencies of Elvis J. Stahr, jr. and John W. Ryan.

Wells continued and expanded in a remarkable way Bryan's practice of accepting responsibility and leadership in higher education organizations, thereby placing Indiana University's name on the national scene. Wells also undertook significant governmental missions both within the United States and abroad. A true internationalist, he was instrumental in making the university and his conservative midwestern state internationally conscious. The broadened awareness and appreciation of the arts among the university family and the university's constituencies owed its impetus at least in part to his consistent patronage.

Many have paid tribute to Herman B Wells in almost biblical terms for leading Indiana University from its rather parochial limitations into the status of a respectable research university capable of becoming one of the top twenty universities in the land. He followed his presidency with an even longer period as chancellor of the university, a position in which he still is active and observes a daily routine. To his record administration of the presidency he has joined record service in gaining private funds for the university during his chancellorship. In recognition of his incomparable contribution, the university has established the Wells Scholars Program, supported financially by an ongoing IU Foundation campaign, designed to attract top students to Indiana University by offering fully funded four-year scholarships and special educational and cultural opportunities. The character of the response has been a gratifying affirmation of the Program.

From Stahr to Ryan: 1962-1987

In 1960 Wells announced that he would keep to his original announced intention to serve no more than twenty-five years in the presidency and would resign on June 30, 1962. The search for his successor led to a Hickman, Kentucky, native, Elvis J. Stahr, jr. Stahr was a graduate of the University of Kentucky and of its Law School with a master's degree from Oxford University, which he had attended as a Rhodes Scholar. He had administrative experience as dean of his alma mater's Law School, vice chancellor of the University of Pittsburgh, president of the University of West Virginia, and, at the time of his election to the Indiana post, secretary of the army under President John F. Kennedy.

Even though Stahr presided over the university during a period of collegiate unrest that mirrored the rebelliousness of the under-thirty age group from coast to coast in the Vietnam War years, he was able to advance the building program made necessary by the growth of the student body and to maintain the quality of faculty recruitment. The more extreme expressions of student activism were delayed and diluted by the time the wave hit the Hoosier state, although the onus of citizen reaction to news reports from campuses of the east and west coasts fell upon students in Hoosier colleges indiscriminately. Suffice it to say that the doors of the university stayed open, and there was no major interruption of the academic program. The Stahr years were troubled also by the campus reflection of the nationwide black student movement, which frequently used the tactics of the antiwar and student activist movements. Stahr, like college presidents across the nation, found himself besieged by student problems almost to the exclusion of carrying on his other presidential duties. His administration suffered from the deep division in public opinion over the appropriate, effective means of handling student and black activism. Yet he presided over a major construction period that saw the completion of such prominent buildings as the Fine Arts Building, the Geology Building, the Psychology Building, the Radio and Television Building, the Student Health Center, the School of Business Building, the Optometry Building, and the University School; the Foster, McNutt, Briscoe, Forest, and Willkie

quadrangles; the Campus View and Tulip Tree apartment buildings; Kettler Hall at Fort Wayne; the Kokomo Campus Building; and Greenwood Hall and the South Bend–Mishawaka Campus Building at South Bend. The large outdoor swimming pool constructed on Fee Lane at this time proved to be a popular addition to the Bloomington campus. With nonstop drive, the building program continued under Stahr's aegis with the start of such important projects as the teaching hospital (now University Hospital) at the Medical Center in Indianapolis and the University Library and Eigenmann Hall in Bloomington.

The principal academic restructuring during Stahr's tenure was the organization of the Division of Regional Campus Administration. This restructuring, along with the beginning of separate legislative appropriations for each campus, gave a needed impetus to the development of these vital units of the university.

After the turmoil, more rhetorical than physical, that had characterized most of his five and a half years as president, Stahr had the unique experience in January 1968 of heading an IU delegation to see the one and only appearance of a Hurryin' Hoosier football team in the Rose Bowl. But, fatigued by the constant crises and threats of crises that he had been forced to confront during his tenure, Stahr resigned the following August. His achievement, disentangled from the web of social conflict that disrupted campuses nationwide as well as in Bloomington, was the determined continuation of the momentum he had inherited when he became the university's thirteenth president.

Chosen as his successor was Joseph Lee Sutton, a hardliner against student activism. An Oklahoma native and an alumnus of the University of Michigan, Sutton had served IU as dean of the College of Arts and Sciences and then as vice-president and dean of faculties. He had been a popular professor of political science, chief of party of an IU project at Thammasat University in Thailand, and a faculty leader. During his administration, the last shrill student protests of the '60s reached their climax and hampered his presidential labors. Unrelated to the protests but disastrous, a fire heavily damaged the university library. At last, frustrated and ill, Sutton resigned in January 1971, and John W. Ryan was chosen to succeed him.

Ryan, who was Sutton's colleague in political science and on the Thailand mission, had returned to IU at Sutton's invitation to head the regional campus system. An alumnus of the University of Utah, Ryan had received his master's and doctoral degrees from Indiana University. After a teaching stint in the Department of Political Science at the University of Wisconsin, Ryan entered the administrative ranks, first at the University of Massachusetts, then at Arizona State. He was again at the University of Massachusetts when he received the call from Sutton to return to his alma mater.

After two relatively brief tenures, the Office of the President was in need of a long-term commitment. Ryan, who had originally accepted the post for only three years, subject at his request to a university-wide evaluation of his performance, led the university for seventeen years, the fourth longest tenure among IU's presidents. The growth and development of the university during this period were enormous. An extensive building program associated with the university's sesquicentennial celebration coincided roughly with the years just preceding and beginning Ryan's presidency. In Bloomington, gift-related construction included Assembly Hall, the Metz Carillon, the Musical Arts Center, the Glenn Black Laboratory, Showalter House, and the Cyclotron. At Indianapolis, buildings in stages of planning, construction, or completion included the Medical Research Facilities Building, Phase II of the Riley Addition, the Dental School Addition, the School of Nursing Building, Phase II of University Hospital, the Science Engineering and Technology Building (Purdue), and the Administrative Service Building.

The regional campuses in general had occupied facilities built for other uses, then bought by the university and converted to academic use. New construction began to appear on one regional campus after another during this period: the Southeast campus, formerly in Jeffersonville, moved into brand new buildings in New Albany; the Fort Wayne campus grew with library, Union Building, and classroom additions; in South Bend a building addition and acquisition of a large business complex provided needed breathing room; IU East (Richmond) acquired its first new facility; a little later a laboratory and classroom

building increased the academic space at Northwest (Gary); and still later the Kokomo campus received a solid boost from the addition of a building housing laboratories, classrooms, and offices.

Fully informed about the outlying needs from his prior direction of the Regional Campus Administration and convinced of the timeliness and importance to the university of substantial development of the network of regional campuses, Ryan presided over their foundational growth. The strengthening of the system directly correlated with the budgetary liberation of the campuses from a unitary university budget, with the initial cleft occurring during the Stahr regime in 1964.

At the time of President Ryan's retirement in 1987, he could point to the university's major growth and development, both physical and academic, during the course of his presidency. On every front—Bloomington, Indianapolis, and the regional campuses—a sturdy operation and increasing enrollments evidenced the maturing of the statewide system.

The New Vision: 1987 and Beyond

Thomas Ehrlich, the fifteenth president of Indiana University and a native of Cambridge, Massachusetts, received his bachelor's degree in 1956 from Harvard College and his LL.B. degree from Harvard Law School. He had university administrative experience as dean of the Law School at Stanford and provost of the University of Pennsylvania. Ehrlich's public service included appointments in the U.S. Department of State, the initial presidency of the Legal Services Corporation, and first directorship of the International Development Corporation Agency. As he took the leadership reins, he assumed direction of an institution so different in size, nature, and control from the one his predecessors led that the administering of it necessarily called for new paths, new plans, new prospects. The years ahead doubtlessly will produce a pictorial history as far beyond the imaginings of this volume's readers as the accomplishments pictured here have exceeded the visions of those who first dreamt the dream of a state university in Indiana.

In this process, the clashings of embedded traditions, habitual modes of operation, and shifts in relative values will inevitably produce a ferment that can lead to progress. Through the years the university has for the most part reflected the values, the temper, the aspirations of Hoosier residents. Politically conservative, Indiana was an unlikely host for the Kinsey studies or for accommodating internationalization, and so it may be for some new initiative of the future. The dominance of rooted ways of thinking and acting has led quite a few Hoosier sons and daughters to leave the state and seek employment where larger visions produced greater opportunities. To slow the "brain drain" of medical graduates, the School of Medicine introduced the Indiana Medical Plan, which did indeed increase retention. No doubt other practical but imaginative ideas for improvement will emerge and engage Indiana University as prime mover or skilled abettor.

In this, President Ehrlich's introduction to public higher education administration, he has boldly confronted the restrictions sanctioned by tradition and habit and, through an emphasis on goals, has set the path for an academically strong, research-minded Indiana University to enter the twenty-first century side by side with other top universities in the land. A fully supportive Indiana University Foundation, fresh from a top-popping fund drive that both lent substantial encouragement for future drives and revealed promising vistas for exploration, is organized for action.

A clear page of the chronicle awaits.

Dorothy C. Collins

INDIANA
UNIVERSITY

CHAPTER XLVIII.

AN ACT to establish a State Seminary, and for other purposes.

Approved, January 20, 1820.

Sec. 1. *BE it enacted by the General Assembly of the State of Indiana,* That Charles Dewey, Jonathan Lindley, David H. Maxwell, John M. Jenkins, Jonathan Nichols, and William Lowe, be, and they are hereby appointed trustees of the state seminary, for the state of Indiana, and shall be known by the name and style of the trustees of the state seminary, of the state of Indiana, and they, and their successors in office, shall have perpetual succession, and by the name and style aforesaid, shall be able and capable in law, to sue, and be sued, plead, and be impleaded, answer, and be answered unto, as a body corporate and politic, in any court of justice: and the trustees hereby appointed, shall continue in office, until the first day of January, one thousand eight hundred and twenty-one, and until their successors are chosen and qualified.

Sec. 2. The trustees aforesaid, or a majority of them, shall meet at Bloomington, in the county of Monroe, on the first Monday in June next, or so soon thereafter, as may be convenient, and being first duly sworn to discharge the duties of their office, shall repair to the reserved township of land in said county, which was granted by Congress to

Marginal notes (left column):
- Trustees appointed
- Style
- Perpetuated
- Powers as a corporation
- Continuance in office
- When and where to meet

this state, for the use of a seminary of learning, and proceed to select an eligible and convenient site for a state seminary.

Sec. 3. It shall be lawful for the trustees hereby appointed, to appoint an agent, who shall give bond with security to be approved of by the trustees aforesaid, payable to the Governor and his successors in office, for the use of the state seminary aforesaid, in the sum of twenty thousand dollars, conditioned for the faithful performance of the duties of his office; and it shall be the duty of the agent aforesaid, after taking an oath of office, to proceed to lay off, and expose to sale, under the sanction of the trustees aforesaid, any number of lots, or quantity of land, within the reserved township, aforesaid, and contiguous to Bloomington, not exceeding one section, or six hundred and forty acres thereof.

Sec. 4. It shall be the duty of the agent aforesaid, first to expose to sale, such lots as may be selected most contiguous to the site which may be selected for the seminary aforesaid, and take of the purchasers of any lots or lands which he may sell, under the provisions of this act, such payments and security therefor, as may be directed by the trustees aforesaid.

Sec. 5. The trustees aforesaid, shall so soon as they deem it expedient, proceed to the erection of a suitable building for a state seminary, as also a suitable and commodious house for a Professor, on the site which may be selected by them for that purpose.

Marginal notes (right column):
- To select a site for seminary
- Agent to give bond
- Penalty
- Condition
- Agents duties
- What lots first to be sold
- Payments & securities
- Trustees to erect buildings

Sec. 6. The trustees aforesaid, shall within ten days after the meeting of the next General Assembly, lay before them a true and perfect statement of their proceedings so far as they have progressed under the provisions of this act, and a plat of the lots or lands laid off and sold, and the amount of the proceeds of such sales, and also a plan of buildings, by them erected, or proposed to be erected.

Sec. 7. The trustees hereby appointed, shall before they enter upon the duties of their office, give bond and security, to be approved of by the Governor, in the sum of five thousand dollars, payable to the Governor and his successors in office, for the use of the state seminary, conditioned for the faithful performance of the duties of their office; and if any vacancy shall happen in the office of trustees, the governor shall fill such vacancy, by an appointment which shall expire on the first day of January next.

Marginal notes (left column):
- To report their proceedings to the General Assembly
- To give bond and security
- Condition
- Vacancies filled

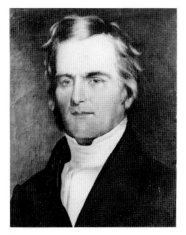

ANDREW WYLIE
1829-51

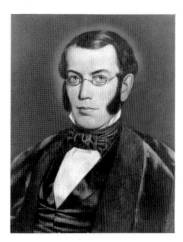

ALFRED RYORS
1852-53

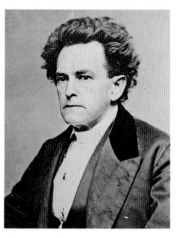

WILLIAM MITCHELL DAILY
1853-59

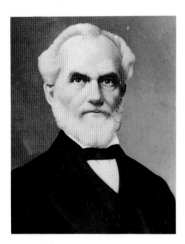

JOHN HIRAM LATHROP
1859-60

CYRUS NUTT
1860-75

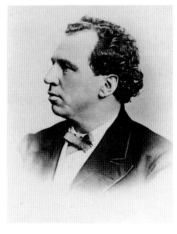

LEMUEL MOSS
1875-84

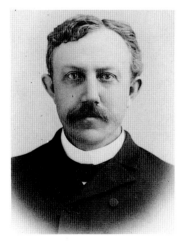

DAVID STARR JORDAN
1885-91

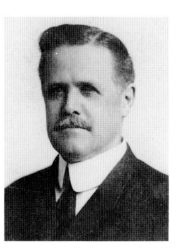

JOHN MERLE COULTER
1891-93

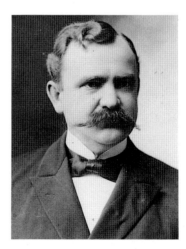

JOSEPH SWAIN
1893-1902

2

PRESIDENTS
OF
INDIANA
UNIVERSITY

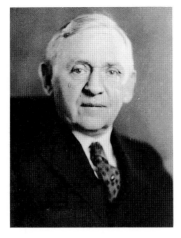

WILLIAM LOWE BRYAN
1902-37

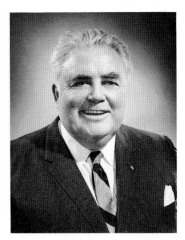

HERMAN B WELLS
1937-38 (ACTING); 1938-62;
1968 (INTERIM)

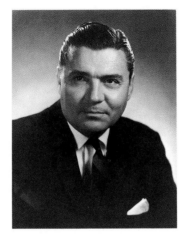

ELVIS JACOB STAHR, JR.
1962-68

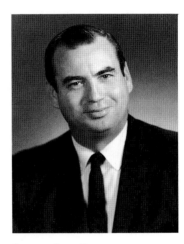

JOSEPH LEE SUTTON
1968-71

JOHN WILLIAM RYAN
1971-87

THOMAS EHRLICH
1987-

3

Come and join in song together,
 Shout with might and main;
Our beloved Alma Mater.
 Sound her praise again.

Honor to the white and crimson
 Banner that we love;
It shall lead us in the conflict.
 And our triumph prove.

Chorus.

 Gloriana, Frangipana,
E'er to her be true;
 She's the Pride of Indiana,
Hail to old I. U.

Senior, Junior. Soph. and Freshman.
 All together we;
Sound the chorus loud and glorious.
 State University.

Here's to her whose name we'll ever,
 Cherish in our songs;
Honor. love and true devotion,
 All to her belong.

"Hail to Old IU," the alma mater hymn of Indiana University, began as a football yell. IU students riding up to Lafayette on a Monon train for a game with Purdue in October 1892 needed a cheer. What would rhyme with Indiana? "Gloriana" came naturally. Then Ernest H. Lindley suggested "Frangipani," the name of a perfumed soap available in his father's drug store in Bloomington. The final "i" in the strange word—the name of a tropical American shrub—was dropped and an "a" added, and the students had a rhyming football yell.

Joseph T. Giles, Class of 1894, who formed the first IU Glee Club, later wrote additional lyrics and arranged the whole to the tune of a Scottish folk song. The first public performance was by the glee club in the Plymouth Church at Indianapolis as part of the state oratorical contest in 1893. This version of the song appeared in the first *Arbutus* yearbook in 1894. One word was changed before the song was copyrighted. In the second stanza "white" became "cream," and in the fourth stanza "songs" was altered to the singular. Cream and crimson had been chosen by the Class of 1888 as the IU colors.

4

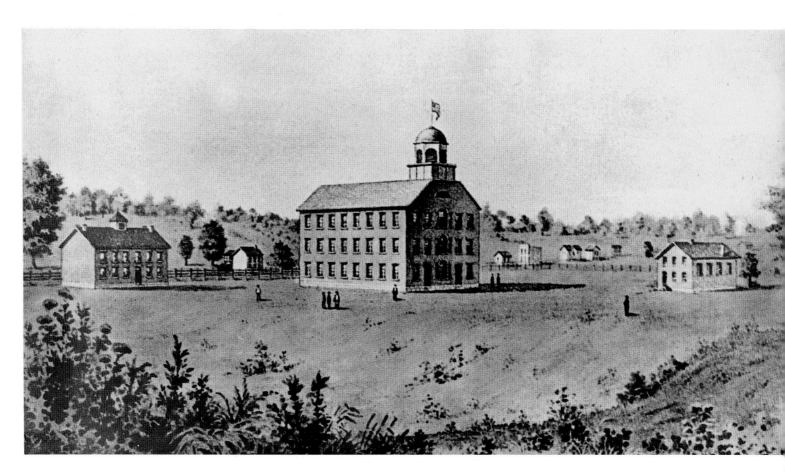

Three buildings on the first campus of Indiana University. The building on
the left was constructed in 1824, in the seminary period. The three-story
structure in the center, constructed in 1836, was destroyed by fire in 1854.
The building on the right was finished in 1840 and was used
for laboratory purposes.

*For sixty years Indiana University was located on eleven acres of land in
Bloomington at the foot of what is now South College Avenue, approximately one-half
mile from the town square. University historians refer to the location as the Old
College Campus. During the sixty years, seven buildings were erected to serve the
institution as it changed from State Seminary (1820) to Indiana College (1828) to
Indiana University (1838). When the university moved to its present location, only a
collegiate Gothic building constructed in 1855 remained at the old site. This building
and the surrounding land were sold to the City of Bloomington in 1897 for use as a
high school. In the 1960s the city created a park in part of the area and named it
Seminary Square Park.*

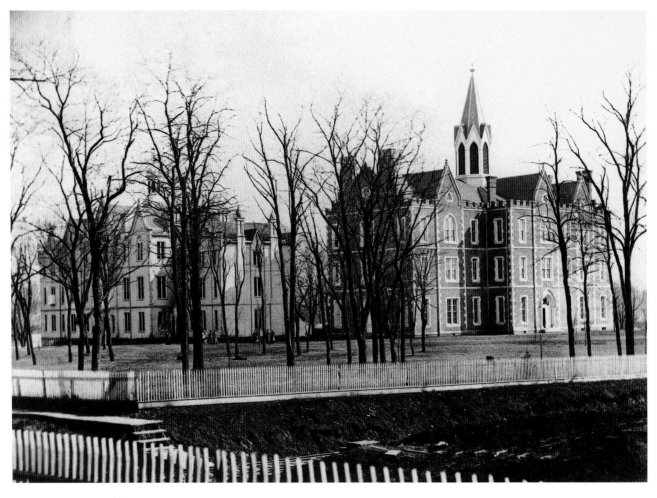

The last two buildings constructed on the Old College Campus, now Seminary Square. The one on the left, built in 1855 and used by the IU Literary Department, became a high school in 1897. The one on the right, Science Hall, was constructed in 1874, but it and most of its contents were destroyed by fire in 1883. Gone up in smoke were the 12,000-volume library, university records, scientific equipment for physics and chemistry, and the 85,000-specimen geological and archaeological cabinet assembled by the Owen brothers (David Dale, Robert Dale, and Richard Dale) and Alexander and William Maclure. The cabinet was said to be the most important collection of its kind in all of North America.

The disastrous fire precipitated the move of the university to its present location in Dunn's Woods.

Early Bloomington, by Cornelius Pering and Theophilus A. Wylie. When the State Seminary opened in 1825, the population of Bloomington was approximately four hundred. These two paintings of the 1830s, when the population did not exceed seven hundred, illustrate the primitive conditions of the town square.

Cornelius Pering established a female institute in Bloomington about 1833. He became the first principal of the Monroe Country Female Seminary, serving from 1835 to 1849, when he moved to Louisville. He used family members as models in his painting of early Bloomington.

Theophilus Adam Wylie, who painted the political meeting on the town square, was a faculty member at Indiana University, 1837-52 and 1855-86. He taught natural philosophy, chemistry, and languages. The university's second historian, he was the author of *Indiana University, Its History from 1820, When Founded, to 1890.*

The two paintings hang in the chancellor's office in Owen Hall.

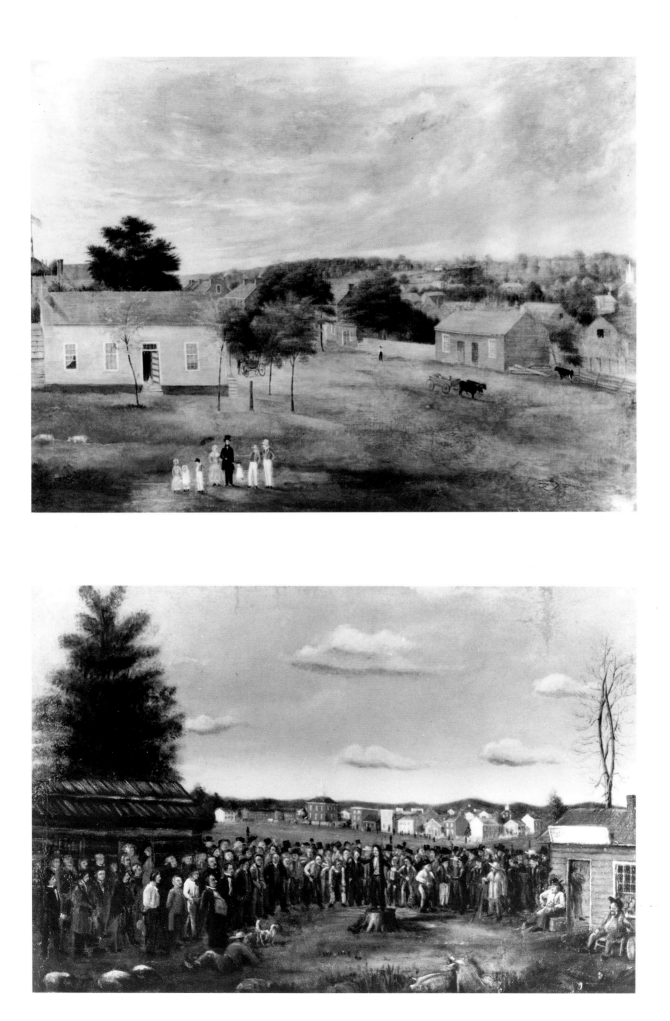

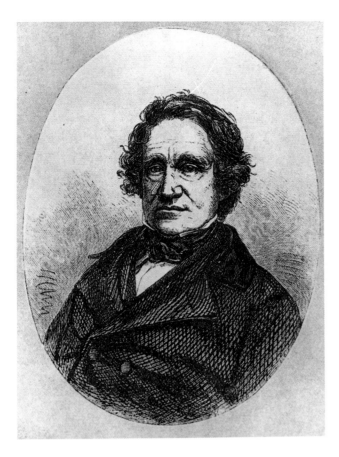

First professor (1825-32). Baynard Rush Hall, the first principal and professor, taught Greek and Latin grammar to the first ten students admitted to the all-male State Seminary in 1825. He resigned after a bitter quarrel with the first president, Andrew Wylie, and left the state. In 1853 Hall published *The New Purchase: or, Seven and a Half Years in the Far West*. Because of his outspoken criticism of persons still living, Hall used the pseudonym "Robert Carlton" and disguised his work with a series of invented names and places. In spite of his marked bitterness toward some of the people he wrote about, the book is a readable and valuable account of life in pioneer Indiana—then a part of the "Far West"—and the early years of IU.

Princeton University Press published a new edition of *The New Purchase* in 1916 edited by Professor James Albert Woodburn of IU. Woodburn revealed the true identities of Hall's fictitious characters and place names in a "Key to the Characters and Places." President Andrew Wylie was "Dr. Bloduplex" and Bloomington was "Woodville."

The first catalog, Indiana College, 1829. "The next session of the Indiana College will commence on the first day of December, 1829, at which time the President, Dr. Wylie, will enter upon the regular duties of his office." The catalog listed the courses offered and announced tuition of $5 per session for the "First Class" and $7.50 per session for other classes. "Boarding, including all expenses of wood, washing, candles, etc. may be procured in respectable families at convenient distance from the College, at from one dollar and a quarter to two dollars per week."

The college academic year consisted of two sessions, each of five months' duration. The first session that began on December 1, 1829, ended the last day of April 1830. The second session began June 1, 1830, and continued through October.

INDIANA COLLEGE,
BLOOMINGTON.

THE next session of the INDIANA COLLEGE will commence on the first day of December, 1829; at which time the President, Dr. WYLIE, will enter upon the regular duties of his office. From the extensive and well established reputation of this gentleman as a scholar and an instructor, and from the qualifications of his coadjutors in the Faculty, the Board of Trustees do, with the greatest confidence, present the State College to the special patronage of our own citizens: whilst they are fully persuaded, that to the citizens of the neighbouring states, no western institution of learning, in regard to the cheapness of living, the low price of tuition, the salubrity of the situation, and the comparatively little temptation to vice, affords stronger inducements than Indiana College.

THE FACULTY CONSISTS OF

THE REV. ANDREW WYLIE, D. D. President and Professor of Moral and Mental Philosophy and Polite Literature.

THE REV. BAYNARD R. HALL, A. M. Professor of the Ancient Languages.

JOHN H. HARNEY, A. M. Professor of Mathematics and Natural and Mechanical Philosophy.

THE STUDIES OF THE SEVERAL CLASSES ARE AS FOLLOWS:

FIRST, OR PREPARATORY CLASS.

LATIN: Ross' Grammar, Mair's Introduction, Latin Reader 2 vols. Viri Romæ, Cæsar, Sallust.

ANNUAL
COMMENCEMENT
OF
INDIANA UNIVERSITY.

Wednesday, Sept. 29, 1841.

EXHIBITION OF THE SENIOR CLASS.
ORDER OF EXERCISES.

PRAYER. *and* MUSIC.

Greek R. T. ALLISON, LOUISVILLE, KY. *Latin*
Salutatory.
MUSIC—"*Louisville March.*"

J. F. DODDS, MONROE COUNTY, IND.
Desire of Reputation.
MUSIC—"*Indiana March.*"

A. R. SHANNON, CARMI, ILL.
Moral Cultivation.
MUSIC—"*Lafayette's Welcome.*"

J. H. WYLIE, BLOOMINGTON, IND.
Courage.
MUSIC—"*Sicilian Mariner's Hymn.*"

did not C. B. THOMAS, LEXINGTON, KY. *Speak*
Valedictory.
MUSIC—"*Home—sweet home,*"

BACCALAUREATE.
MUSIC—"*Marseilles Hymn.*"

Students were the chief participants in commencements in the early days, delivering their views on scholarly subjects at the ceremonies until the time of President David Starr Jordan. He began the custom of inviting a well-known adult to give the major commencement address.

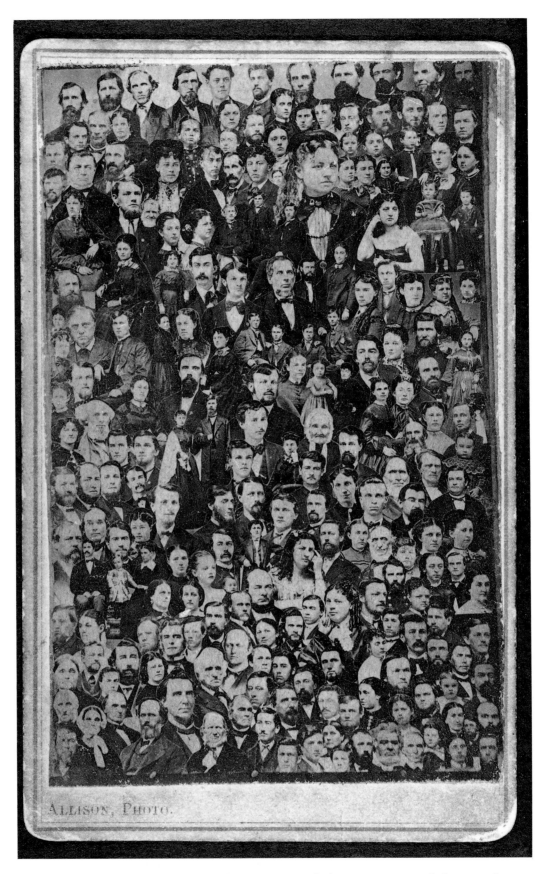

Bloomington citizens in 1860. This photo montage of Bloomingtonians includes several professors of the university. Amzi Atwater, Elisha Ballantine, Theophilus A. Wylie, and President Cyrus Nutt can be identified.

THE INDIANA STUDENT.

VOL. I. INDIANA STATE UNIVERSITY. No. I.

BLOOMINGTON, FRIDAY, FEBRUARY 22, 1867.

The Indiana Student.

A WANT.—There is badly needed, at the present time, a walk from the campus gate to the college. Many of our citizens have been deterred from attending performances at the college, in consequence of the deep mud through which they were compelled to wade. This could be remedied at a small outlay, and should be attended to at once, if we desire to keep up our reputation; all it needs is some one to take hold and it can be put through. Who will make the move?

SERENADE—We had scarcely assumed the position of "quill driver," till we were honored with a serenade by the Bloomington String Band, which discoursed a "concord of sweet sounds" at our window, to the very great delight of all within. Come again; our window is always open.

How "The Indiana Student" was named.

THE idea having entered the fertile craniums of some of the more knowing ones of the students of Indiana University, that the public was sustaining a great loss from the non-existence of a literary magazine of some character, in which the genius and talents of these hopeful objects of the State's care and parental solicitude might be displayed; and this idea was the more indelibly impressed, in view of the fact that the citizens of Bloomington, though generally noted for their energy and enterprise, had not, as yet, succeeded in establishing an organ, in the columns of which, a student or literary man, who had any respect for himself or regard for his reputation as a writer, would be willing for his productions to appear. A meeting was accordingly convened in the office of a distinguished representative of the legal fraternity, in Bloomington, at which the following great literary lights were present: Hon. Henry J. Raymond, Geo. D. Prentice, Washington Irving, James Gordon Bennett, Andrew Johnson and Horace Greeley. The meeting was organized by calling Horace Greeley to the chair.

After a prolonged discussion on various topics, in which much learning, prophetic statesmanship and literary research were displayed, the chair announced that the first thing in order was to select a name for the paper, and suggested for the consideration of the meeting, the name of the "Bloomington Regulator," and urged as a reason for its adoption, that it would be one of its principal objects to regulate society, regulate literature, regulate students, regulate the faculty, regulate public exhibitions, regulate Bloomington; in short, it was to be a regulator in the fullest sense of the term. Washington Irving proposed the name of the "Prairie Flower," as it would indeed be a rare gem, and no doubt be highly prized by the young ladies. James Gordon Bennett proposed the name of "The Elevator;" for, said he, it will be the means of elevating everybody in general and ourselves in particular. Geo. D. Prentice proposed to call it the "Indiana Draw'-er," draw being a very popular word with certain classes, and the name would thereby be constituted an element to its success. Henry J. Raymond thought "The University Lightning Rod" exceedingly appropriate, as it would undoubtedly be the means of silently conducting all the superfluous gas generated in the fruitful craniums of certain "smart students," either to immortal glories in the skies, or perhaps, to its more appropriate place, the dominions of Pluto under the earth. His majesty, Andrew, earnestly insisted on the singular appellation of "My Policy Gazette," strenuously adhering to the principle that all "Big Things" are controlled by policy. The meeting was frequently interrupted by some disorderly persons who had assembled in the room immediately overhead, and just at this stage of the proceedings, the learned assembly was brought to a dead halt, by a deafening racket and confusion proceeding from the room in which said persons had congregated, and indicating that a regular midnight carousal of a "Host" of jolly "Good Tipplers," was being held. His majesty suggested that the interruption arose from a set of jolly fellows, his friends and boon companions, who were celebrating some important event over a bottle of inspiration, and moved that a committee of one be appointed to negotiate with them for portion of their inspiration, as something of the kind was absolutely necessary to a successful accomplishment of the object of the meeting. The committee was about to proceed to perform his duty, when it occurred to Horace Greeley that the aforesaid disorderly persons were a camp of the Temperance Host, and if the learned assembly depended for inspiration from that source, they would experience an exceedingly dry time of it indeed. The confusion having subsided, the meeting, with great mortification and disappointment, resumed its labors. A volume of names, both great and small, were proposed, such as "Collegian," "Review," "Banner," "Mirror," "Bummer," etc., and each rejected as inappropriate. After much deliberation it was agreed that it should be "The Indiana and something else," but as to what the something else should be no one could decide, until Henry J. Raymond, by a heroic stretch of imagination and herculean wielding of brain power, was delivered of the word "Student," which was unanimously adopted, and the author, for the wise sagacity, great foresight and transcendent genius displayed in originating this name, was subsequently elected one of its editors. The learned assembly having thus succeeded in its prime object, adjourned, and as the result, we have, appearing in flying colors, "*The Indiana Student.*"
NEILE.

IT IS OUR intention, after the present issue, to double the size of our paper, if the patronage it receives at the hands of the public will justify us. This is to supply a need which has long been felt in our midst. If persons will take hold of the matter and aid us by their subscriptions, we promise to supply them with a first class college paper.

MARRIAGE NOTICES inserted free of charge. Students will please bear this in mind.

First number of *The Indiana Student*. Variously sponsored and with changes in frequency, consistency of publication, and title, this student-generated newspaper became the present-day *Indiana Daily Student*.

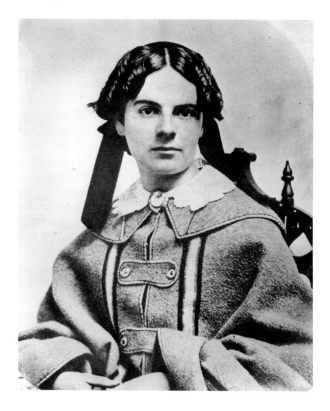

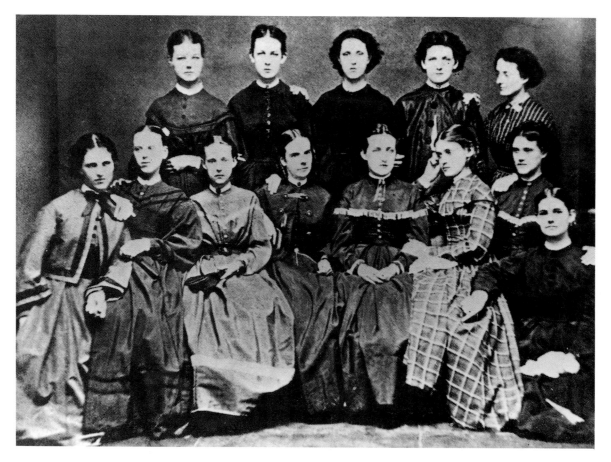

Sarah Morrison with the women who matriculated in 1868. Standing left to right: Rachel E. Cox, Clara E. McCord, Helen Alford, Sarah Craig, Ella Fellows; seated left to right: Laura Turner, Jennie Bray, Susannah Hamilton, Morrison, Elizabeth Harbison, Sina Green, Mell Rogers, and Mattie Moffitt.

Sarah Parke Morrison, the first woman student and degree recipient, 1867-69, and the first woman teacher in the university, 1873-75. University historians declare that Indiana was the first state university to admit women. The mistaken maxim "Mixed colleges will not live" was heard from many males of the period.

A mature woman when admitted to IU, Morrison had attended a female academy in Salem, Indiana, and had graduated from Mount Holyoke Seminary in Massachusetts in 1858. She apparently was urged to apply for admission to the university by her father, John Irwin Morrison, who served as an IU trustee, 1846-55 and 1874-78. The 1942 *Arbutus* reported that male students "called her a blue-stocking and refused to accept her . . . thinking she couldn't possibly have the mental ability to get through college." But Sarah Morrison weathered the prejudice and survived her first year at Indiana, opening the door for twelve young women who were admitted the next year.

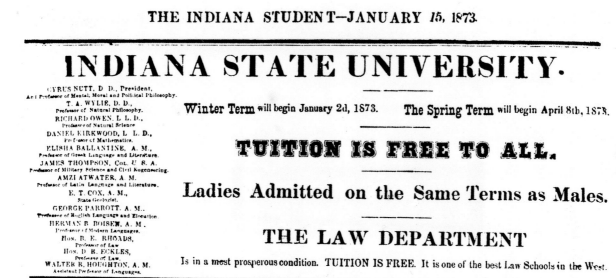

This advertisement from *The Indiana Student* of January 15, 1873, sought to assure women that they would have no difficulty in being admitted to the university. The institution was referred to as Indiana State University, a term frequently used in the early days to emphasize its connection with the State of Indiana. The ad claimed that "Tuition is free to all." Then as now, students paid fees, not tuition.

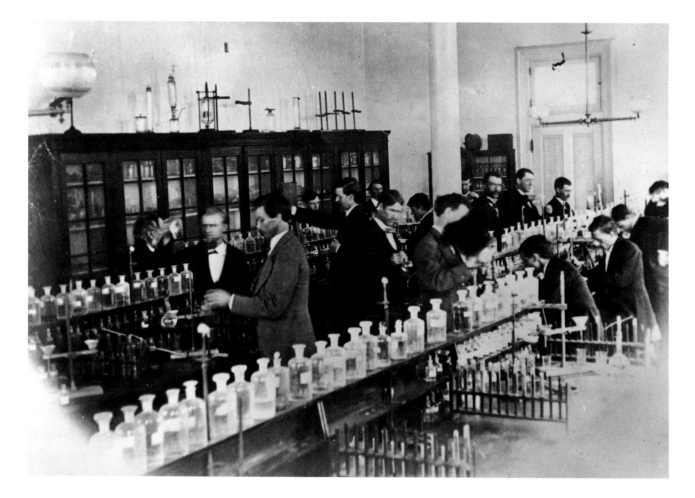

A chemistry laboratory in 1875.
The denizens are all males, with
starched collars and bow ties.

Law students in Science Hall, 1875. Law, the earliest of IU's professional schools, was established in 1842. Several times between 1870 and 1877 the number of law graduates was equal to or greater than the number of graduates in liberal arts. In 1877 the Law School was abolished by the legislature as an economy move but was revived in 1889.

When the school reopened, IU President Jordan persuaded Judge David Demaree Banta to resign from the Board of Trustees (on which he had served since 1877) to become dean of the Law School. Judge Banta remained dean until his death in 1896. The first six chapters of Professor James A. Woodburn's *History of Indiana University 1820-1902* contain Banta's history of the university from the beginning through 1850, given as Foundation (Founders) Day addresses beginning in 1889.

The Law School has had many able deans since Banta. Probably the best known was Paul V. McNutt. Law graduates with the widest name recognition were Sherman Minton, U.S. senator and associate justice of the United States Supreme Court, and Wendell Willkie, utility executive and Republican nominee for the presidency in 1940.

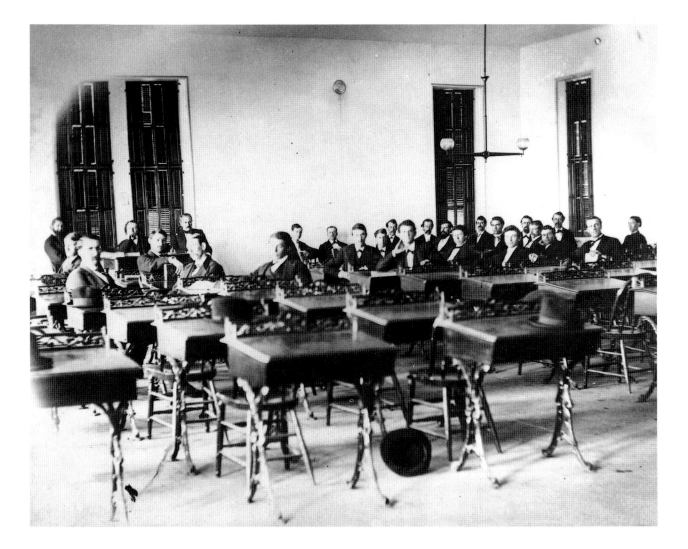

Following the destruction of Science Hall by fire in 1883, a decision was made to move the university from Seminary Square, a location that was considered too restrictive for future growth and too noisy—the Monon Railroad ran just beside the campus.

Twenty acres about a half-mile east of the town square in what was called Dunn's Woods were purchased from Moses F. Dunn. The trustees named the new campus University Park but the name was never used much. Most people, including students, continued to call it Dunn's Woods.

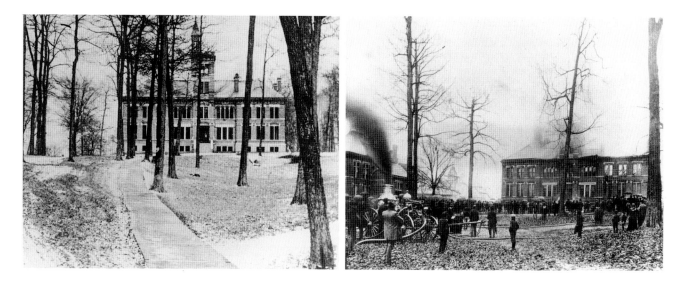

Wylie Hall, the first building constructed on the new campus, in 1884. Named to honor the first president, Andrew Wylie, and longtime professor Theophilus A. Wylie, it originally boasted a spire and tower, but a fire in February 1900 destroyed the tower. When restored, a third floor was added to the building.

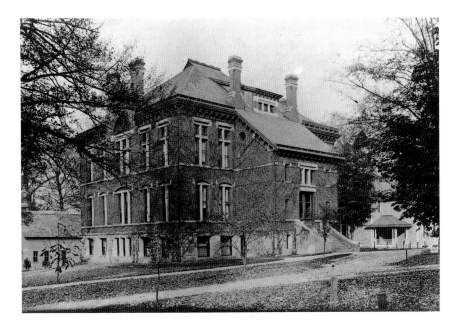

The second building on the new campus, Owen Hall, 1884. The building was named to honor the Owen brothers Robert Dale, David Dale, and Richard Dale, sons of the social philanthropist Robert Owen of New Harmony fame. Robert Dale served as a trustee of IU for ten years between 1838 and 1852. Richard Dale was a professor of chemistry at IU, 1863-79. David Dale was Indiana state geologist for a short period and was distinguished for his geological surveys of the Midwest.

To the right a part of the first Assembly Hall and to the left a part of the old carpenter shop can be seen.

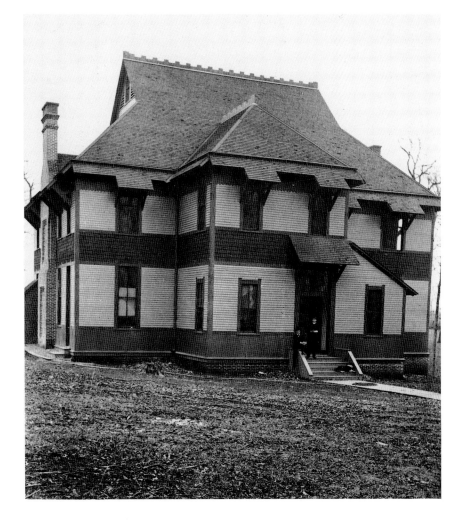

The third building on the new campus, the wooden structure first named Maxwell Hall, 1885, and renamed Mitchell Hall in 1894. It was named to honor James Lewis Mitchell, Class of 1858, a lawyer, Civil War veteran, and IU trustee, 1883-94. The building served many departments, including music, band, and fine arts. Radically altered many times over the years and moved from its original location, it was razed in 1991.

17

Baseball, the first recorded sport for men at the university, began in 1867. Indiana had an undefeated season going into this final game against DePauw in 1892. An unknown informant described the game, played May 30 on the Seminary Square field: "This . . . was the deciding game of the Inter Collegiate Champion-ship series of 1892. There was an enormous crowd and wild excitement. 300 DePauw students went down to witness the game and both sides were determined to win. Indiana University won the game by a score of 13 to 11, this gave her the pennant of 1892."

It would appear that the baseball teams had no coach before the 1902 season. Coaching, if any, came from the most skilled player or the team captain. The future IU president William Lowe Bryan played right field on the baseball team during his senior year, 1884.

The undefeated baseball team of 1894.

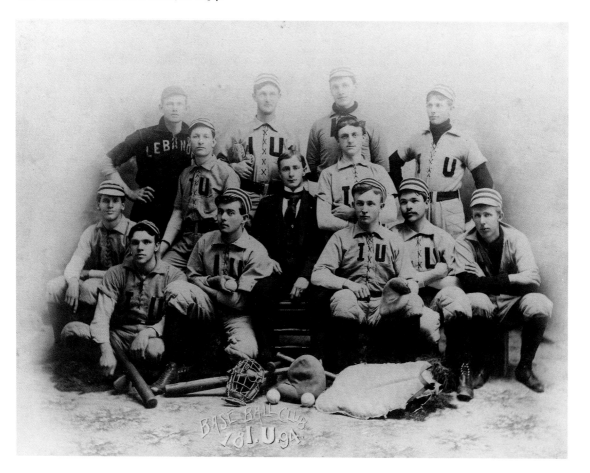

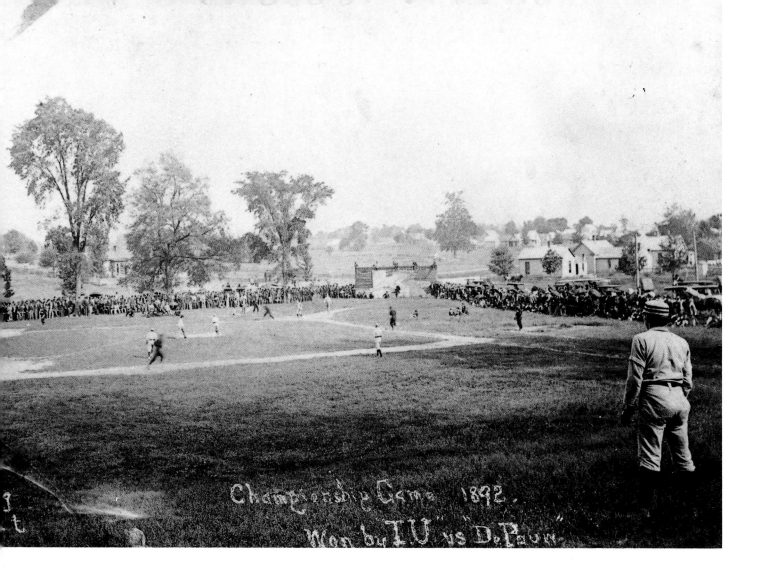

Championship Game 1892.
Won by "IU" vs "DePauw"

The first men's gymnasium, measuring 60 by 40 feet, cost $1,000 and was completed in 1892. It was located north of Owen Hall and contained Indian clubs, rings and ropes, horizontal and parallel bars, and other apparatus for physical conditioning. Converted into a carpenter shop in 1896, the building was razed in 1932.

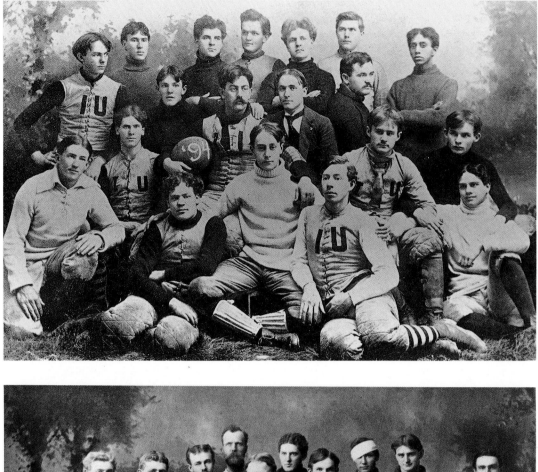

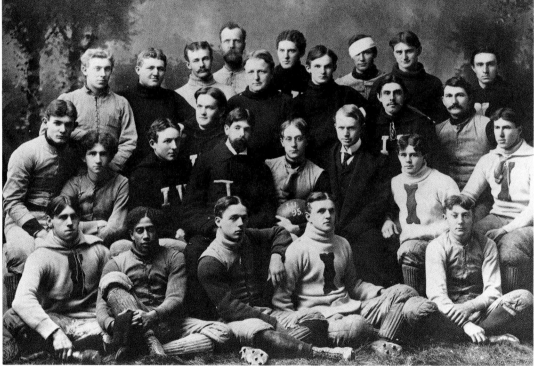

Football was introduced at the university by Arthur B. Woodford during the academic year 1886-87. A professor of political and social science, 1886-89, Woodford was familiar with the game from his student days at Yale. He served as the first football coach until he left the university. Evans Woollen succeeded as coach for the 1889 season. *The Indiana Student* comment on the 1894 team was blunt: "At present Indiana University is the laughing stock of the Intercollegiate Football Association."

In the 1894 photo, standing at far right in the top row, is Preston Eagleson, from Bloomington, the first African American player to participate in football at the university. In the 1895 photo he is in the front row, second from left.

Marcellus Neal, first African American to graduate from the university, 1895, and his wife as they were pictured in the 1895 *Arbutus* photo of the Married Folk's Club, which was organized that year. Members were required to be seniors as well as married. In 1914 the name was changed to Married Students Club.

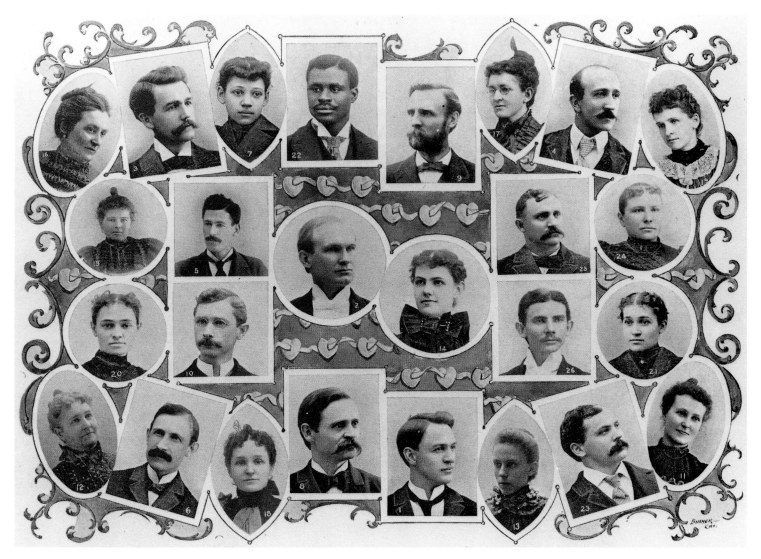

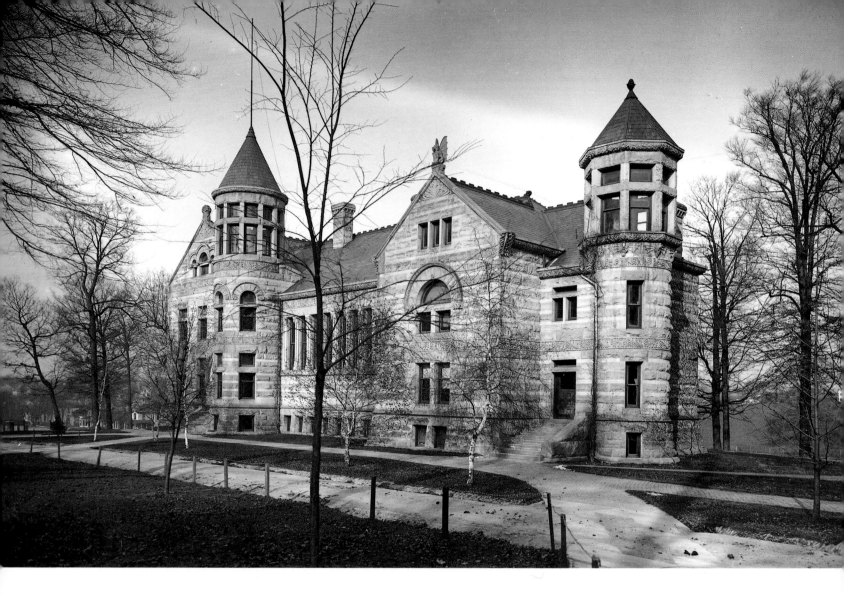

The first library building on the new campus at Dunn's Woods. Called Library Hall, it was constructed in 1890. In 1894 it was renamed Maxwell Hall to honor David H. Maxwell, IU trustee, 1820-37 and 1839-52, and his son, James Darwin, trustee, 1861-92, both Monroe County physicians. The elder Maxwell has been called the "Father of Indiana University." He was a member of the Indiana Constitutional Convention, which drafted the 1816 constitution calling for education at all levels, and he lobbied in the General Assembly for the law creating the State Seminary in 1820. For thirty years he was one of the strongest advocates for Indiana University.

The library collections were destroyed by fire twice while the institution was located at Seminary Square, in 1854 and 1883. When the library occupied Maxwell Hall, the university by gift and purchase had accumulated approximately 13,000 volumes.

View of part of the library in Maxwell Hall.

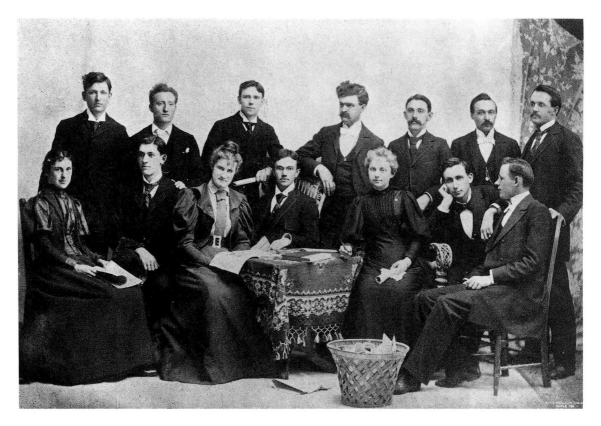

Board of editors of the first *Arbutus* yearbook, 1894.

Kirkwood Hall, constructed in 1894 and named to honor Daniel Kirkwood, professor of mathematics and astronomy, 1857-86. IU historian Thomas D. Clark wrote that Daniel "Daddy" Kirkwood was "a genuine scholar who perhaps more than any other man of his time at Indiana, gave status to the academic program of the university." Kirkwood Observatory and Kirkwood Avenue (Bloomington's Fifth Street, which leads from courthouse to campus) were also named to honor the popular and learned professor.

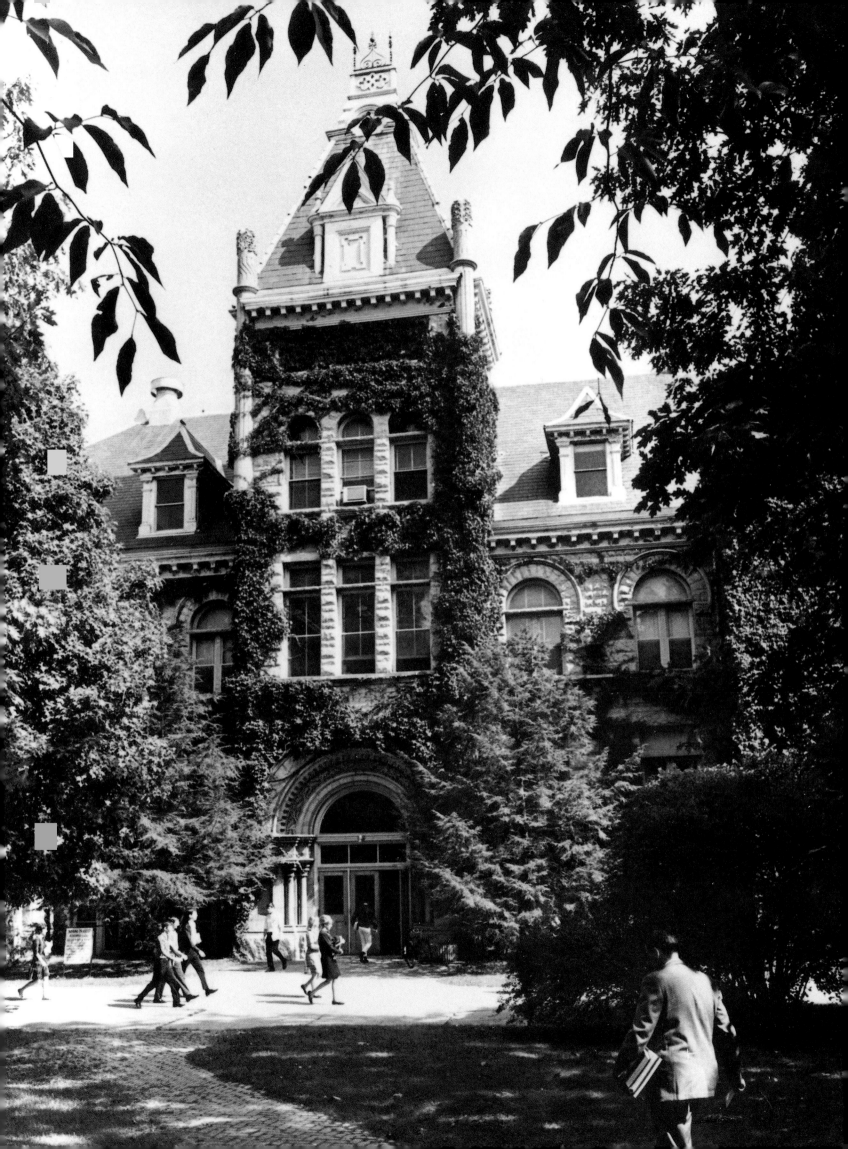

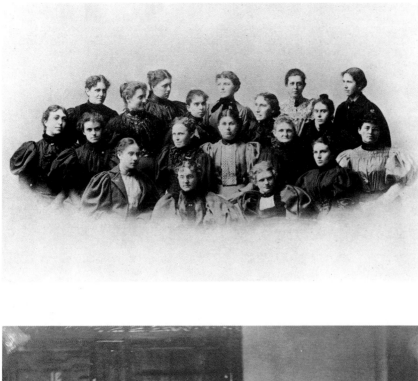

The Women's League, organized in 1895-96. The 1896 *Arbutus* stated that the league "aims to unite in mutual helpfulness those who . . . would otherwise spend their college life in ignorance of one another." Mrs. Joseph Swain, wife of the IU president, was the prime mover. The league, open to women faculty, resident alumnae, and women students, had a major role in raising funds for the Student Building.

The one thousandth student registering at the university in 1898. Enrollment reached 1,048 that academic year, according to President Swain's report to trustees.

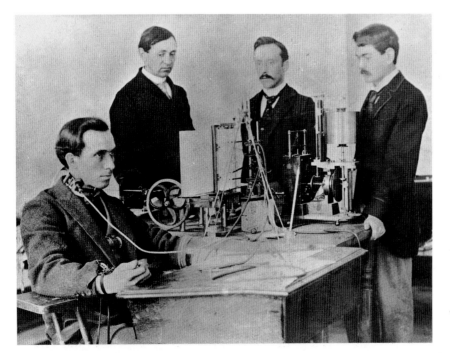

The psychology laboratory in 1897, one of the earliest experimental laboratories west of the Alleghenies. Left to right: James P. Porter, William Lowe Bryan, John A. Bergström, and Clark Wissler.

Bryan and Bergström were members of the IU faculty. Porter and Wissler, both students, received A.B. and A.M. degrees from IU, then went on to other universities for Ph.D.s. Wissler, anthropology, became curator of the American Museum of Natural History in New York and a professor at Yale. Porter became a professor of psychology, first at Clark and later at Ohio University. He was editor of the *Journal of Applied Psychology*, 1920-43.

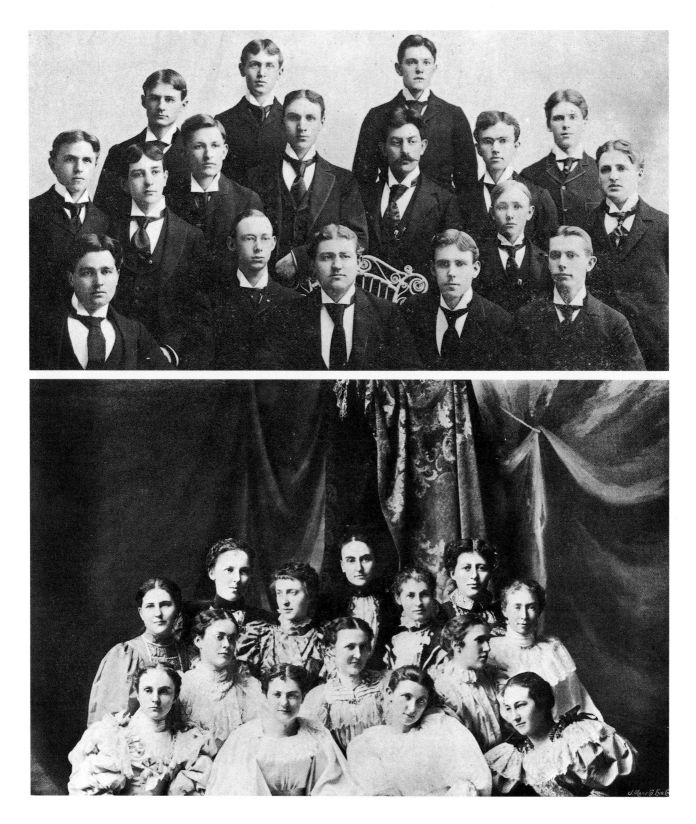

Beta Theta Pi in 1894 and Alpha Zeta Beta in 1897. Beta Theta Pi was introduced on the IU campus in 1845, suspended in 1847, then revived in 1855. Alpha Zeta Beta was founded at the university on November 15, 1892.

The first houses of IU's Greek-letter organizations were converted family residences located on the periphery of the campus. Gradually, sororities and fraternities were able to finance buildings planned as chapter houses along Third, Jordan, Tenth, Seventh, Woodlawn and other streets. It is thought that Sigma Chi was the first fraternity to build a chapter house specifically designed for fraternity living. The house, of Indiana limestone, stands at the corner of Seventh Street and Indiana Avenue. House development in the area north of Tenth Street started during the Wells administration and still continues.

The university band in 1896, J. M. Winger, musical director. James A. Woodburn, in his *History of Indiana University 1820-1902*, captioned this photo "The First Band."

Women's gym class, 1897. A gymnasium for women was provided in the basement of Wylie Hall as early as 1891. Harriet Colburn Saunderson, wife of IU's professor of rhetoric and oratory, was the director from 1891 through 1893. The equipment provided was for light physical exercise: Indian clubs, dumbbells, hoops, and basketballs. Basketball was at first played as an exercise, but by 1898 teams within the university were competing. Membership in the gymnasium was voluntary. In 1894 Juliette Maxwell became director of the Women's Gymnasium and served as head of physical education for women until she retired in 1928.

1820 —— —— 1900

Indiana University

Bloomington

Sixty-three members of the Faculty. Two hundred and eighty graduate and undergraduate courses. One thousand and fifty students; every county in Indiana represented. Nineteen departments, as follows:

I. Department of Greek, two teachers and eleven courses.

II. Department of Latin, three teachers and twenty courses.

III. Department of Romance Languages, four teachers and fourteen courses.

IV. Department of Germanic Languages, five teachers and fourteen courses.

V. Department of English, seven teachers and twenty-four courses.

VI. Department of History and Political Science, four teachers and twenty-nine courses.

VII. Department of Economic and Social Science, two teachers and sixteen courses.

VIII. Department of Philosophy, four teachers and eight courses.

IX. Department of Pedagogy, four teachers and seven courses.

X. Department of Mathematics, six teachers and twenty-four courses.

XI. Department of Mechanics and Astronomy, one teacher and nine courses.

XII. Department of Physics, four teachers and fourteen courses.

XIII. Department of Chemistry, five teachers and twenty-four courses.

XIV. Department of Geology, two teachers and fifteen courses.

XV. Department of Zoology, three teachers and eight courses.

XVI. Department of Botany, two teachers and nine courses.

XVII. Department of Fine Arts, one teacher and four courses.

XVIII. Department of Physical Training, four teachers and seven courses.

XIX. Department of Law, three teachers and twenty-three courses.

Special courses for teachers the Spring Term.

Graduates of commissioned high schools of Indiana are admitted without examination, except in conditioned English, to the freshman class of the University.

Catalogue will be sent on application to the Registrar, or to

JOSEPH SWAIN, President

The curriculum in 1900.

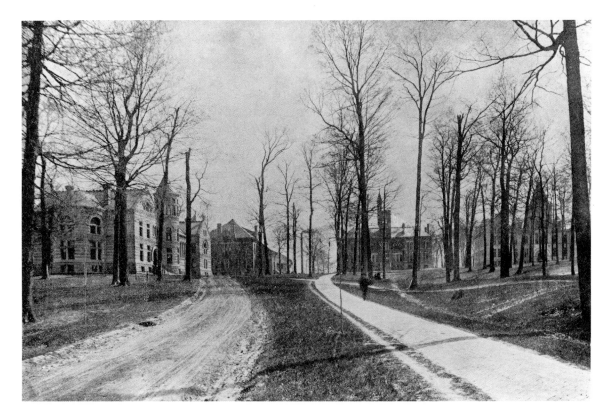

The campus in 1900. Left to right: Maxwell, Owen, Wylie, and Kirkwood Halls.

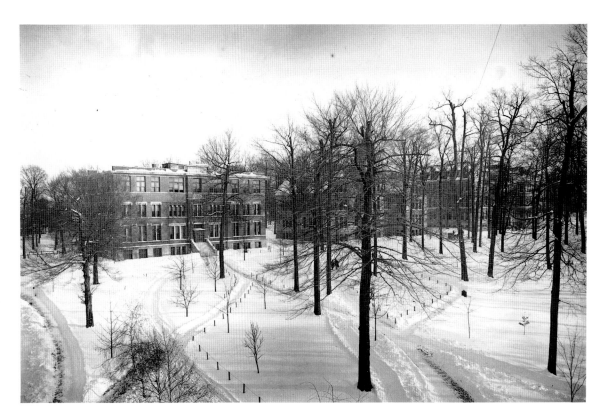

The campus under two feet of snow in 1904. Wylie Hall is on the left.

President Bryan frequently rode on horseback from his College Avenue home to the campus. He hitched his horse in front of Maxwell Hall, where his office was located.

Cast of *Much Ado About Nothing*, 1903.

Boarding house landlady, about 1905. The economy of Bloomington has been stimulated since 1825 by the presence of the university. Many Bloomingtonians have made a living renting rooms and operating boarding clubs for students. Boarding clubs were replaced by restaurants beginning in the 1920s, but group living in apartments is still popular. Approximately 40 percent of today's IU students live in privately owned facilities in Bloomington and the surrounding area.

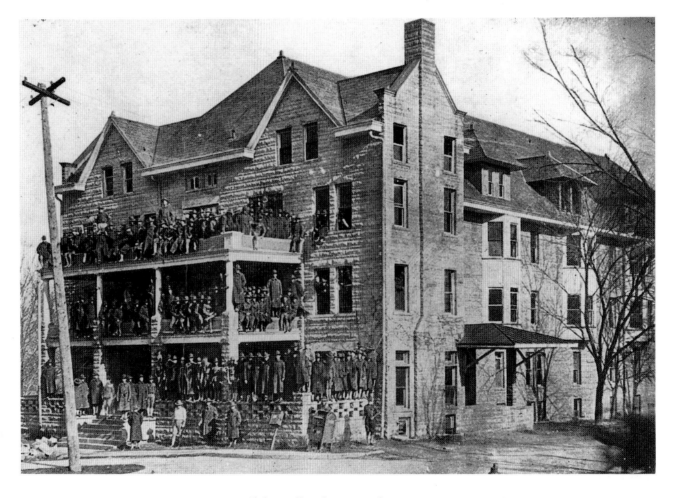

Alpha Hall, a dormitory for women, constructed in 1906 as a private venture headed by Colonel Theodore J. Louden. In 1918 the building housed soldiers training in radio communications during the First World War. IU leased it as a women's dormitory in 1919 and called it Residence Hall, then purchased it in 1936 for use by the School of Education, the Psychology Department, and other departments as classrooms and offices. It was razed in 1961.

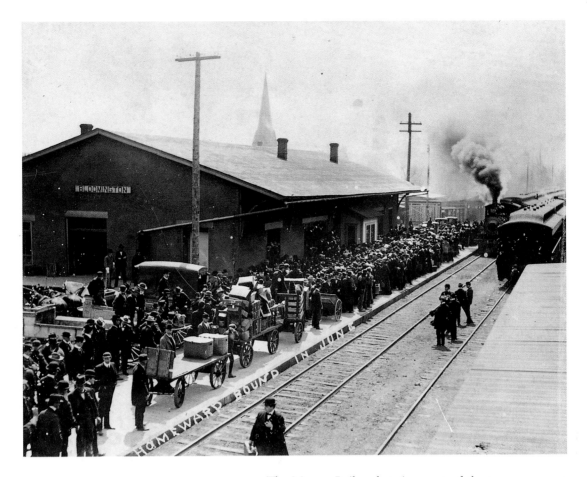

The Monon Railroad station west of the town square at the end of an academic year. Before the coming of the Monon in 1853, students reached the university on foot, by horseback, and by stagecoach. The Monon—and later the Illinois Central—became the principal mode of travel to and from Bloomington until the arrival of the automobile.

J. O. Howe, Bloomington businessman, preparing to demonstrate his Winton, the first car in Bloomington, to a posing audience about 1907. Included in the group were Grace Young, professor of French and Italian, 1917-56, and Juliette Maxwell, director of physical education for women, 1894-1928.

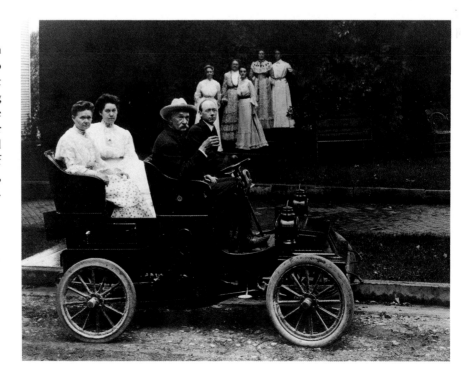

A boardwalk through the woods. The most famous of the boardwalks ran from Kirkwood Hall east to the present site of Ballantine Hall. Campus lore held it to be the pathway of courtship and love on the way to Sorority Alley. "Few collegiate tourists learn the short-cuts to an education, but even the dullest Freshman knows the Board Walk," according to the 1914 *Arbutus.* "Romance and sentiment have given it a place far above the power of Road Guides to add or detract." A common male adage in the days of the boardwalk was "Faster the girl, slower the walk."

John Whittenberger, principal founder of the Indiana Union. Whittenberger Auditorium in the Indiana Memorial Union Building commemorates his name. Organized during the academic year 1909-10, union members made herculean efforts in the memorial fund drive, 1921-26, that enabled the university to construct Memorial Hall, Memorial Stadium (for football), and the Memorial Union Building. When organized, the Union Board was males only; women were finally admitted to membership in 1952.

IN MEMORIAM

JOHN WHITTENBERGER
Founder and First President of
Indiana Union

N the twenty-sixth day of September, 1910, John F. Whittenberger died. He was founder and first president of the Indiana Union and one of the foremost men among the student body of Indiana University. To the students of Indiana University, the name of John Whittenberger means far more than the memory of a mere undergraduate. With him will be forever associated the biggest and most democratic organization in school—The Indiana Union. Whittenberger conceived the idea of a democratic spirit and materialized that idea in the Union which he founded. It was his organization, but he gathered about him the most influential men in the University in his campaign for a big Union. He succeeded so well that "Whit" was, last spring, unanimously elected to serve another year as president. While in the midst of his plans for this collegiate year he was stricken with typhoid fever and was removed, in August, to his home at Peru, where he remained till his death in September.

John Whittenberger was a man in the truest sense of the word, and his death closed a brief but remarkable career. He died in the midst of a great work and his death brought his fellow students to a realization of a life of inestimable service. The name of John F. Whittenberger will adorn with modest glory Indiana's hall of fame; and he will be remembered as a man who stood for something, and a man who accomplished that for which he stood.

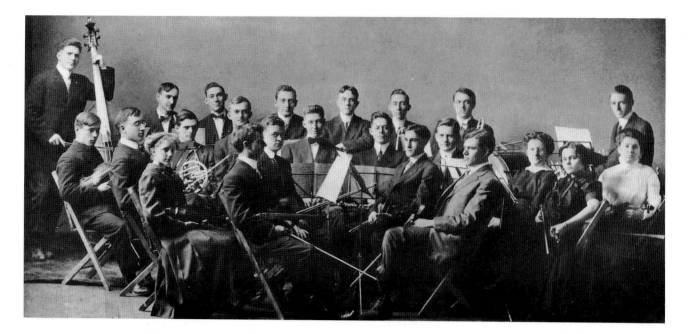

The University Orchestra in 1912, Charles Diven Campbell, director.
Campbell came to the university as a teacher of German, but he had a musical
background, having taken his degree at Strassburg in both German and music.
In 1910 Campbell was made chairman of the Department of Music, and
courses offered in the department received university credit.

Three alumni secretaries: Edward Von Tress, 1923-25; Claude Rich, 1947-68; and George "Dixie" Heighway, 1925-47.

The predecessor of the present Alumni Association, calling itself the Society of the Alumni, was formed in 1854 after the disastrous fire of that year. Concerned with social and scholarly affairs, it had a planned program during commencement observations, usually an oration by a distinguished alumnus and a dinner. The president of the society was a prominent nonresident; the secretary was a local resident whose services were volunteered.

The Alumni Association as now known was organized in 1913 with a new constitution and a corresponding secretary who was a full-time salaried official of the university.

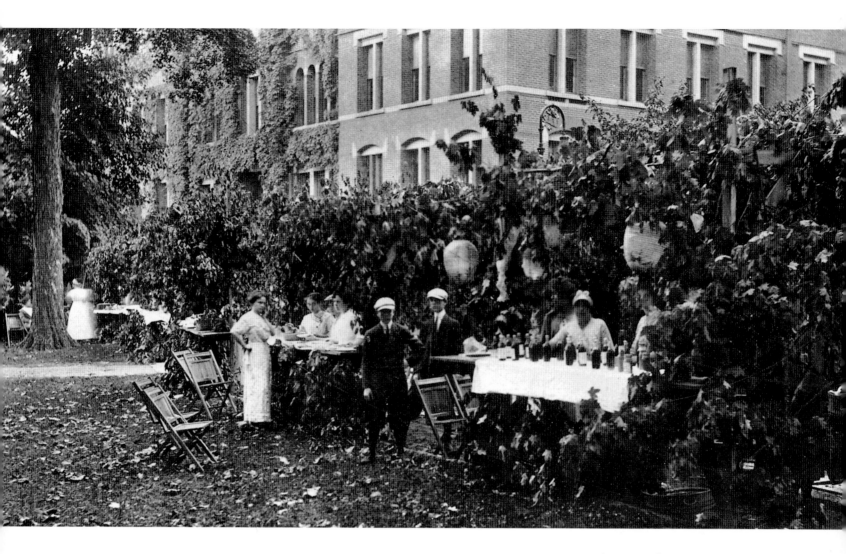

A campus fete in 1913.

The university went all out in celebrating the centennial of Indiana statehood in 1916. A pageant of more than one thousand participants portrayed the state's hundred-year history. Four May performances were necessary to meet public demand.

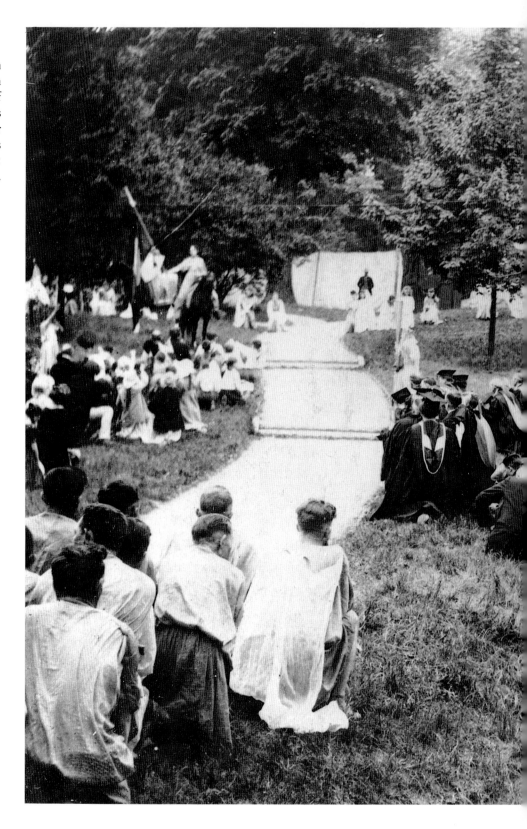

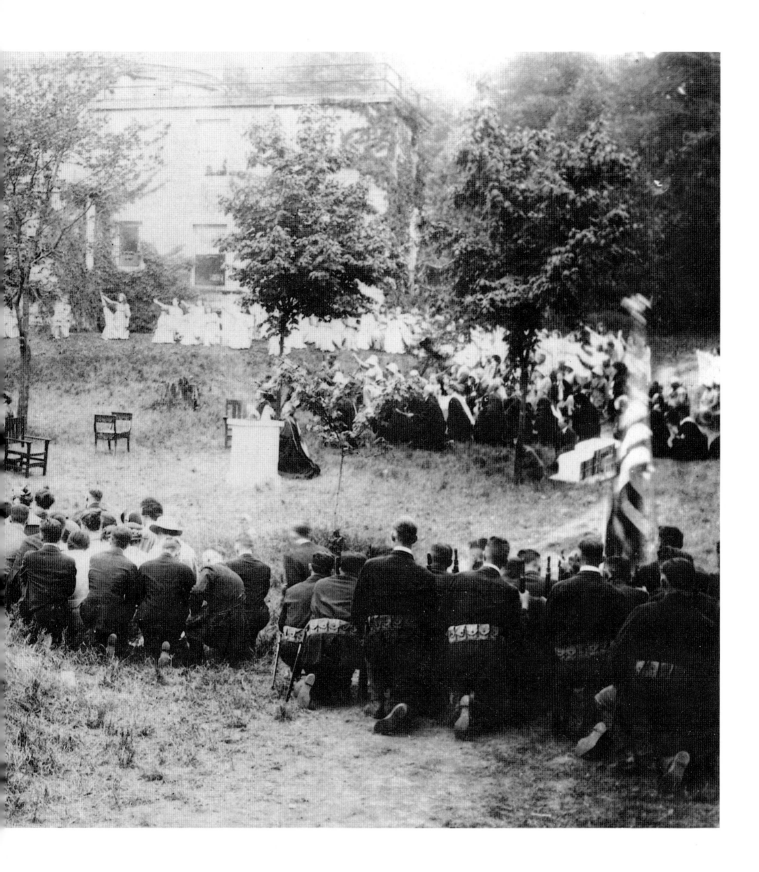

The Men's Gymnasium, completed in 1917, and its addition, the IU Fieldhouse, 1928. The building was renamed Ora L. Wildermuth Intramural Center in 1971, commemorating Judge Wildermuth, who served on the university Board of Trustees for more than two decades and was its president from 1938 to 1950. Wildermuth was greatly interested in university library development (he was also a trustee of the Gary Public Library) and in improved athletic facilities. He was responsible for the plan to finance the fieldhouse addition.

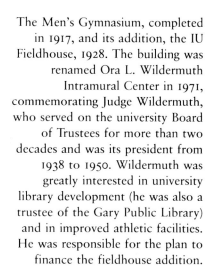

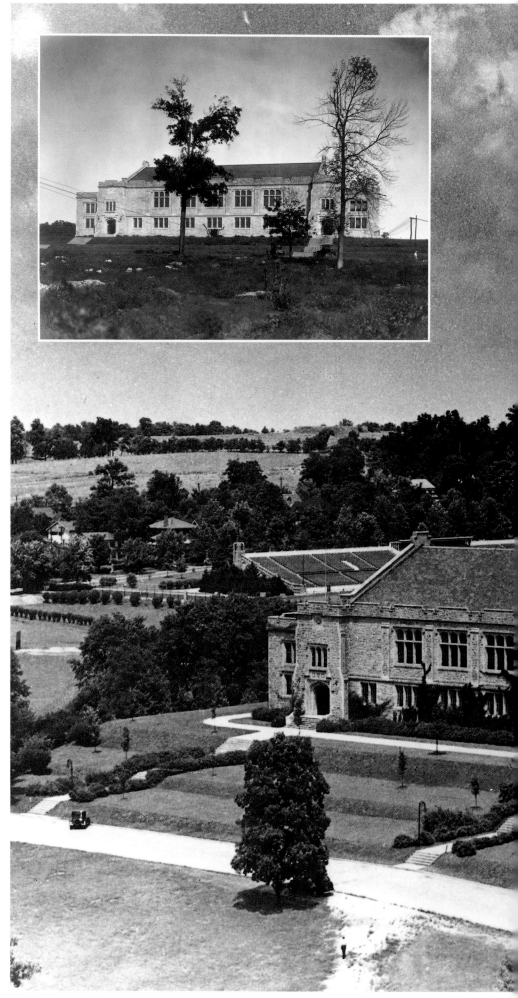

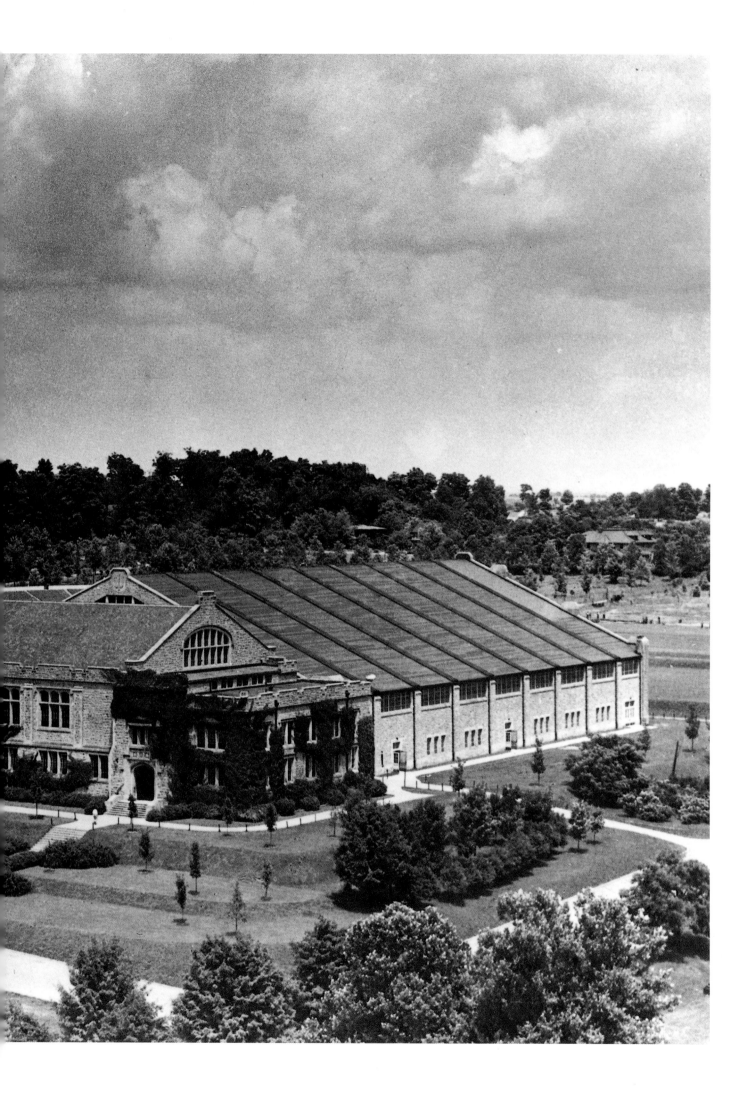

Clarence C. Childs, IU football and track coach for the 1914 and 1915 seasons. Childs and Frank H. Gentry, Bloomington circus owner, thought it would improve the speed of the track men to pace them with Gentry's circus whippets. The results did not lead to record performances. Childs also used an automobile to train his runners, attaching a large bull's-eye to the rear of the car and having his men follow while the car's speed gradually increased.

It was Childs who brought Jim Thorpe, famed athlete of Carlisle Indian School and the Olympics, to IU as his assistant coach during the 1915 season. Thorpe left when Childs was replaced.

Women's basketball championship game, 1922. Women's basketball began in 1898. Competition was interclass and between sorority and unorganized women. All unorganized students were called "Barbs," which was short for "barbarians." Middies, bloomers, and stockings were standard wear. The midline of the court marked the barrier between guards and forwards.

Radio men and their float in front of the Student Building, ready for a parade in 1918. The university did its share to help the war effort, giving U.S. Army and Navy recruits specialized training on the campus. More than one thousand recruits were trained in radio communications.

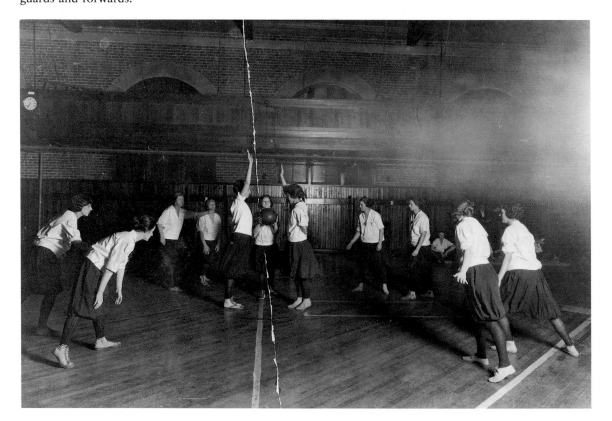

The Union Revue of 1915. "Only men take part in the production," the 1917 *Arbutus* stated, "but fair ladies, from ballet dancers to chaperones, never fail to appear in large numbers when the performance is actually given."

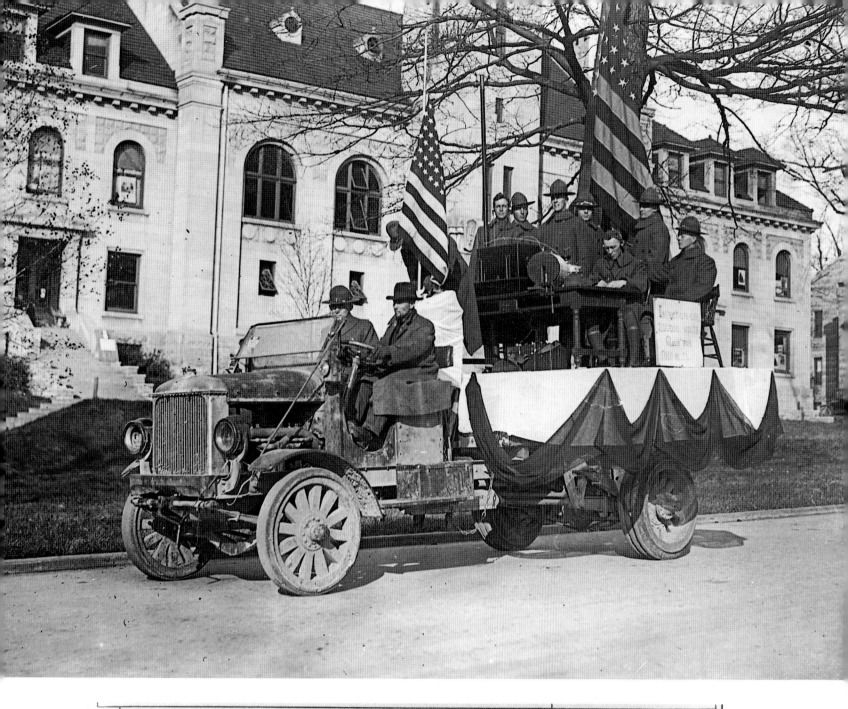

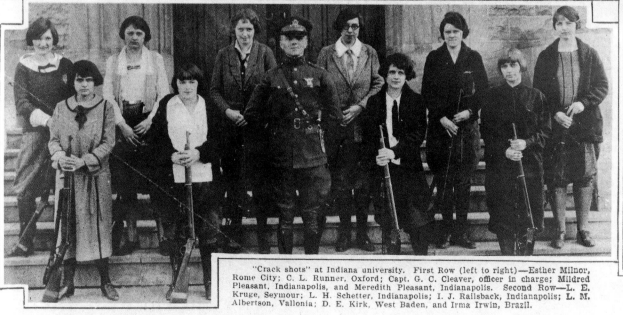

"Crack shots" at Indiana university. First Row (left to right)—Esther Milnor, Rome City; C. L. Runner, Oxford; Capt. G. C. Cleaver, officer in charge; Mildred Pleasant, Indianapolis, and Meredith Pleasant, Indianapolis. Second Row—L. E. Kruge, Seymour; L. H. Schetter, Indianapolis; I. J. Railsback, Indianapolis; L. M. Albertson, Vallonia; D. E. Kirk, West Baden, and Irma Irwin, Brazil.

University women also received training during the First World War. These young women were declared crack shots.

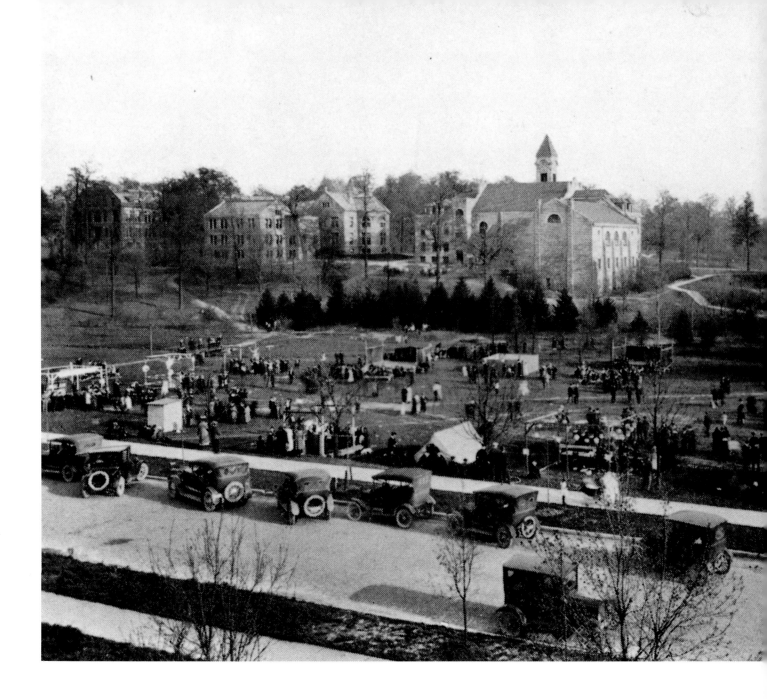

May Day celebration, 1919. The event was sponsored by the Young Women's Christian Association to raise money for the dormitory fund. This collegiate carnival featured a parade, a sideshow, a track meet, and a play in pantomime.

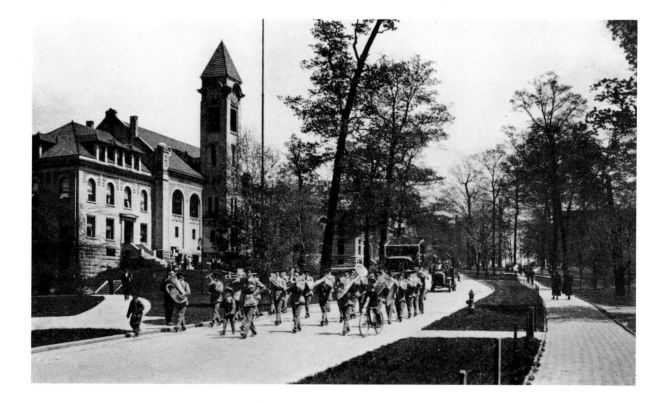

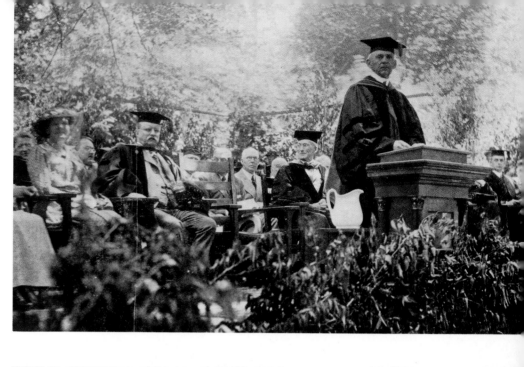

Commencement in 1918, 1919, and 1956. The 1918 commencement was held in the amphitheater, site of the present Chemistry Building. Former President Theodore Roosevelt was the principal speaker.

The 1919 commencement was also held in the amphitheater. The hanging banner with the large star, containing the number "1539," was to commemorate the service of IU students and graduates in the First World War.

The 1956 commencement was held at Memorial Stadium on Tenth Street, in the horseshoe at the east end. Since 1971, commencement ceremonies have been held either in Assembly Hall or at Memorial Stadium on Seventeenth Street.

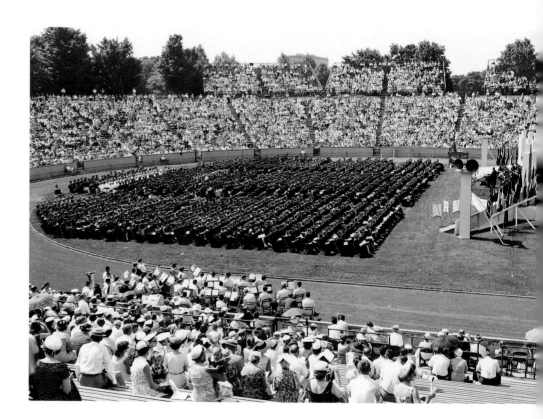

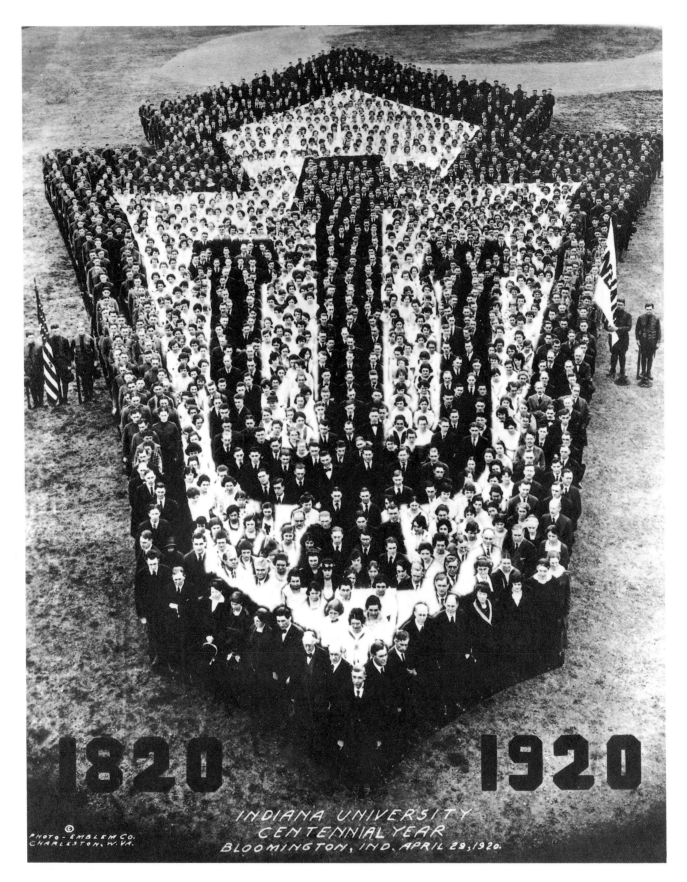

During 1920 the university observed its centenary with a pageant, a fund drive, and a special commencement in which three former presidents of IU participated. The pageant, written and directed by William Chauncy Langdon, had a cast made up of faculty, students, schoolchildren, and a host of townspeople. Langdon, who had been appointed director of pageantry in 1915, also wrote and directed the pageant for the centennial of Indiana statehood in 1916. Shown here are students and faculty forming the IU identifying symbol as part of the centennial observation.

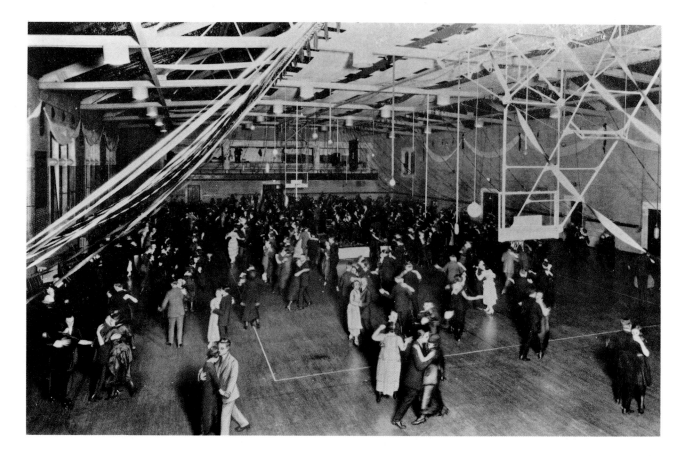

The Blanket Hop in 1920. Proceeds from the dance, sponsored annually by Sigma Delta Chi, the honorary journalism fraternity, went to the Athletic Department for the purchase of "I" blankets for the football team. The 1920 hop was held in the Men's Gymnasium following the Iowa game.

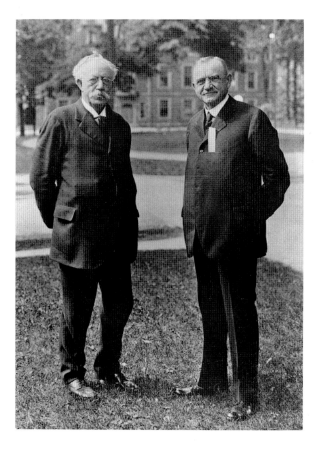

Two former presidents of the university at the centennial observance, 1920. David Starr Jordan, left, president from 1885 to 1891, became the first president of Stanford University in 1891. Joseph Swain, president from 1893 to 1902, became president of Swarthmore College in 1902. A third former president, John M. Coulter, also participated.

The first members of Mortar Board, an honorary society established on the campus in 1920. At first, only women of the senior class were elected to membership, based on their scholarship and service to the university. Later, junior class women were also elected. Today men are eligible for membership.

Members of the Cosmopolitan Club, 1920. The university developed an enviable reputation for its work with foreign students both on campus and abroad in many countries. The Cosmopolitan Club became more visible on the campus following the Second World War.

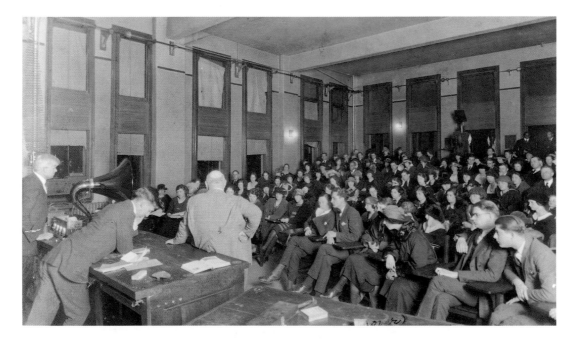

Demonstration of radio reception, 1921. Rolla Roy Ramsey, extreme left of the photo, longtime professor of physics, pioneered in the field of radio and electronics. Ramsey was the leading instructor in the radio school established by the U.S. Army on the university campus in 1917.

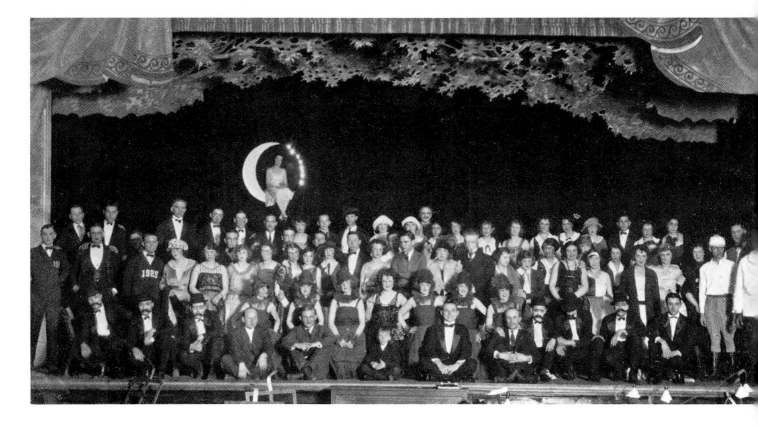

Cast of the first Jordan River Revue, 1921, and scenes from 1928. The revue was one of the most original of the variety shows produced by students. For more than two decades it charmed the student body, and for many years it also went on the road, playing in Indianapolis, Fort Wayne, and South Bend. In recent years the revue has been revived as a cabaret-style show with a repertoire of show tunes.

Above—Tuxedo Boys

Above—More Chorines

Jordan River
Revue

Right—Kessler
and His Leads

Left—
Doty and
Her Boy
Friend

Above—Miles and Countryman

Above—Merged Choruses

53

The first Board of Aeons. Organized in 1921 as an all-male society of junior and senior men appointed by the president of the university, the board is still active but now includes both men and women, who are nominated by the faculty. The twelve-member board acts as an advisory body to the Bloomington chancellor and the university president on problems affecting students and the university.

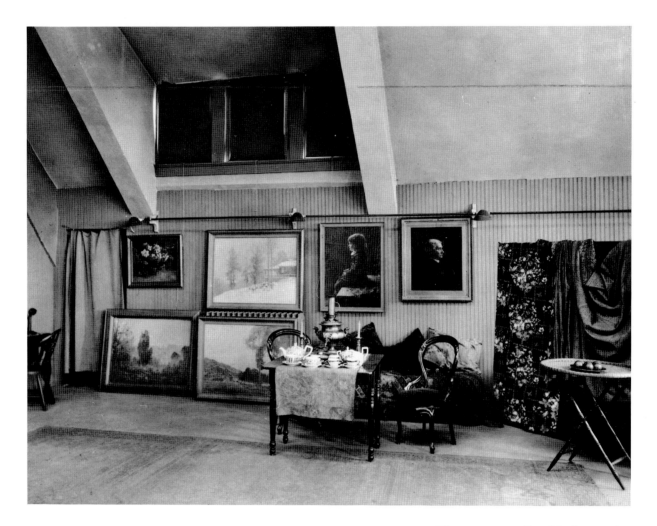

The campus studio of Indiana artist T. C. Steele, on the second floor of Franklin Hall (the old library building). Steele, perhaps the most famous of the Brown County artists, was appointed an honorary professor of painting in 1922. His paintings have become prized and increasingly valuable possessions. His home and studio near Belmont are tourist attractions.

The traditional faculty versus seniors baseball game was a semi-serious occasion, anticipated with planning and scheming for weeks in advance. It is not known whether the stretcher and medical satchel were precautions or psychological props in this 1922 contest.

Indiana Governor Warren T. McCray wishes bon voyage to the IU baseball team on its departure for Japan, 1922. The team was invited to Japan by Waseda University of Tokyo for a series of games, with expenses guaranteed by Waseda. Thirteen players, Coach George Levis and his wife, Dean of Men Clarence E. Edmondson and his wife, and Assistant Coach Roscoe C. Minton made up the traveling party. They left Bloomington on March 28 for Seattle, then sailed for Japan on April 1, arriving April 13. It was May 22 before they were back in Bloomington.
The team played ten games, six with Waseda, three with Kelo University, and one with the Osaka Stars. It won two games and tied one, which was called on account of darkness.

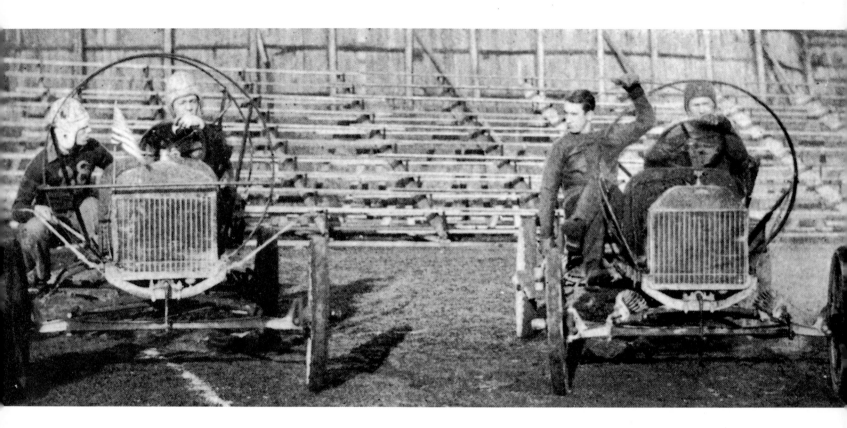

Auto polo, 1923. As the 1923 *Arbutus* reported, "The band needed money to journey to Lafayette. It's pretty hard to get money out of students unless you have a novelty to offer them in return. Therefore, auto polo. Ernie Pyle and Bill Pierce, in Methuselah, faced Barrett Woodsmall and Joe Breeze, driving Apollo, Jr., on Jordan Field, November 18. The score stood 1-1 when the Pyle-Pierce car had to withdraw on account of engine difficulties. Vern Ruble and Art Coulter, mounted on mules, faced Merritt Reed, mounted on horseback, in a novelty polo match on the same day."

The President's House, now renamed Bryan House, was completed in 1924. President William Lowe Bryan contributed $10,000 toward the cost of construction. Bryan retired in 1937, but the trustees permitted him to continue living in the presidential home until his death in November 1955.

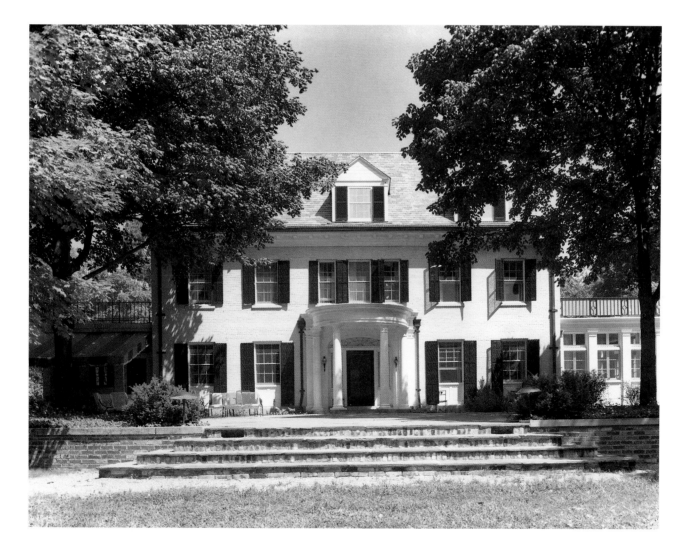

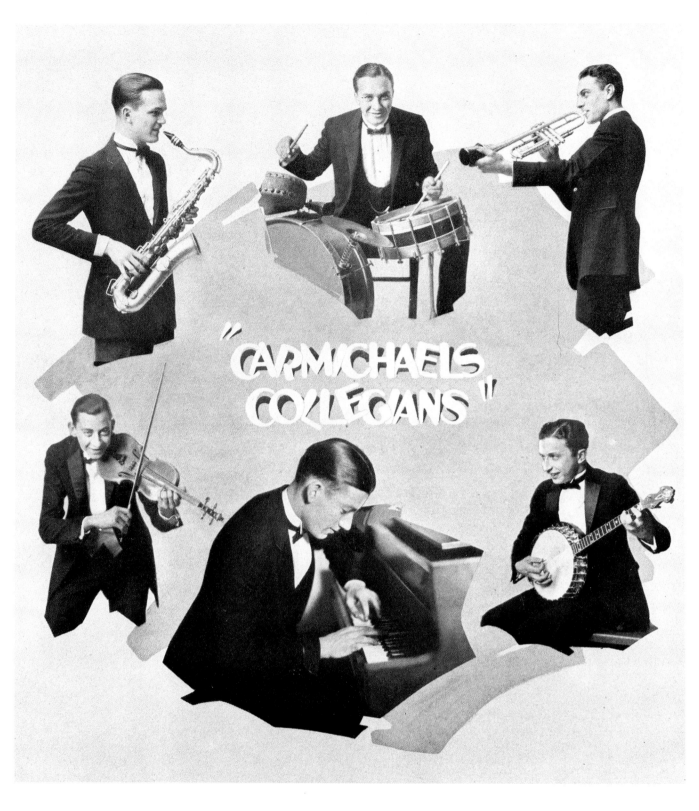

"CARMICHAELS COLLEGIANS"

Carmichaels Collegians, 1924, one of several bands organized by Hoagy Carmichael during his Bloomington and Indiana University days. Few people know that this master composer of popular music received a law degree from IU in 1926.

Nellie Showers Teter, first woman member of the IU Board of Trustees. Teter was elected by alumni in 1924 and served on the board until 1945. Her particular interest was construction and equipment of university dormitories for women students.

First IU-Purdue football game in Memorial Stadium, November 1925. The stadium was one of the funding objectives of the memorial fund drive, 1921-26. Renamed Tenth Street Stadium after the new Memorial Stadium was built on Seventeenth Street, it was demolished in 1982. The Arboretum now occupies the site.

The memorial fund drive was directed by William A. Alexander, who was appointed librarian in 1921 with the understanding that he would direct the campaign for funds. In addition to the stadium, funds were sought for a dormitory for women and a large auditorium. The fund drive was oversubscribed, making possible not only the stadium but also Memorial Hall for women and the Memorial Union Building containing a large auditorium.

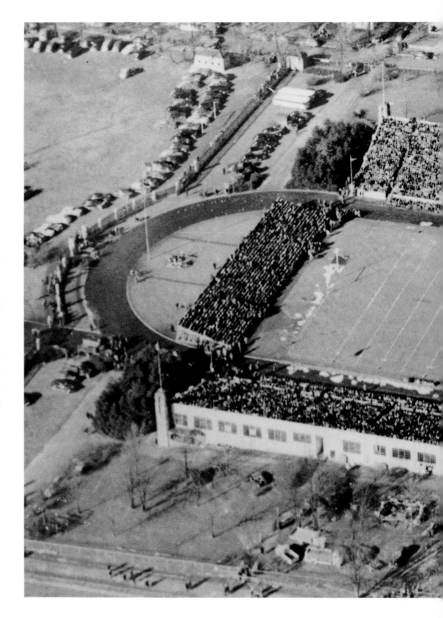

Presentation of the Old Oaken Bucket before the IU-Purdue football game, 1925. The ceremony was part of the dedication program for Memorial Stadium. George Ade, Purdue alumnus and noted humorist, stands in front of Purdue's captain, Harold Harmeson. Holding the bucket, Harry Kurrie, president of the Monon Railroad and Indiana alumnus, stands in front of Indiana's captain, Larry Marks. The winning team keeps possession of the bucket for a year. In the event of a tie, it resides for six months with each school. An "I" or a "P" is added to a chain for each win; an "I–P" designates a tie.

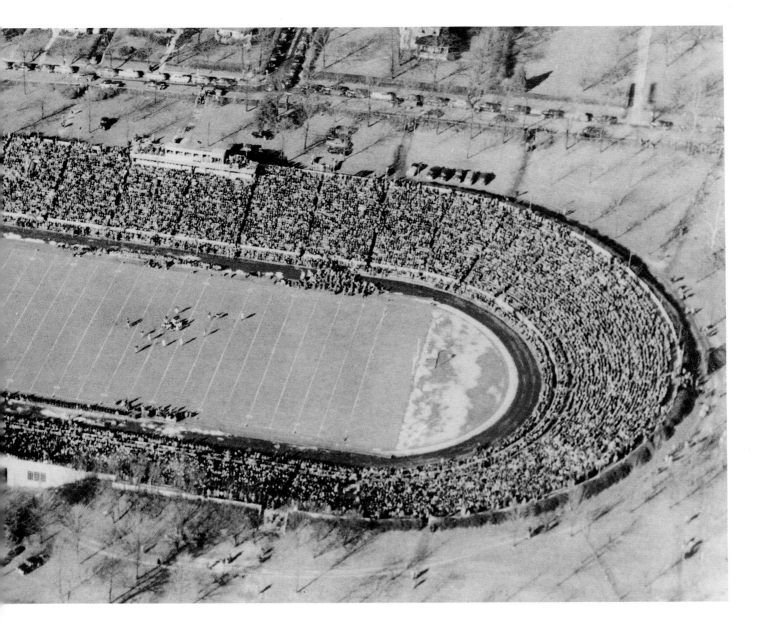

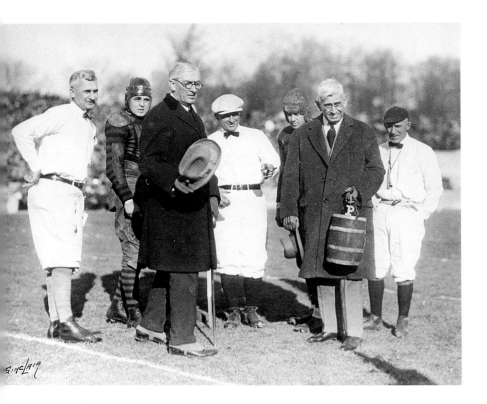

63

Aerial view of Agnes E. Wells Quadrangle, named to honor the longtime dean of women. The buildings in the quadrangle include Memorial Hall; Goodbody Hall (1936), named to honor Louise Ann Goodbody, dean of women, 1908-11; Morrison Hall (1940), memorializing Sarah Parke Morrison, the first woman admitted to IU; and Sycamore Hall (1940). Once exclusively dormitories for women, these buildings are now used for a variety of academic activities.

Memorial Hall was the first university-constructed dormitory for women. Completed in 1925, it was financed by the memorial fund drive of 1921-26.

The university bookstore had been in the basement of the library (Franklin Hall), but the addition of a library wing in 1925-26 necessitated a move. This cottage, between Owen and Maxwell halls, was erected to house it temporarily. A new bookstore opened in the east wing of the Indiana Memorial Union Building, its present location, in April 1932.

The Alumni Day barbecue has a long tradition, as this 1927 picture of the event in Dunn Meadow illustrates. A trashed Jordan River and long lines waiting for service suggest a large margin of tolerance.

Members of the Class of 1903 at their twenty-five-year reunion, photographed in front of the Student Building.

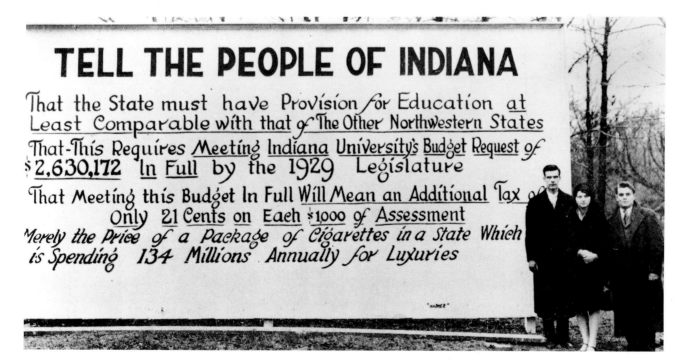

The plea of the university for funds has been constant since the first legislative appropriation was made in 1867. This billboard represented a unique appeal to the 1929 General Assembly.

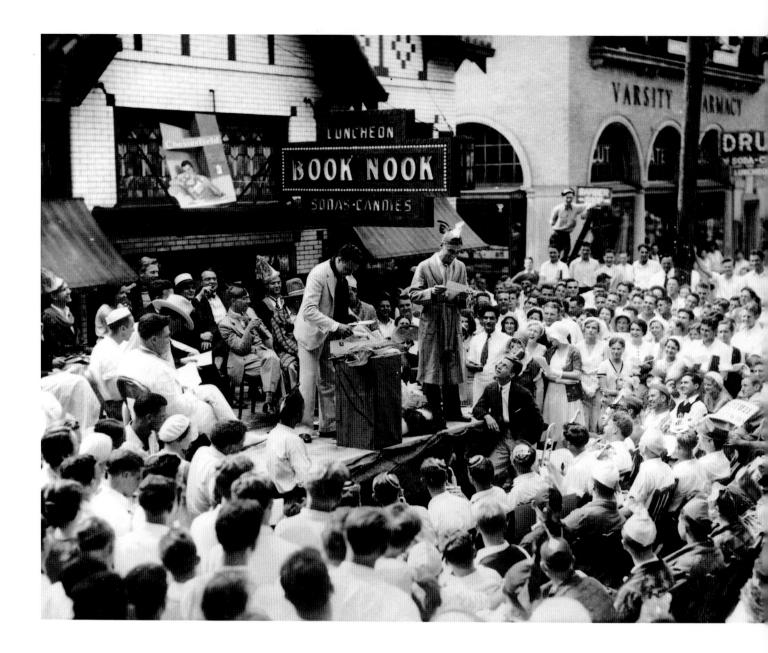

The Costas brothers, owners of the Book Nook, a campus hangout on Indiana Avenue in the 1930s and after, produced a mock commencement in early June prior to the real thing. The affair included a band, a parade, speeches, and the awarding of mock degrees. In these scenes from the 1932 affair, Herman B Wells is seated in the front seat of his Packard Phaeton, Peter Costas is standing, Ward G. Biddle is seated holding a straw hat, and Ray Thorpe is at Biddle's left; and Peter Costas is on the podium in front of the Book Nook awarding the "doctor's degree" to Wells.

Biddle was manager of the IU bookstore when the photo was taken. He later served as director of the Union Building and as comptroller and vice-president and treasurer of the university.

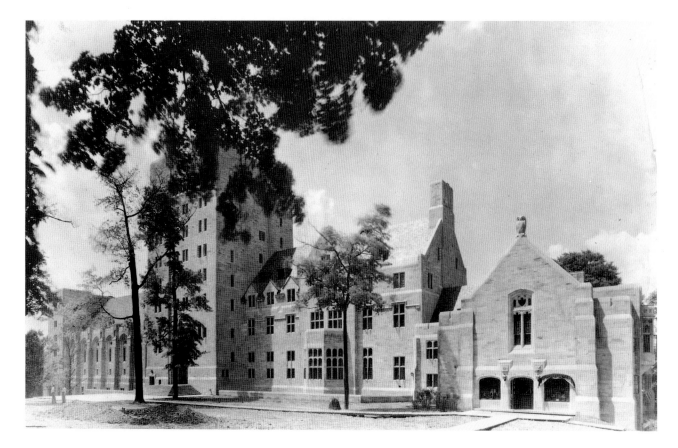

The Union Building, dedicated in 1932. The building was financed in part by the memorial fund drive of 1921-26 and in part by student fees. Additions in 1939 and 1946 more than doubled the floor space.

Forest Place, also known as Sorority Alley. This abbreviated street once marked the eastern edge of the campus. Private homes lined its east side, but they were gradually converted into sororities or acquired for university functions. Jordan and Ballantine halls now fill the space.

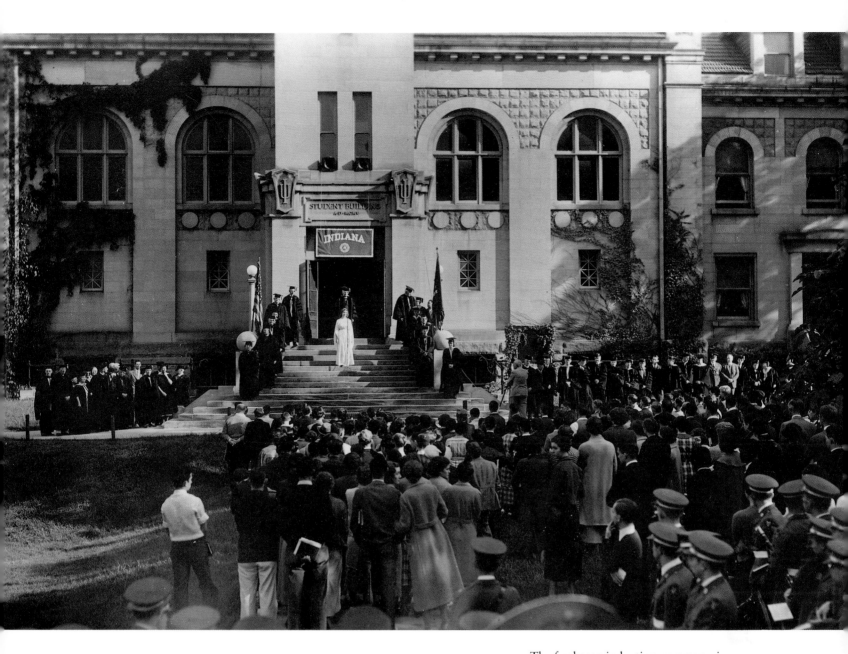

The freshman induction ceremony in front of the Student Building, 1934. "When as a student I first witnessed this ceremony, the colorful regalia, the beautiful ritual, the excitement of starting another school year combined to make the moment memorable," Herman B Wells has stated. "I always enjoyed participating in the annual event as a faculty member and later as president. I regret that it has been dropped from university tradition." The young woman draped in white, on the steps in front of President Bryan, represented the Spirit of Indiana.

Herman B Wells is surrounded by flowers of congratulation in March 1938 on the day following his election by the Board of Trustees as the eleventh president of Indiana University.

University presidential inaugurations call forth splendor, flaming colors, and observance of venerable traditions. The new president, Herman B Wells, is with Indiana Governor Henry Schricker, followed by his immediate predecessor, William Lowe Bryan, in the procession to his inauguration in 1938.

Radio station WIRE of Indianapolis offered free time in 1938 for programs from the university. Lee Norvelle, longtime head of the Speech and Theatre Department, which included classes in broadcasting, began a series of programs based on campus projects. Eventually radio was separated from speech and theatre and evolved into the Department of Telecommunications.

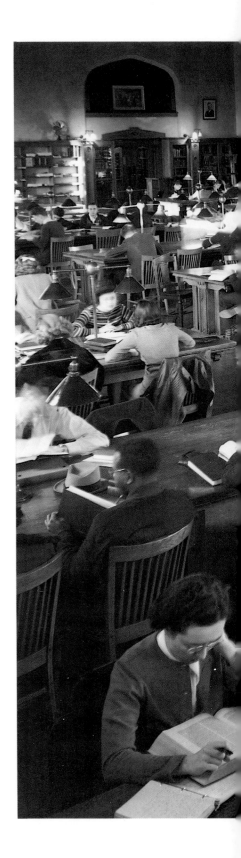

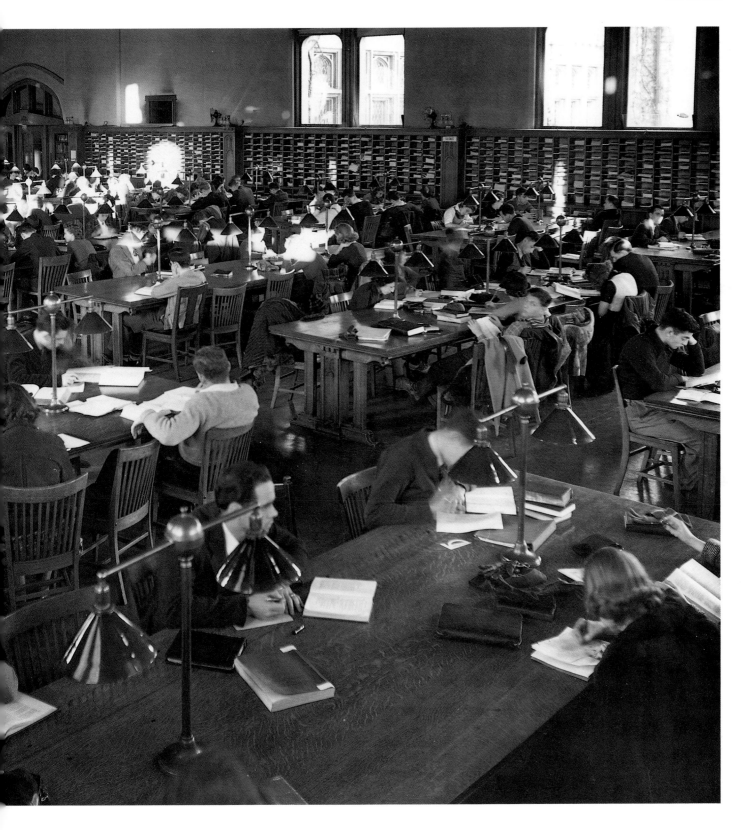

View of the west reading room in the library (now Franklin Hall) in 1939. This room, which contained current periodicals and the reference desk, also controlled the entrance to the stacks.

Indiana University Auditorium, completed in March 1941. This was the first campus building designed by the New York architectural firm Eggers and Higgins. It was financed by a state appropriation, a grant from the Public Works Administration, and a bond issue. In the words of Herman B Wells, "The funding enabled us to build one of the outstanding auditoriums in the country, noted from coast to coast as the home of many superior cultural attractions, and to provide the Little Theatre and classrooms for our Department of Speech and Theatre. It likewise, as is still the case, provided a home for the University Band."

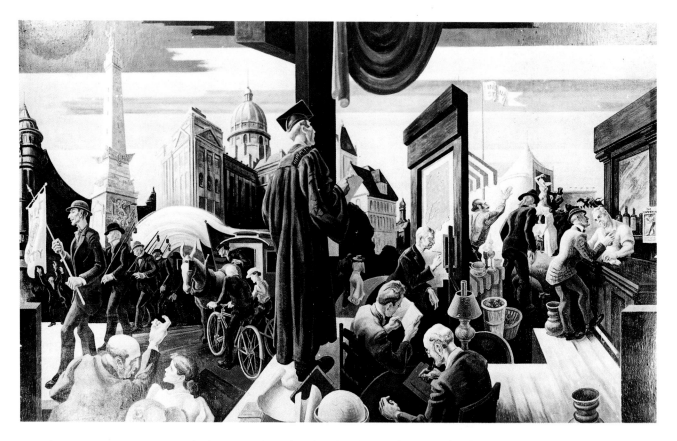

Thomas Hart Benton's murals depicting the cultural and industrial history of Indiana were executed for the State of Indiana to adorn its building at the Century of Progress Chicago World's Fair, 1933. After the fair closed, the murals were given to Indiana University and were mounted in Woodburn Hall, the University Theatre, and the IU Auditorium. *College and City Life* and *Leisure and Literature* are on the north wall of the auditorium's Hall of Murals. Among the faces represented are those of James Whitcomb Riley, William Lowe Bryan, and Paul V. McNutt.

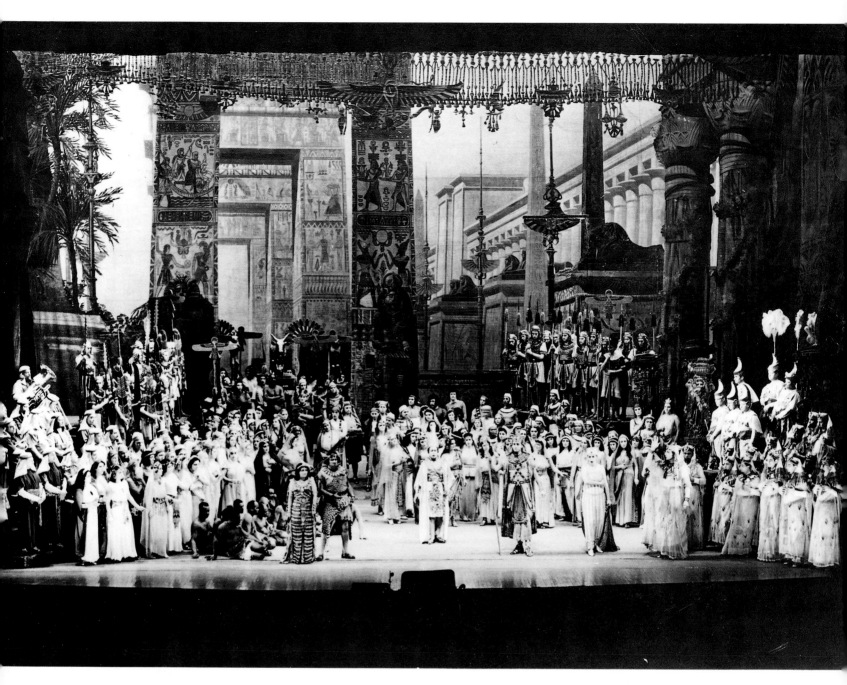

Cast of Verdi's *Aida*, presented
in the IU Auditorium by the
Metropolitan Opera Company of
New York, April 13, 1942. This was
the Met's first performance on a
university campus and its first in a
city as small as Bloomington. The
Met came back regularly after the
Second World War, presenting
fifteen productions in the decade
after the auditorium's opening.

University War Council and Student War Council, 1942. The Second World War taxed the ingenuity of the university leadership. The problems were twofold: to continue the educational process and at the same time to commit the total resources of the university to aid the national defense effort. The war councils, composed of students, administrators, and faculty, worked long and thoughtfully to meet the educational and military crisis. Students not called to the services continued their education in an accelerated program. The campus became a training camp for many branches of the military service.

Naval personnel, preparing to be yeomen or storekeepers, march to the IU Auditorium to hear Franklin P. Adams (FPA), the author and humorist. During their sixteen-week stay on the campus, these navy men and women were permitted to enjoy all events at the university open to regular students. Many of the Waves shown in the line had not yet received their uniforms.

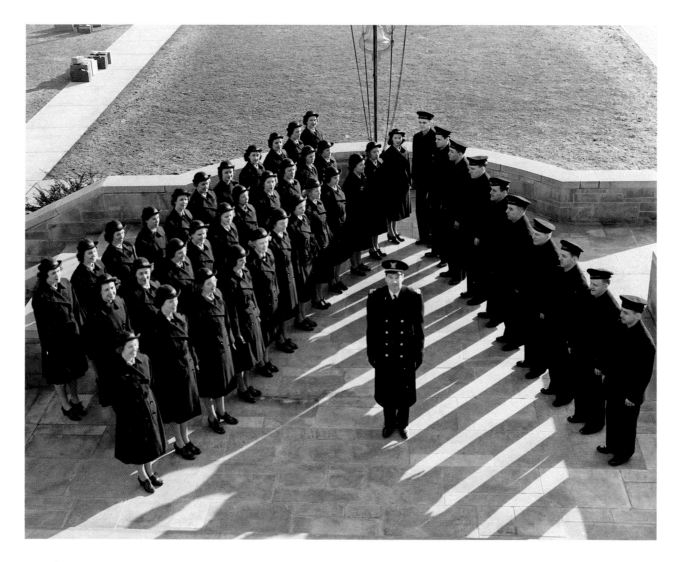

The Men's Residence Center, now Collins Living-Learning Center, became
a "ship" for navy trainees during the Second World War. The students who
had been living in the center were moved to houses along Sorority Alley
(Forest Place). One house was occupied by premedical students slated for
military service.

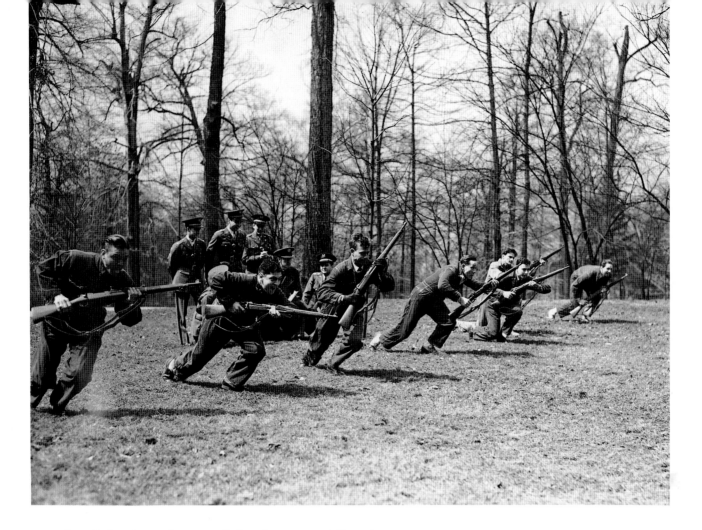

Indiana University students enrolled in the Reserve Officers Training Corps (ROTC) received training in commando tactics as part of their program. Historian Thomas D. Clark wrote that "no special group became more war minded than the crack drill corps of Pershing Rifles. They injected imagined British commando ferocity into their training."

Veterans of the Second World War in the trustees' meeting room, 1946. Twelve veterans spent six weeks in this unusual "dormitory" before more appropriate housing became available. One vet recalled that they used President Wells's office as a study hall, his lavatory for ablutions, and his secretary's typewriter when typing was to be done.

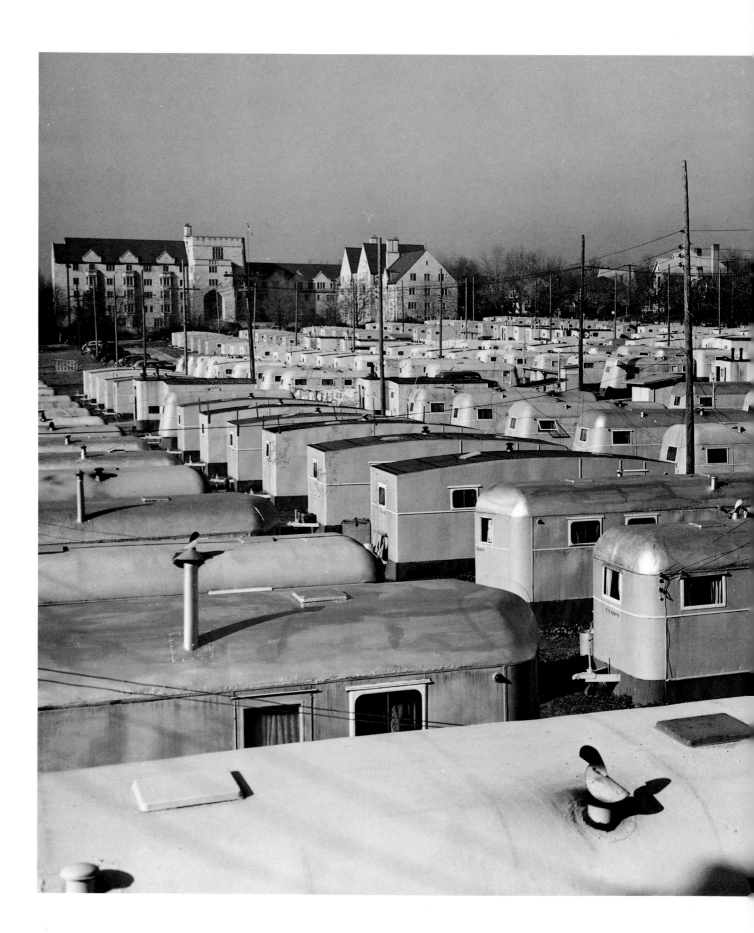

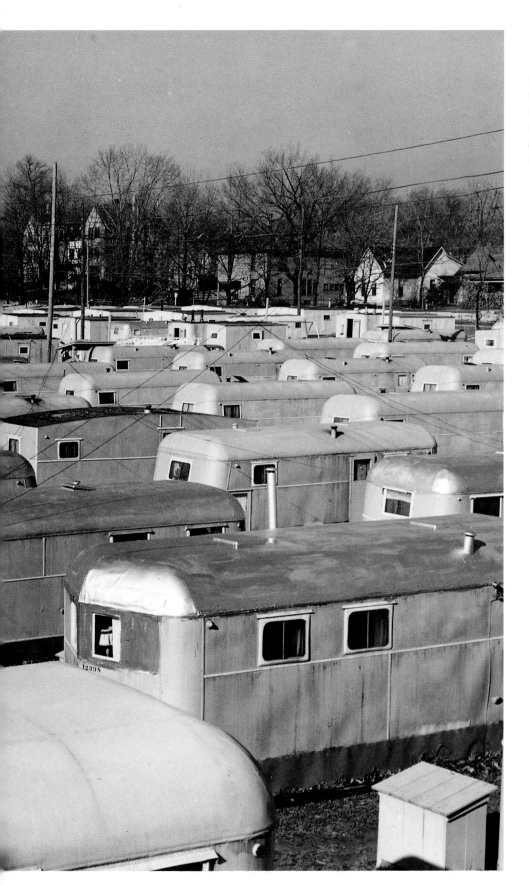

Woodlawn Trailer Courts for married GIs, 1946. The eagerness with which veterans sought educational opportunities offered under the GI Bill of Rights brought a tidal wave of students to the university campus.

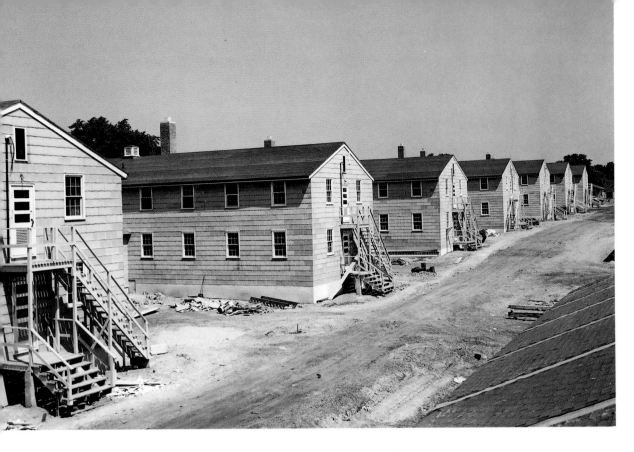

Old Hoosier Courts. These former army barracks were dismantled and reassembled on campus to house married GIs and new members of a growing IU faculty on a temporary basis—which stretched into several years.

For years it was traditional on the eve of the IU-Purdue football game to have a dummy identified as "Jawn Purdue" lying in state in a prominent location on the IU campus. A crowd moves by the bier in joyful anticipation as the ROTC honor guard stands watch over the corpse.

Quonset huts from military installations were squeezed between academic buildings to provide offices for faculty who taught the returning veterans. These two were between Wylie and Kirkwood halls.

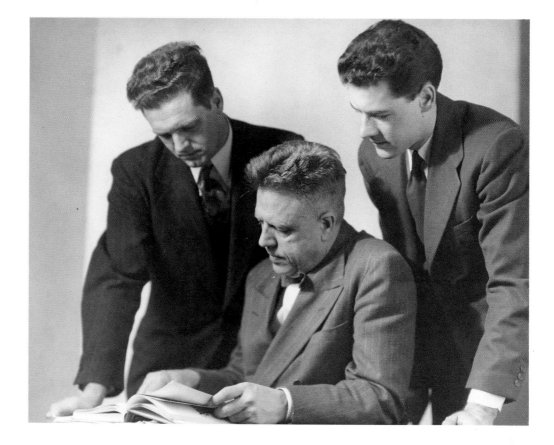

Alfred C. Kinsey, seated, and his co-authors, Clyde E. Martin, right, and Wardell B. Pomeroy. Their first volume, *Sexual Behavior in the Human Male* (1948), and the subsequent *Sexual Behavior in the Human Female* (1953) brought praise and criticism of IU's Professor Kinsey and his associates in the Institute for Sex Research. Both volumes were pioneering studies in a taboo field. The institute, which Kinsey founded, later became the Alfred C. Kinsey Institute for Sex Research. Paul H. Gebhard became its executive director in 1956 after Kinsey's death and served until he retired in 1982. He was succeeded by June M. Reinisch. Today it is known as the Kinsey Institute for Research in Sex, Gender and Reproduction.

Children gardening at Hilltop Garden Nature Center. Founded in 1948 by biology professor Barbara Shalucha as a summer gardening experience for children between the ages of seven and twelve, the Hilltop program expanded through the years to include a limited number of adult gardeners. Indiana University provides Hilltop's five acres of land and the director's salary. The city of Bloomington pays the summer teaching assistants. An estimated 5,000 teachers from across the country have come to Hilltop for training since its inception.

The first outlet for university television programs was over WTTV, established by Sarkes Tarzian, Bloomington manufacturer, in 1948. The university began television broadcasting from its own station, WTIU, in 1969. Television has enabled the university to expand its cultural and educational mission while providing students an opportunity to obtain on-the-job training.

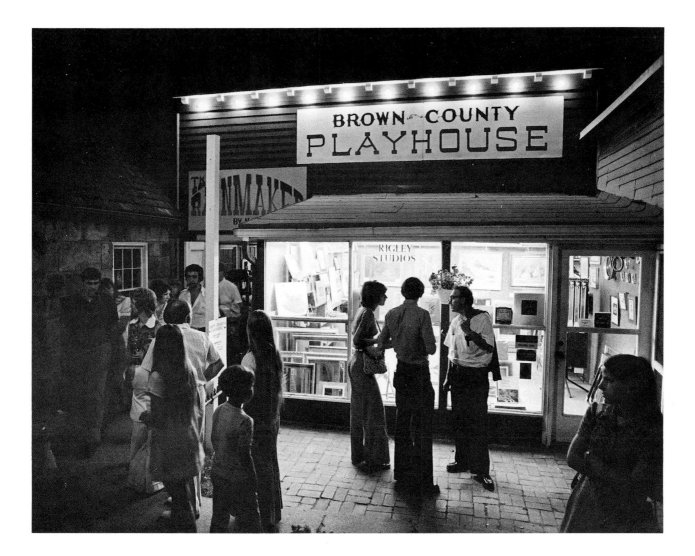

Brown County Playhouse, a fixture in the tourist town of Nashville, Indiana. The playhouse, the idea of Professor Lee Norvelle, opened in July 1949. It was the first summer stock theater to start in Indiana after the Second World War. Initially, the stage was the end of an old barn and the audience sat in a tent erected in front of the stage. A. Jack Rogers, a Nashville businessman, provided the land and a loan to start the project. A new enclosed theater building opened on the original site in 1977.

The playhouse has offered hundreds of IU theater students an opportunity to work in a professional theater setting and has brought many tourists to Nashville. Professor Richard A. Moody directed the playhouse from 1958 to 1970. He was succeeded by Professor R. Keith Michael in 1972.

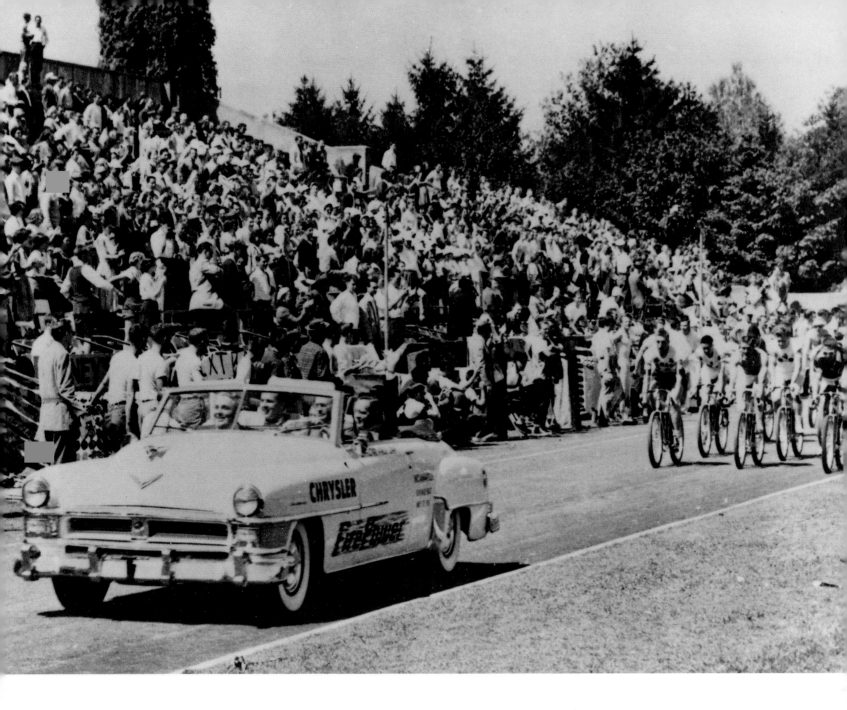

Wilbur Shaw, three-time winner of the Indianapolis 500, driving the pace car for IU's Little 500. President Wells and Tony Hulman, owner of the Indianapolis Speedway, are riding with him.

The first Little 500 in 1951 was the brainchild of Howard S. (Howdy) Wilcox, then executive director of the IU Foundation. This annual spring event is planned and directed by the Student Foundation, a committee organized in 1950 by Wilcox and President Wells to promote IU and the IU Foundation. The bicycle race and associated events attract large crowds. Proceeds provide scholarships for working students.

The Mini 500 tricycle race made its first appearance in 1955 as the women's counterpart to the men's Little 500. It has become one of the major events preceding the bicycle race. Men began competing in the Mini in 1978, and in 1988 a separate men's division was added. Also in 1988 a women's Little 500 was added to the weekend carnival.

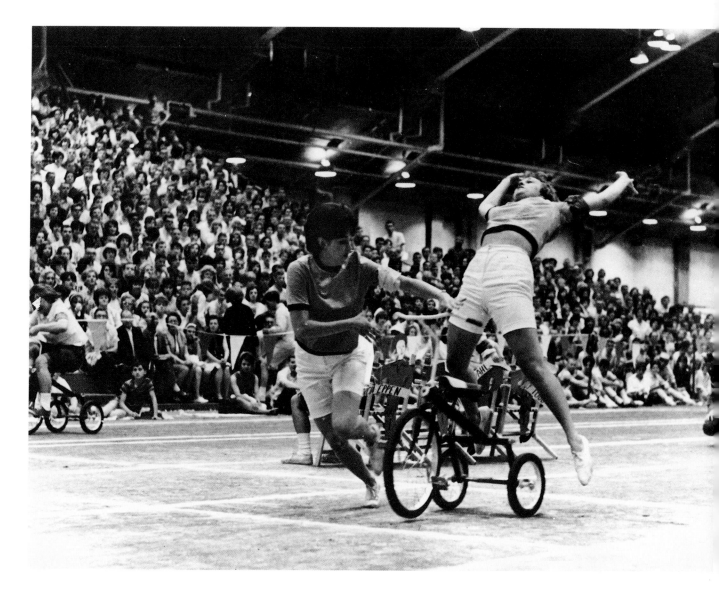

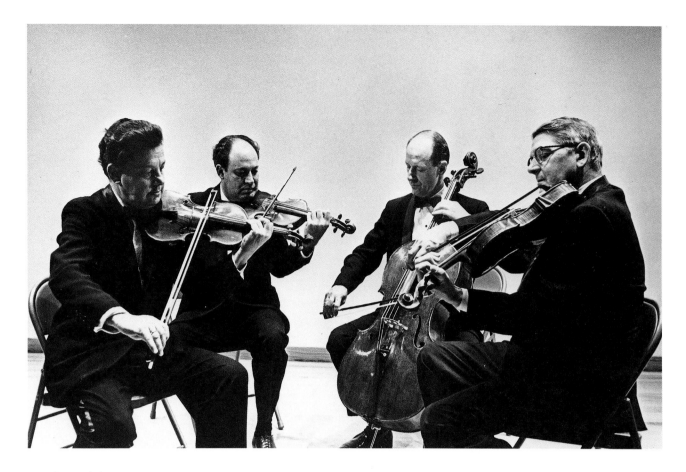

The Berkshire Quartet was brought to the School of Music by Dean Wilfred C. Bain as a quartet in residence. In addition to teaching duties, the members gave regular concerts both on and off campus for more than two decades. Left to right: Urico Rossi, Irving Ilmer, Fritz Magg, and David Dawson. Ilmer was a replacement for original member Albert Lazan.

The Belles of Indiana. For many years this singing group of students charmed audiences over much of the world. Formed by Professor Eugene Bayliss of the School of Music in 1952, the group made annual summer tours for the USO in the Far East, the Caribbean, Western Europe, and the United States. The Belles also toured the Midwest periodically.

The Marching Hundred at the inauguration of President Dwight D. Eisenhower, January 1953. The IU group was the only band to represent the State of Indiana and the only band from the Big Ten Conference invited to perform in the parade.

Dr. Joseph C. Muhler, a principal investigator of the effect of fluorides on dental caries, personally conducted a number of experiments to test his theories. Along with Dr. Harry Day and Dr. William H. Nebergall, colleagues in the Chemistry Department, Muhler discovered the formula that led to Procter and Gamble's production of Crest toothpaste.

Professor Judson Mead directs the caravan preparing to travel to the university's Geologic Field Station. The field station, about ninety miles northwest of West Yellowstone in the Tobacco Root Mountains of southwestern Montana, sits on sixty acres given to the university by the State of Montana in 1949. More than 4,500 students have received instruction in field geology during the summer programs. In August 1991 the Department of Geology began sponsoring a week of outdoor historical and scientific activities for IU alumni and their families at the field station.

Aerial view of the campus in the 1950s (overleaf). Nine of the structures in this view were placed on the National Register of Historic Places in September 1980. Forming what is now called the Old Crescent, the structures are Kirkwood Observatory; Franklin Hall; the Student Building; Maxwell, Owen, Wylie, Kirkwood, and Lindley halls; and the Rose Wellhouse.

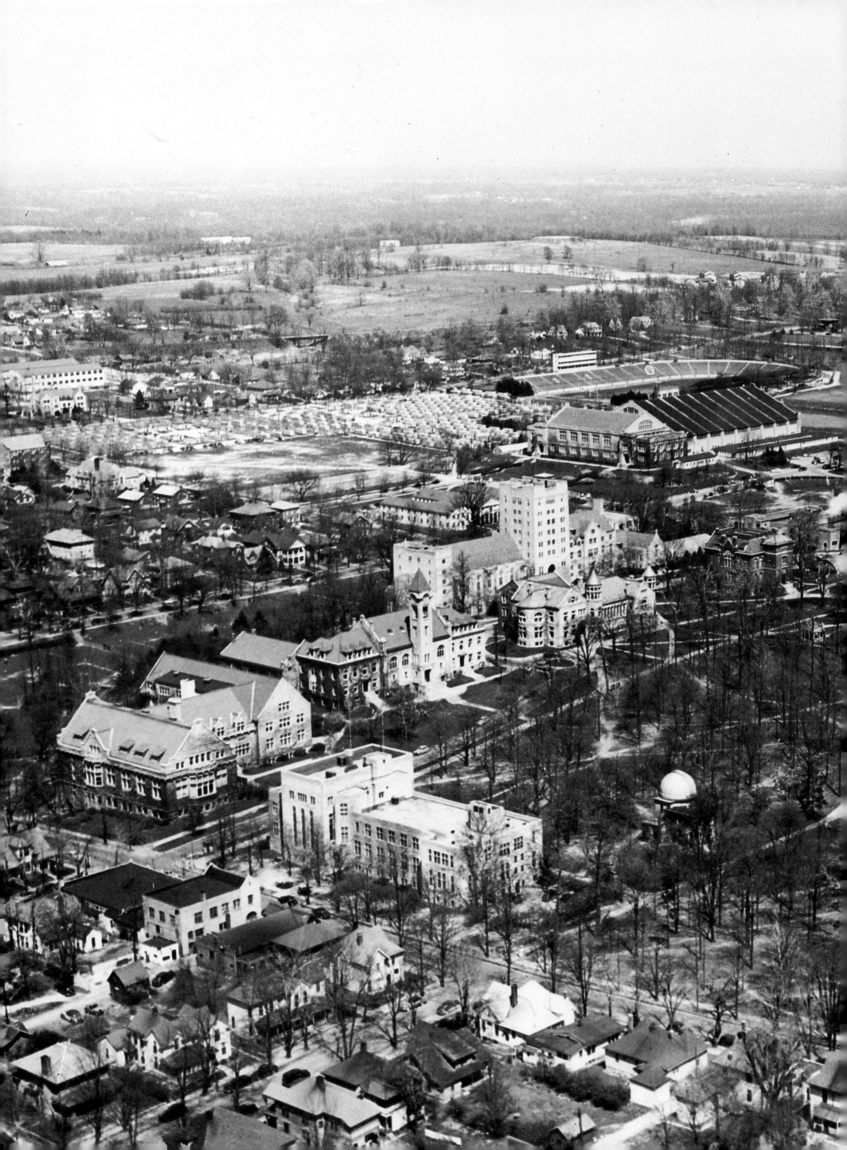

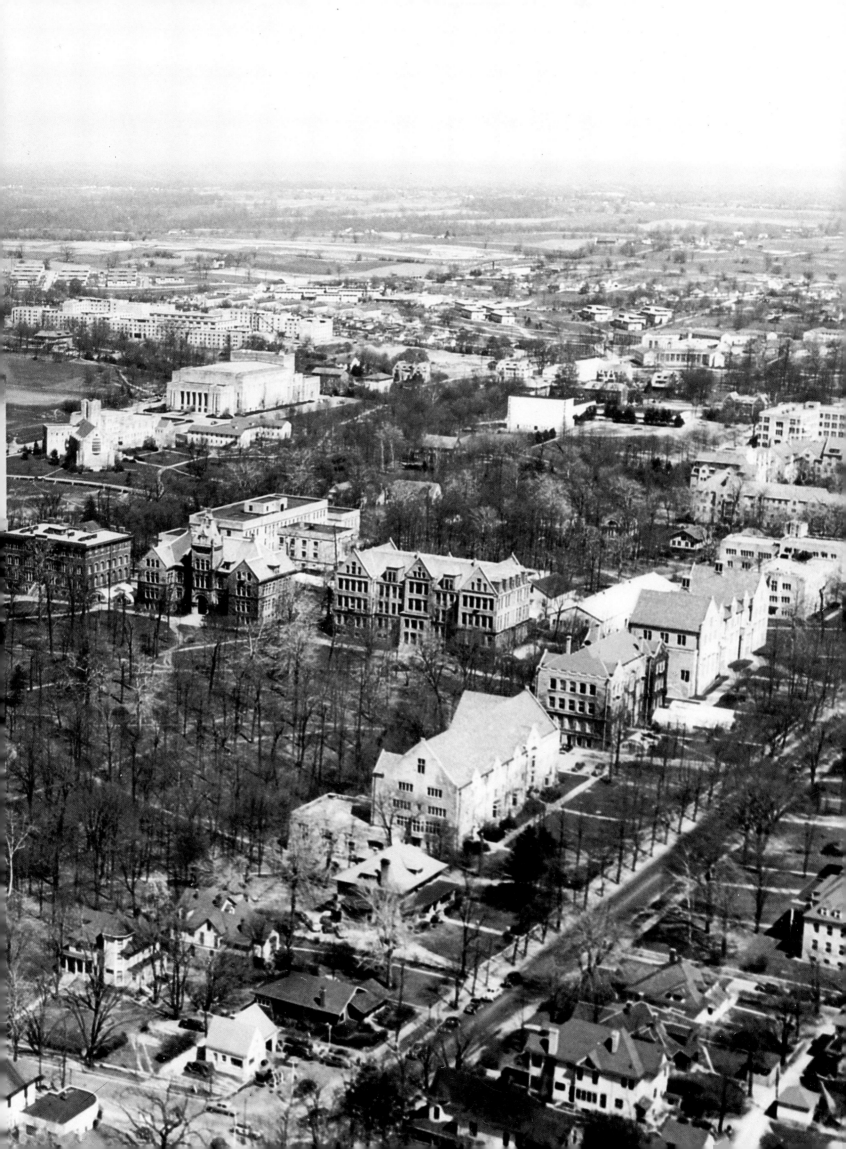

The Indiana University cyclotron, constructed under the direction of physics professor Milo B. Sampson in the basement of Swain Hall West, was the forerunner of the federally funded accelerator facility on Milo B. Sampson Lane where scientists and engineers from the United States and abroad conduct research the year round. Sampson is at left; facing him is Martin E. Richey. At the top of the ladder is Bryce Bordin, and below, physics professor Daniel W. Miller.

The Swain Hall cyclotron, which became operational in 1941, was one of the world's very early cyclotrons. Funded by IU, it was dismantled in 1968 to make room for design studies for the accelerator now located on Milo B. Sampson Lane.

The first electron microscope at the university. Standing is Hershel Lintz. The electron microscope, not limited by the powers of the optical lens and light, permits great magnification and depth of focus. It is used extensively in the Department of Biology.

Ernie Pyle, famed Second World War correspondent and IU alumnus, returned to the campus in 1944 to receive an honorary degree. He looks at a copy of the *Indiana Daily Student*, with editor Pat Kingbaum looking over his shoulder.

Ernie Pyle Hall, converted from the old Stores and Services Building for the School of Journalism and named to commemorate Ernie Pyle, IU student, 1919-22, and reporter and editor of the *Indiana Daily Student*. Pyle was killed on the island of Ie Shima by a sniper's bullet. He is buried in the National Cemetery in Hawaii.

ERNIE PYLE

BORN NEAR DANA, IND., AUG. 3, 1900
DIED ON IE SHIMA, APRIL 18, 1945

REPORTER — EDITOR

COLUMNIST — CORRESPONDENT

A SNIPER'S BULLET ON IE SHIMA ENDED ERNEST TAYLOR PYLE'S REPORTING OF WORLD WAR II IN WHICH HE BROUGHT HOME TO MILLIONS THE REALITIES OF WAR BY WRITING THE DAY-TO-DAY STORY OF G.I. JOE. IN WAR AS IN PEACE HE WAS MASTER OF TELLING ACCURATELY IN SIMPLE, VIVID WORDS THE EXPERIENCES OF ORDINARY MEN AND WOMEN.

PLACED OCT. 5, 1953 ON THE CAMPUS OF INDIANA UNIVERSITY WHERE HE BEGAN AS A STUDENT IN JOURNALISM A CAREER THAT WAS MARKED BY 20 YEARS WITH SCRIPPS-HOWARD NEWSPAPERS - BY HIS COLLEAGUES IN SIGMA DELTA CHI, NATIONAL PROFESSIONAL JOURNALISTIC FRATERNITY.

A lighted globe, donated by Mr. and Mrs. Stuart Wilson, IU alumni,
attracts the interest of students in Ballantine Hall. The globe revolves and can
be altered to show political changes in national boundaries.

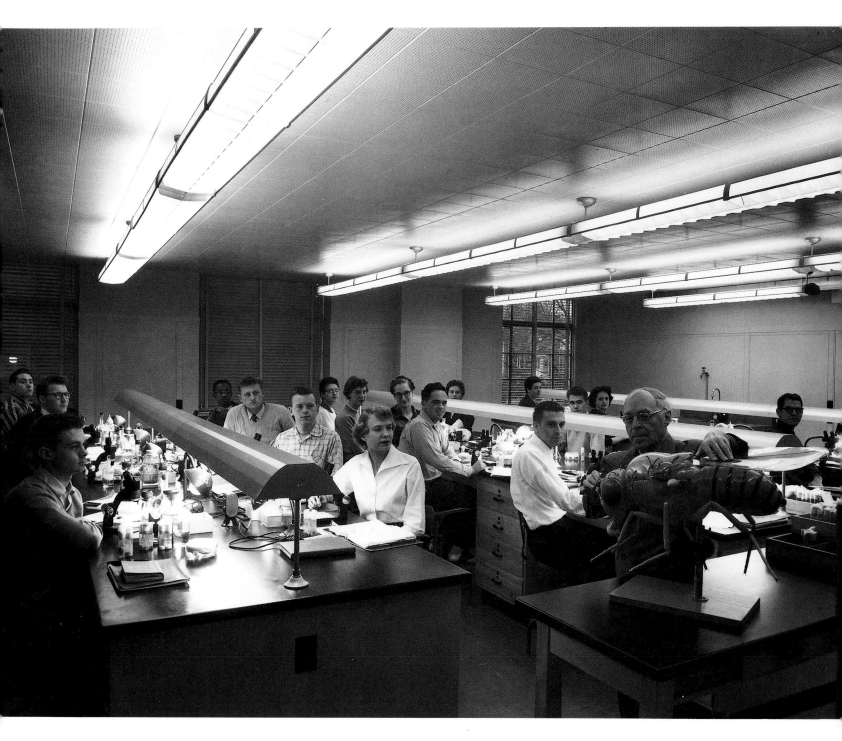

Hermann J. Muller, distinguished professor of zoology, demonstrating to his students in a laboratory session in 1955. Dr. Muller is using an enlarged plastic model of a fruit fly (*Drosophila*) for his lecture. His genetic experiments with the insect won him the Nobel prize in 1946.

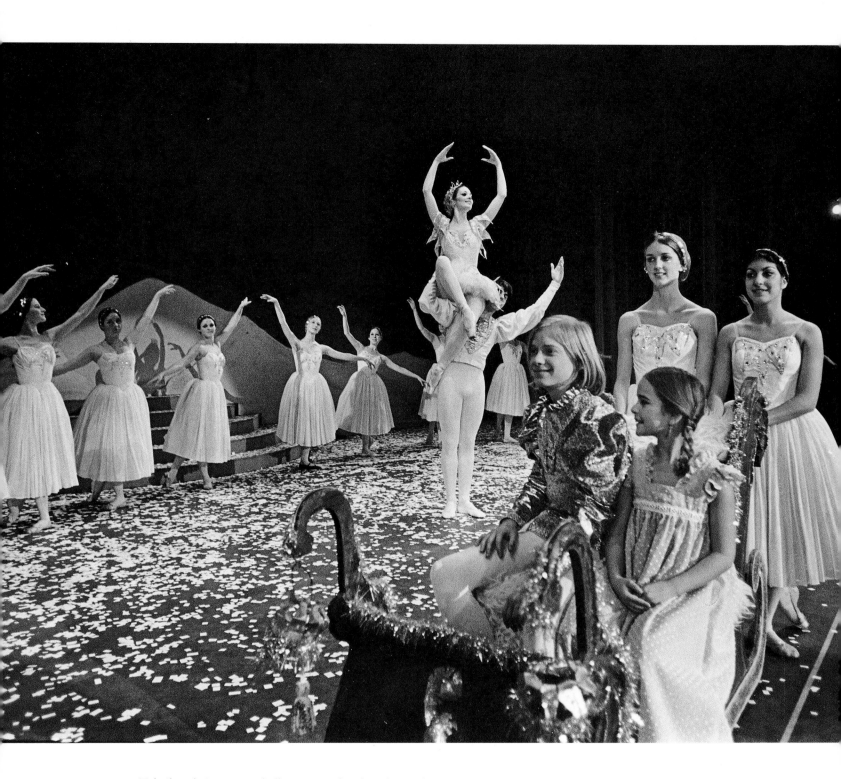

Tchaikovsky's two-act ballet *Nutcracker,* based on a fairy tale by E.T.A. Hoffmann, has been produced annually by the IU ballet theater since 1958. The ballet is a holiday event in December, drawing capacity audiences for the three performances. Auditions are held for the children in the cast, creating excitement and expectation in many Bloomington homes. The Ballet Department is an important constituent of the School of Music.

Arthur O. Clouse at the console of the first nuclear magnetic resonance machine acquired by the Chemistry Department. The machine, used to examine the structure of molecules, has long since been replaced by improved models. The department's NMR laboratory now has more than half a dozen of the improved models.

The Sigma Chi Watermelon Mess in 1958. It was an event at the beginning of the school year to which favorite faculty members and administrators were invited.

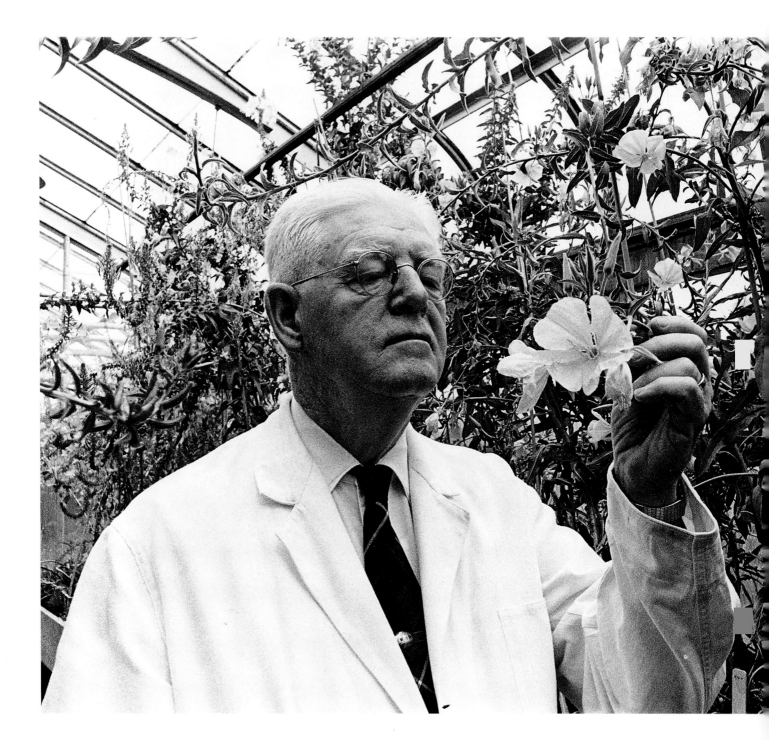

A zoology laboratory is home for axolotls, a form of salamander, to be used in research and instruction. Standing at right is Rufus Humphrey, famous in his field, who spent several years at IU after his retirement from the University of Rochester.

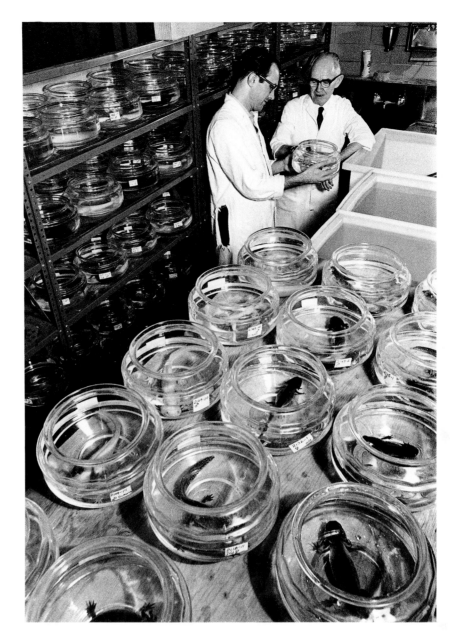

Distinguished botanist Ralph E. Cleland was one of the famed group of geneticists at IU supported by the Rockefeller Foundation. The group included William R. Breneman, Tracy M. Sonneborn, and Hermann J. Muller. Dr. Cleland's area of research was the evening primrose.

Camp Brosius, a family summer camp on Elkhart Lake, Wisconsin, is operated by the IU Alumni Association. The camp became the property of IU in 1941 when it merged with the Normal College of the American Gymnastic Union in Indianapolis. IU acquired the Fleck Hotel at Brosius, the kitchen, classrooms, the cottages of several turnverein families, and fifteen acres of land. It was named for George Brosius, nineteenth-century leader in the physical culture seminary movement.

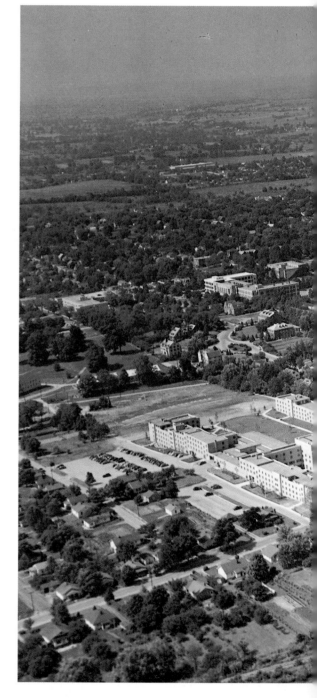

Aerial view of part of the Bloomington campus in the 1950s before Memorial Stadium on Tenth Street was razed and made into the Arboretum. In the foreground is Wright Quadrangle. Originally called Men's Quadrangle and completed in 1949, it was named to honor Joseph A. Wright, one of the first ten boys admitted to the Seminary in 1825. Wright was the most popular Indiana political figure of the 1850s and a warm friend of IU. He served as governor of the state, 1849-57.

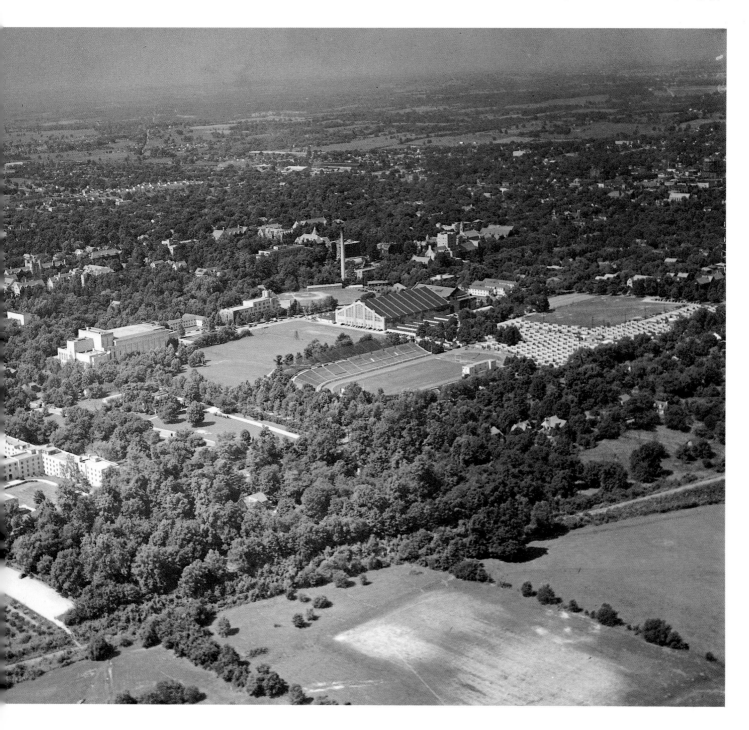

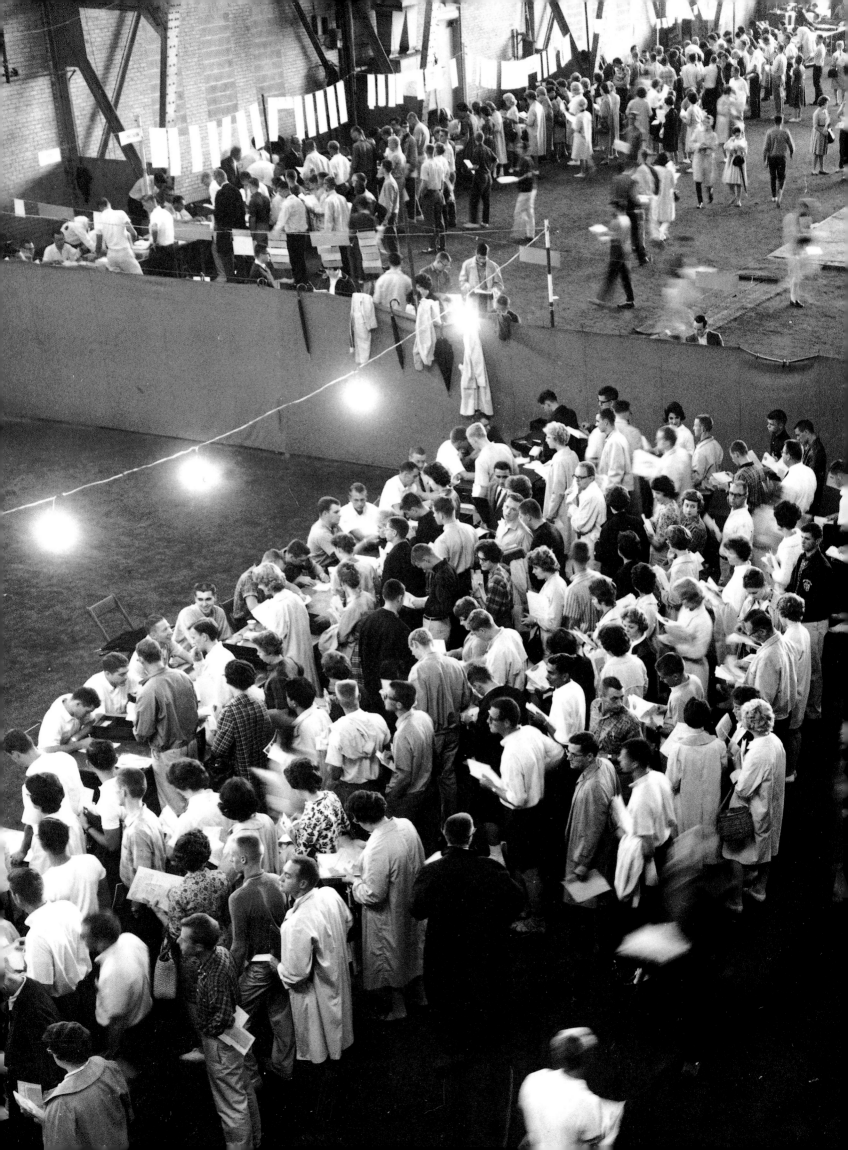

Registration was a hassle even for medical students before the system became computerized. The fieldhouse (Wildermuth) was either too hot or too cold on registration days.

The first electronic scattering machine with nonphotographic registration to scattered electrons acquired by the Department of Chemistry in the 1960s. Observing the equipment, right to left, are Russell A. Bonham, professor of chemistry, John Dorsett, and postdoctoral student Manfred Fink.

Tracy M. Sonneborn,
distinguished professor of zoology,
won international acclaim as a
geneticist and star rank in the field
of teaching as judged by his students
and colleagues. Mary Austin, a
retired faculty member from
Wellesley College, is an attentive
participant in this class.

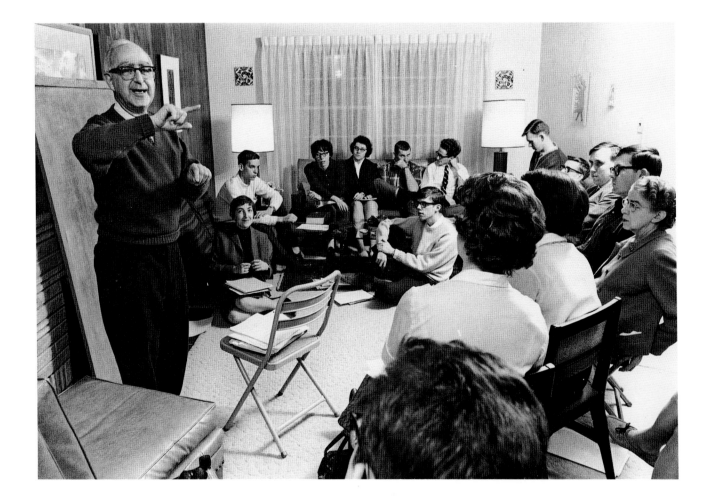

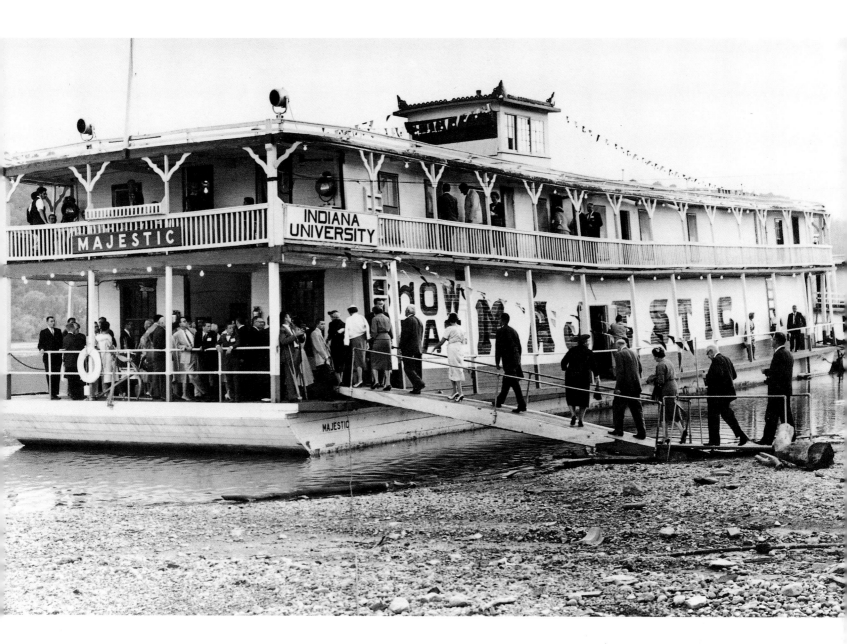

The showboat *Majestic* toured the Ohio River during the summer seasons 1960-64. The company of student actors, directed by Professor William E. Kinzer, delighted audiences at river towns between Cincinnati and Shawneetown, Illinois, with such melodramas as *Ten Nights in a Bar Room, In Old Kentucky, The Taming of the Shrew,* and *Rip Van Winkle.*

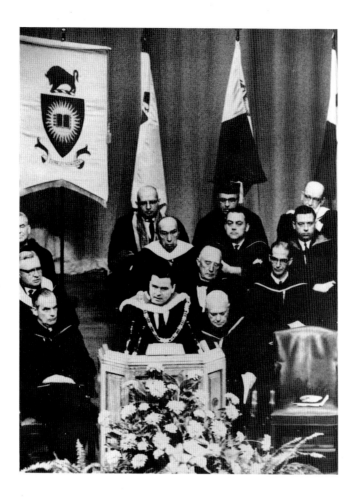

The inauguration of Elvis J. Stahr, jr., as the twelfth president of IU, 1962.

Joan Sutherland, Australian soprano of international acclaim, performing with the IU Philharmonic Orchestra in 1964.

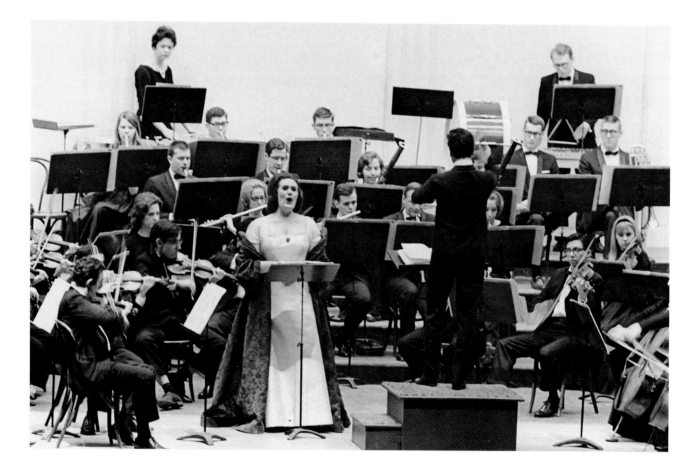

The Singing Hoosiers returning to
Bloomington after four weeks
entertaining in the Caribbean during
the summer of 1964. The group was
sponsored by the USO to entertain
service personnel throughout the
Caribbean region. Professor Robert
E. Stoll, who became director of the
group in 1971, is standing on the
extreme right.

This well-known student group,
founded in 1950 by Professor
George F. Kreuger, has performed
nationally before alumni groups and
delighted audiences on the campus
with song and dance.

School of Music Dean Wilfred C.
Bain talking to the student cast of
Turandot in Singer Bowl at the New
York World's Fair in August 1964.
This last opera by Giacomo Puccini
was performed twice by the School
of Music cast for appreciative
audiences.

Jane Ann Rutledge, B.Mus. 1969,
Miss Indiana of 1966, with her
mother, Mrs. H. W. Rutledge, who
was Miss Kansas in 1937.

The Physics Department graduated from handmade instruments to the increasingly sophisticated equipment required in nuclear physics. One-time chairman of the department Lawrence M. Langer is at the control desk of the high-resolution beta ray spectograph. Along with colleague Emil J. Konopinski, Langer had a leading role in the development and deployment of the hydrogen bomb.

The university purchased Wylie House, home of the first president of IU, in 1947, and through the years gradually restored the house to its former condition. The house is open for individual or group tours on a regular schedule. Here, Chancellor Wells and President Stahr are in the yard of the home with an interested group on Founders Day, 1965.

The custom of observing the birth of the university (January 20, 1820) with appropriate ceremonies began in 1889. It was initially called Foundation Day. In 1924 the observance was changed to May. During the presidencies of Wells, Stahr, and Ryan, Founders Day, as it has been designated since 1950, included a pilgrimage to the gravesite and home of Andrew Wylie. The pilgrimage has been discontinued and the observance of Founders Day moved to April. The day is largely devoted to honoring faculty members who excel in teaching, scholarship, and public service, and students for scholastic achievement.

The Wylie House was entered on the National Register of Historic Places in 1977.

Dedication of the Morgan-Monroe State Forest Goethe Link Observatory in 1966. Left to right: Byrum E. Carter, dean of the College of Arts and Sciences, Dr. and Mrs. Goethe Link, and Professor Frank K. Edmondson, head of the IU Department of Astronomy. The observatory, built with federal funds, was placed in the forest to escape city lights. It is still in use. This observatory is not to be confused with the Goethe Link Observatory located between Martinsville and Indianapolis on a high ridge above White River. This latter facility was created by Dr. Link, an IU alumnus and distinguished Indianapolis surgeon, through the Helen and Goethe Link Foundation and was given by him to IU in 1949. The night lights from Indianapolis have vitiated its use for scientific purposes, but many amateurs go there on observatory nights to look at the sky through its thirty-six-inch telescope. Others go in the spring to enjoy the beauty of Mrs. Link's daffodil garden.

William M. Zeller, a 1919 graduate, was honored on November 4, 1967, as a fifty-year "I" man. Zeller won his first varsity letter in basketball during the 1917-18 season.

Dedication of Bradford Woods. This 900-acre property on Highway 67 in Morgan County between Mooresville and Martinsville was given to the university in 1937 by John Bradford, the only remaining son of the Bradford family. It was his wish that the farm be used for the benefit of James Whitcomb Riley Hospital.

The university has enlarged the holding to 2,300 acres and has used Bradford Woods for conferences, a summer camp for handicapped children, and a training site for students in the School of Health, Physical Education and Recreation. The Monroe County Community Schools use the winterized camp for fifth-grade classes, and the Girl Scouts maintain a camp there. In 1989 Bradford Woods was added to the National Register of Historic Places.

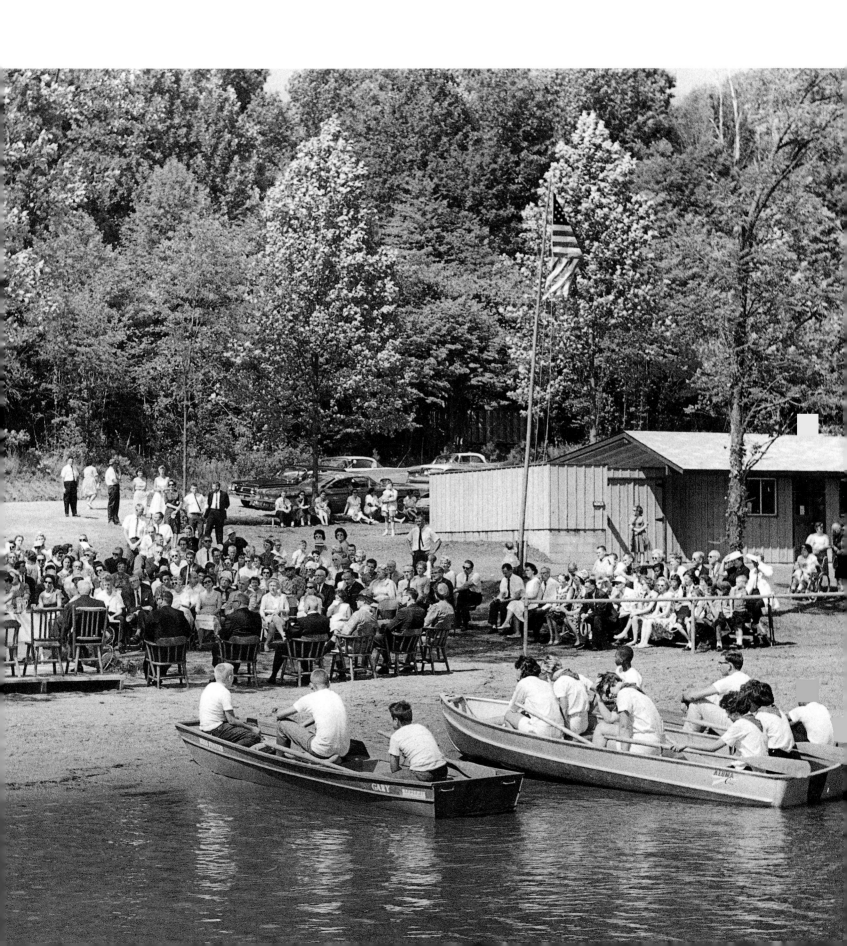

Administrators of the School of Business stand before the new Business Building completed in 1966. Front and center, Dean George Pinnell stands between associate deans Edgar G. Williams and E. Wainright Martin. Back row, left to right: John H. Porter, Schuyler F. Otteson, William G. Panschar, Edward J. Kuntz, and Howard G. Schaller.

The School of Business has gained national recognition for the excellence of its programs and attracts students from a wide area. The school was formerly located in what is now Woodburn Hall. In 1982 an addition to the Business Building was completed and dedicated for the use of the School of Public and Environmental Affairs, which was established in 1972. The complementary disciplines share library and other facilities in the enlarged building.

Arrival of the IU football team in California before Christmas, 1967, for the Rose Bowl game with Southern California. The team was met by the Tournament of Roses queen and her court and other dignitaries. IU was defeated in its only Rose Bowl appearance, 14 to 3.

The university television studio is used to perform a public service for the Girl Scouts of America. IU's Dean Eunice Roberts, a member of the Girls Scouts National Board, with mike, faces the camera.

Founders Day 1967 was a double celebration: the birthday of the university and the hundredth anniversary of the admission of women to IU. To commemorate the occasion, the university bestowed honorary degrees upon (top row, left to right) Mary Rieman Maurer, Nina Mason Pulliam, and Ellnora Decker Krannert; (bottom row, left to right) Jeannette Covert Nolan, Elsie Irwin Sweeney, and Grace Montgomery Showalter.

Maurer graduated from IU with honors in 1916. She was elected by alumni to the Board of Trustees in 1945, the second woman to serve as a trustee of the university. For eighteen years, Maurer was the sole woman trustee, serving with devotion and distinction.

Pulliam, newspaper executive and writer, was for twenty-five years secretary-treasurer and a director of Central Newspapers, Inc., which owned and operated several Indiana and Arizona newspapers. As a writer, Pulliam visited many countries following the Second World War and published several books relating to the countries she visited.

Krannert, wife of Herman C. Krannert, founder of Inland Container Corporation, served as vice-president and director of the corporation. She was best known for her benefactions to medicine, education, and the arts.

Nolan, Hoosier author, was married to Val Nolan, Evansville attorney, who served as an IU trustee from 1935 to 1940. She started her writing career as a reporter and feature writer for the *Evansville Courier*. She published her first book in 1932, and it was followed by forty-three books of adult and juvenile fiction.

Sweeney, of Columbus, Indiana, spent her life as a musician and promoter of music both at the university and abroad.

Showalter graduated from IU cum laude in 1913. Soon after graduation she married Ralph W. Showalter, an executive with Eli Lilly and Company. She was a devoted supporter of IU, serving on the IU Foundation's Board of Directors for twenty-one years. Her gift of the Showalter Fountain on the campus was a distinctive memorial to her deceased husband. Showalter House, home of the IU Foundation, is another of her benefactions.

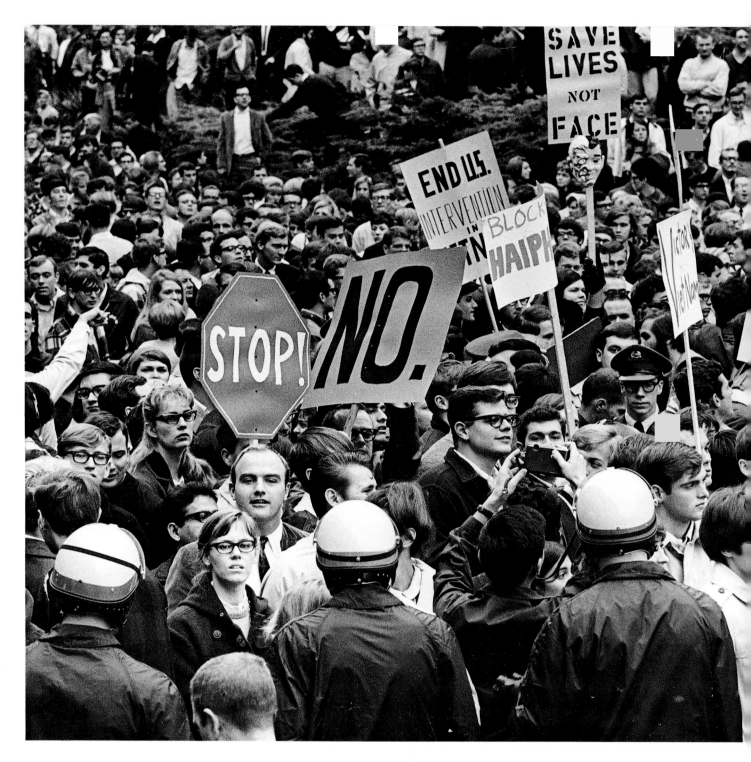

The Vietnam War years at the university were a period when students marched in protest and presented demands and petitions. The good sense of the faculty, the administration, and thoughtful students kept the protests under reasonable control. Riot police were present at this demonstration in Dunn Meadow but did not have to intervene.

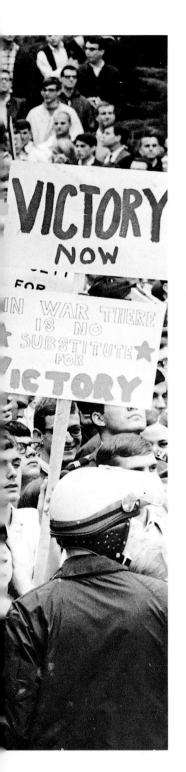

Members of the freshman class at Freshman Camp in 1969 (overleaf). Freshman Camp, as it came to be called, began in the late 1940s as the freshman leadership training camp sponsored by the YWCA and YMCA. In the 1950s the Junior Division joined with the two founding organizations to sponsor this unusual orientation for incoming freshmen. The camp was held at McCormick's Creek State Park, usually for a three-day period, and was limited to the first two hundred who registered. The program included panel discussions and lectures by faculty and upperclassmen. The participants held a talent show, formed a band and a choir, and made friendships that lasted long beyond their university years.

Students and faculty on their way into the IU Auditorium to attend a memorial service for Martin Luther King, Jr., after his assassination in 1968.

Coach John Pont observes
workmen covering the football field
at Memorial Stadium with astroturf
in 1970. Pont, football coach from
1965 to 1972, was the only coach to
take the Hoosiers to the Rose Bowl.

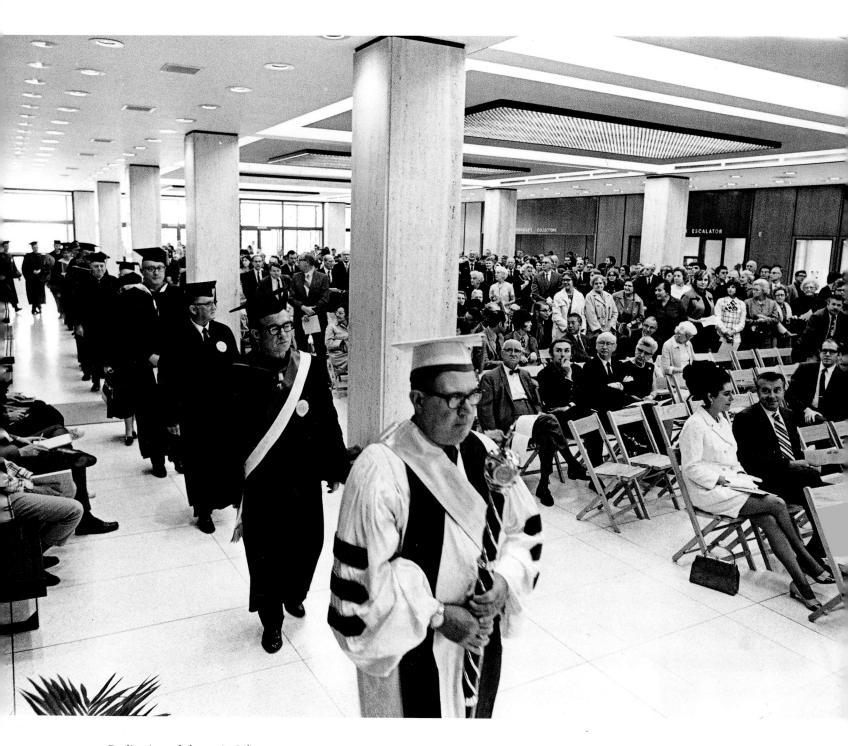

Dedication of the main Library
Building in October 1970, the third
library building constructed on the
Bloomington campus. The first was
Maxwell Hall; the second is now
called Franklin Hall. Professor
William R. Breneman, grand
marshal, leads the procession of
faculty, administrators, and guests to
the platform in the main lobby of
the new building.

A young and dimpled Bob Knight looks out over Assembly Hall in 1971, perhaps envisioning the packed houses his basketball teams would attract in the coming years. His win-loss record for that first season, 1971-72, was 17-8, presaging the days of national championships.

Guard Keith Smart shoots the Hoosiers into NCAA history with this buzzer beater in the 1987 championship game against Syracuse. (AP/WIDE WORLD PHOTOS)

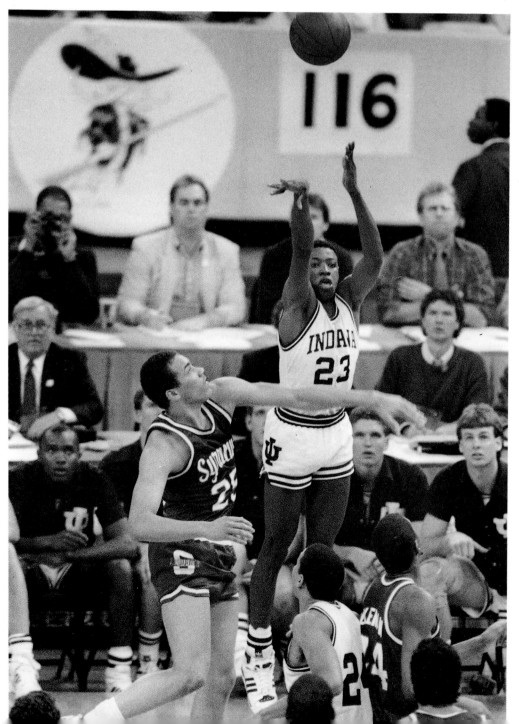

Three men who served as president of Indiana University—Elvis J. Stahr, jr., Joseph Lee Sutton, and Herman B Wells—are shown in this photo taken by Mrs. Keith Robinson at the unveiling of the portrait of Ralph L. Collins. Collins served IU from 1935 to 1963 as a professor and administrator. From 1959 to 1963 he was vice-president and dean of faculties.

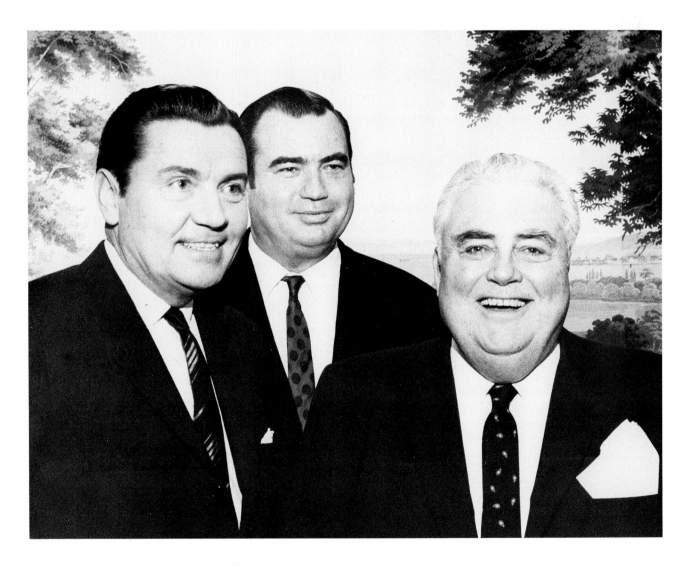

A loyal IU football fan regularly
descended from the stands to assist
the cheerleaders in their pleas for a
crescendo response. Students looked
forward to the appearance of this
popular volunteer and greeted him
with cheers.

IU's noted swimming coach, James "Doc" Counsilman, has words of praise for Mark Spitz, winner of seven gold medals, all in world record time, at the Munich Olympics in 1972.

Janos Starker, world-renowned
concert cellist and professor of
music at IU, stresses a point in
string-playing technique to students
in the School of Music's Summer
Seminar.

Members of the Class of 1924 on
the fiftieth anniversary of their
graduation. The Alumni Association
awards a pin and certificate to
alumni on this occasion each year.
The gentleman with the big smile
has the initials H. B (no period) W.

A scene from the movie *Breaking Away* being shot in front of Franklin Hall, with the Student Building in the background. The movie, based on IU's Little 500 bicycle race and the perennial conflict between town and college youths, was filmed in and around Bloomington in 1978. The director, Peter Yates, is in the foreground, standing at left. Hero Dennis Christopher is with bicycle.

Kenneth R. R. Gros Louis, vice-president of the university and chancellor of the Bloomington campus, talks with Donna Biven and Randy Umbaugh. The two freshmen won prestigious Metz scholarships in 1981.

David L. Dilcher, formerly adjunct professor of biology and of geological sciences, and Gregory Retallack, postdoctoral research associate, demonstrate how they investigate fossil flowers from fifty million years ago to learn how flowering plants have developed into their present forms.

A summer band concert on the Fine Arts Plaza in front of Lilly Library.
The early-evening concerts, directed by the School of Music faculty, are
favorite attractions for band enthusiasts of every age.

Spirit of Sport All-Nighter. This twenty-four-hour activity is sponsored by the IU Student Recreational Sports Association to raise funds for the Indiana Special Olympics. Held in Wildermuth Intramural Center, the affair has been an annual feature of campus life since 1975.

Red Skelton, a native of
Vincennes who made the big time in
the entertainment world, whips up
the crowd at the homecoming
football game, 1981.

An umbrella for two at the homecoming game, 1981.

The Afro-American Choral Ensemble in 1982. The ensemble, organized in 1975, has a repertoire that includes spirituals, gospel songs, art songs, and excerpts from operas and musicals by and about African Americans. The ensemble travels extensively between semesters both in and out of the state to give its variety concerts. The present director is James Mumford. The Afro-American Art Institute also sponsors a dance company and the IU Soul Revue.

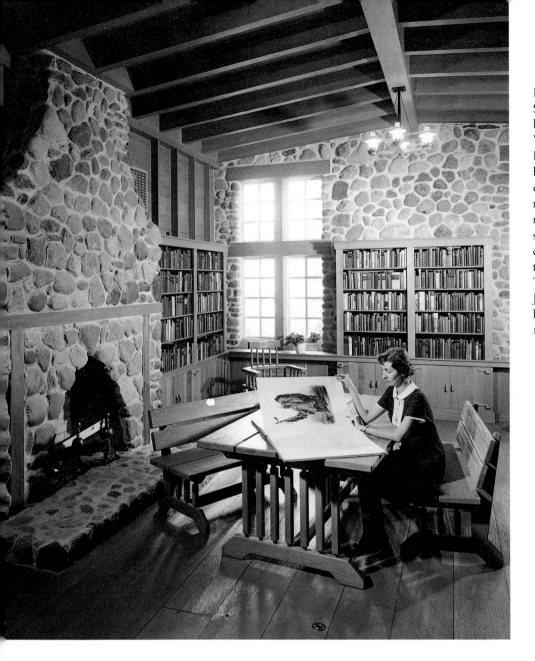

The Ellison Room in Lilly Library, named to honor Robert Spurrier Ellison, A.B. 1900, who gave his magnificent collection of Western Americana to IU. Lilly Library contains the university's rare books and manuscripts. At the close of the academic year 1990-91, it held more than 360,000 books, 6,000,000 manuscripts, and 100,000 pieces of sheet music. It is named for the distinguished family that founded the Indianapolis pharmaceutical firm. The founder's grandson, J. K. Lilly, Jr., gave his superb collection of books and manuscripts to IU in 1956.

William R. Cagle, Lilly Librarian, standing in front of a portrait of Josiah Kirby Lilly, Jr. (1893-1966). Lilly's gift to I U of his superlative collection of books, manuscripts, and paintings led to the construction of the Lilly Library.

Shakespeare's *Macbeth*, produced by the Department of Theatre and Drama in 1986, broke box-office records. It was directed by Professor Howard Jensen, with Andrei Hartt as Macbeth and Lia D. Mortensen as Lady Macbeth.

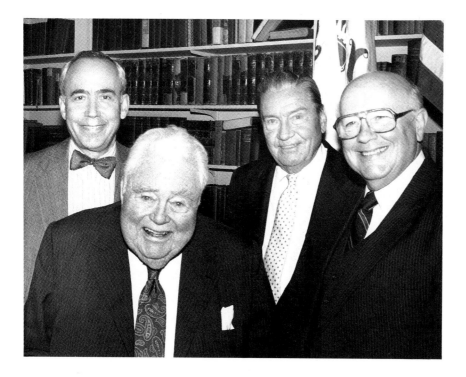

June 7, 1991, was the eighty-ninth birthday of University Chancellor Herman B Wells. He was visited in his office by, left to right, President Thomas Ehrlich and former presidents Elvis J. Stahr, jr., and John W. Ryan.

The end of the Women's Little 500 in 1991 leads to congratulations by two of the participants.

One of the many groups participating in the IU Sing, 1991, a music and drama competition among IU housing units sponsored by the Student Foundation. The antecedents of the present two-night affair date back to the Show Down of the 1920s. The first official IU Sing was sponsored by the YMCA and held on the steps of the Student Building. In 1941 the show was moved to the IU Auditorium. The Student Foundation has had full responsibility for the event since 1979.

The first class of Wells Scholars arrived at the university in the fall of 1990. Named in honor of Chancellor Wells, a Wells Scholarship offers full four-year support on the Bloomington campus to outstanding high school graduates. The scholarships are based solely on merit. Over the course of their university study, Wells Scholars are offered a unique educational opportunity, including close interaction with outstanding members of the faculty, special small-group seminars, and the option of study abroad. Pictured here are sixteen members of the first class of twenty scholars. Professor Breon Mitchell, shown below, is director of the program.

Indiana University–Purdue University Indianapolis (IUPUI) has many educational ancestors. The oldest antecedent in the IU branch of the family was the School of Medicine, which had its beginnings in Indianapolis in 1906. Then came Social Service; the Training School for Nurses, 1914; the Extension Division, 1916; Dentistry, 1925; the Normal College of the American Gymnastic Union, 1941; the Law School, 1944; Division of Allied Health Sciences, 1959; the Herron School of Art, 1967; and finally, the merger in 1969 of all IU-Purdue educational programs in the city. From these many components, a viable, imposing university has grown in the state's capital, with IU having the fiscal and administrative responsibility for IUPUI.

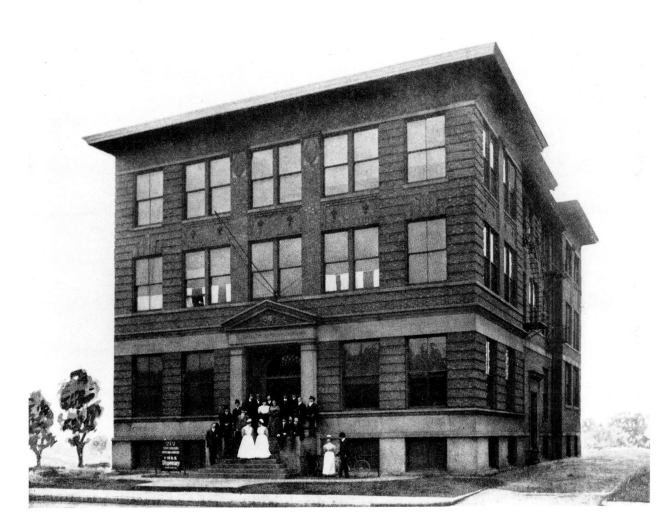

The two clinical years of IU's School of Medicine began in this building on North Senate Avenue in September 1906. Bloomington citizens helped purchase the building, which was the property of the Central College of Physicians and Surgeons. Burton D. Myers spent the summer of 1906 transforming the building into a teaching hospital. The school was first affiliated with a proprietary group and was known as the State College of Physicians and Surgeons. In 1907, by agreement, it became the Indiana University School of Medicine offering a four-year course in medicine. In 1908 IU absorbed the Indiana Medical College, a competing school formed by Purdue in 1905. The first building on the present medical campus, Emerson Hall, was completed in 1919.

Two of the early faculty members of the IU School of Medicine. Dr. Charles P. Emerson, on the left, served as dean, 1911-30. Dr. Frank B. Wynn served on the faculty until his accidental death in 1922.

In the early years of nurses' training at the IU School of Medicine campus, student nurses relied on a jitney to take them from their rented rooms to their campus assignment in Long Hospital (which was dedicated on June 15, 1914, and admitted patients the next day). The Ball Residence for Nurses, completed in 1928, provided housing for nurses on the campus for many years. The building was made possible by a gift from the Ball Brothers of Muncie. The building is now a coed undergraduate dormitory. The School of Nursing was founded in 1914 as the Indiana University Training School of Nursing. It now offers baccalaureate programs on seven of the eight IU campuses in the state.

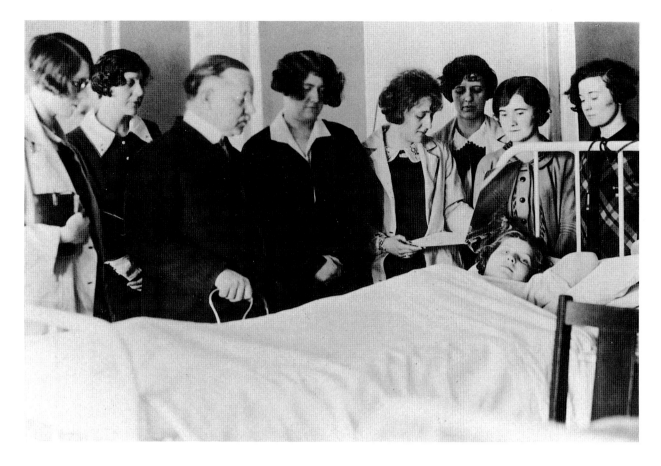

Dr. Emerson with students, making the round of patients. The first School of
Medicine building on the West Michigan Street campus was constructed in 1919.
In 1961 the building was renamed Emerson Hall to honor the longtime dean.

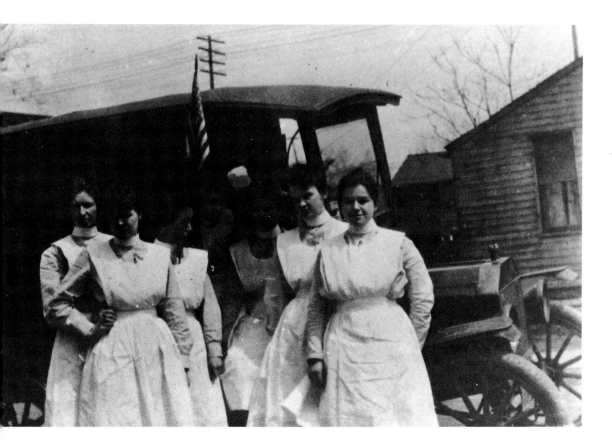

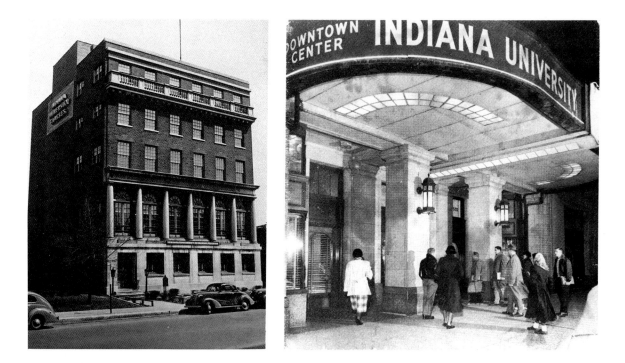

The Bobbs-Merrill Building, at 122 East Michigan, was purchased for the work of the Indianapolis Extension Center in 1928, and the Lumberman's Building, at 518 N. Delaware, was purchased in 1948. These two buildings served until the development of the IU campus on West Michigan. The Indianapolis Center was established on a regular schedule in 1916, offering a variety of evening classes in rooms at Shortridge High School.

Registration for classes in the
Bobbs-Merrill Building in the 1930s.

Flag raising at the opening of Riley Hospital. The James Whitcomb Riley Hospital for Children, a part of the School of Medicine, has largely been a project of the Riley Memorial Association since its inception in 1921. The association has had splendid cooperation from service clubs and organizations (for example, Kiwanis, Rotary, and Cheer Guild) in financing special projects. The organization has promoted the hospital as a memorial to the renowned Hoosier poet, raising funds from both public and private sources. Riley is recognized in the front ranks of children's hospitals. The first patient was admitted in November 1924.

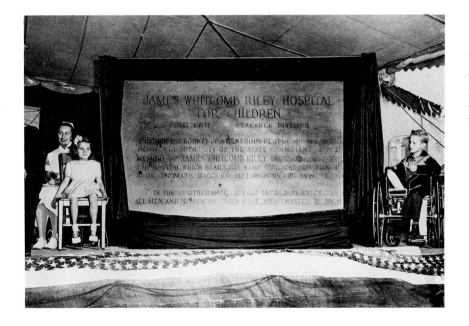

The dedicatory plaque at Riley Hospital appeals to all men and women of good will to support research into unknown life-saving treatments for children, whom the hospital was designed to serve.

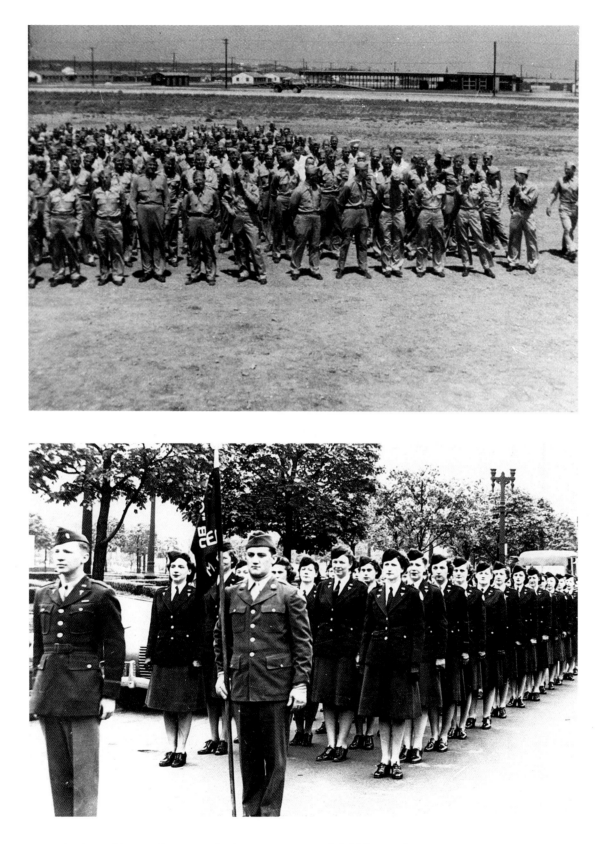

In both world wars the IU Medical Center sponsored field hospitals. Base Hospital No. 32 served with distinction in the First World War. General Field Hospital No. 32, staffed by nurses and doctors from the Medical Center, Indianapolis, and other Indiana cities, served with equal distinction in the Second World War. The 32d General Hospital was activated at Camp Bowie, Texas, in January 1943. The unit went to England in September 1943 and operated two hospitals in the Midlands. It moved to Normandy in July 1944, then to Liege, Belgium, in November. In March 1945 the unit moved to Aachen and became the first major U.S. Army medical unit to be established in Germany.

Student nurses lend their talents to the All-Campus Revue in 1950.

Dean John D. Van Nuys delivering the Hippocratic Oath to the medical school graduating class. Customarily the oath avowal was at a site apart from the commencement ceremony. Dr. Van Nuys served as dean of the School of Medicine, 1947-64.

Herman and Ellnora Krannert with President Joseph Sutton and Chancellor Wells at the dedication of the Krannert Pavilion in the University Hospital in 1970. Funds for the construction of the pavilion and for its maintenance were the gift of the Krannert Charitable Trust. The Krannert gift was sufficient for constructing the entire sixth floor of the hospital and providing spacious patient rooms, dining facilities, and special furnishings. The pavilion has a separate outside entrance.

David Rubins, IUPUI faculty member, 1967-81, sculptured
the statue of the youthful Lincoln that stands in front of the Indiana
Statehouse.

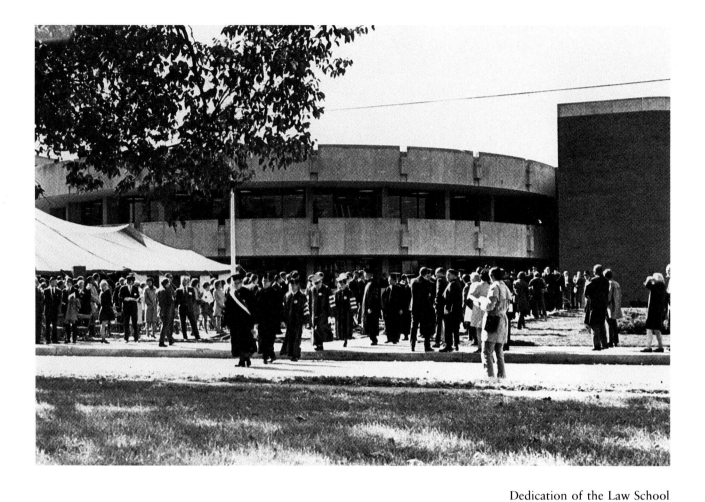

Dedication of the Law School Building on the IUPUI campus, 1970. U.S. Attorney General John H. Mitchell was the dedicatory speaker. The IU School of Law at Indianapolis has several antecedents, principally the Benjamin Harrison Law School and the Indiana Law School, both located in Indianapolis. IU acquired the latter in 1944 and operated it as a part-time division of its Bloomington counterpart until it became independent in 1968 as a full-time school within the structure of IU. For twenty-four years prior to the construction of the new building, the school was in the Maennerchor Building. Now the largest law school in the state, it offers programs for both part-time and full-time students.

IUPUI homecoming queen Cathy Witter, receiving her crown from Lieutenant-Governor Robert Orr in 1980.

155

Life-size artificial animals greet
children in the atrium at Riley
Hospital.

A curious student views the
dedication of the Business-SPEA
Building from inside the skywalk
spanning Michigan Street, October
1981.

The Sports Medicine Laboratory does drug testing for athletic programs and runs tests for research purposes for the School of Medicine and for clinical toxicology at IU hospitals.

Gerald Bepko, vice-president of IU and chancellor of IUPUI, talks with U.S. Representative Lee Hamilton. Hamilton was on the campus to discuss ethics at a breakfast for educators.

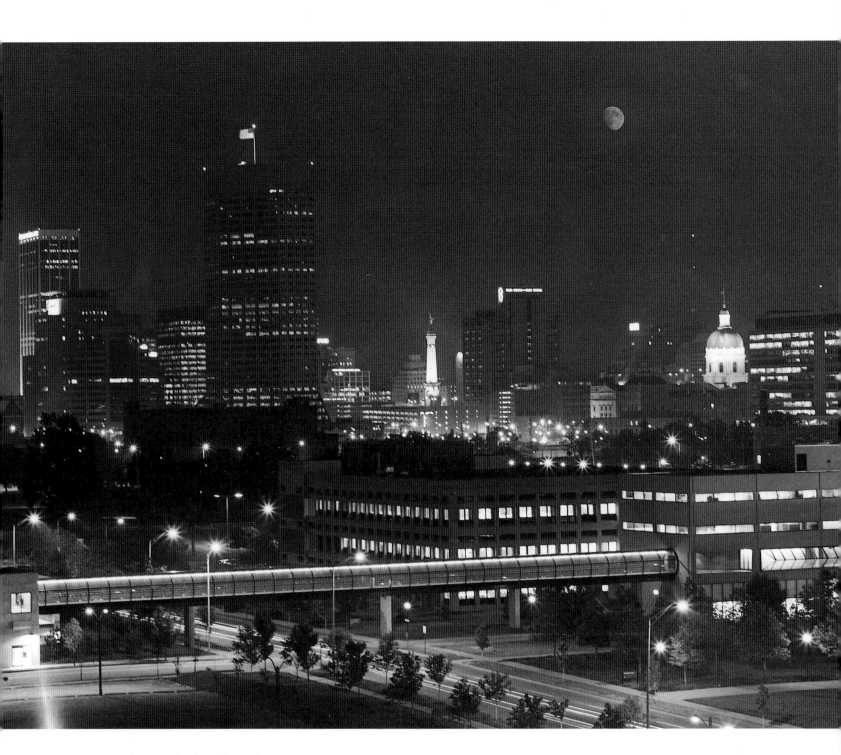

A night view, looking from the west. The IUPUI skywalk and buildings are in the foreground, with the city and the State Capitol in the background.

Members of dentistry's Class of 1935 mark the fiftieth anniversary of their graduation at the 1985 Fall Dental Conference. The class made a special gift to support programs at the School of Dentistry.

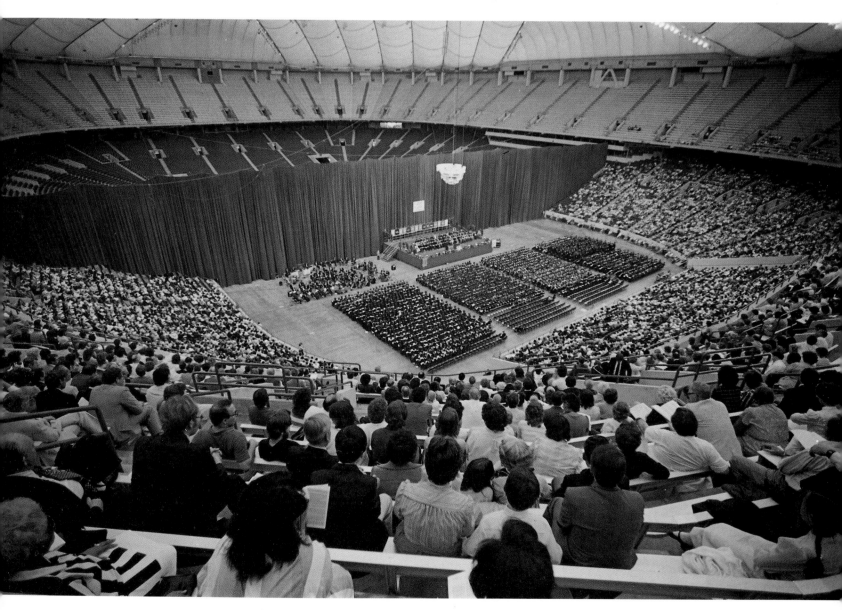

IUPUI commencement at the Hoosier Dome, 1984. At IUPUI commencements, IU conducts its part of the ceremony and Purdue presides over its part.

For more than three-quarters of a century, IU has served the people of Indiana beyond the confines of Bloomington with a variety of educational programs in populated areas where a demand for education has existed. Initially the IU Extension Division, in close cooperation with local school authorities, was charged with this responsibility. In addition to Indianapolis, IU has taken its educational programs to Fort Wayne, Gary, South Bend, New Albany, Kokomo, and Richmond.

IU classes were first offered in Fort Wayne in 1917 in classrooms in the old Central High School. Frank W. Shockley began the work but was succeeded in 1918 by Floyd R. Neff, whose distinguished career at Fort Wayne spanned many years. Purchase of the Luther Institute building in 1939 gave IU a home until the new campus was opened on Coliseum Boulevard in 1964. In 1958 the programs of IU and Purdue in Fort Wayne were combined. The state Mental Health Division gave the two universities 114 acres at the north edge of the city which have been developed into an attractive campus. Indiana University–Purdue University Fort Wayne (IPFW) is administered by Purdue. The campus now has 565 acres, with twenty-two educational and auxiliary buildings.

IU first offered classes in Lake County in 1922 as part of an innovative program of the Gary public school system. In 1932 an IU Center was opened in Calumet. When Gary College floundered, the Gary School Board asked IU to assume the management. From this beginning, IU Northwest has grown. In 1955 the Common Council of the city of Gary authorized the sale of twenty-seven acres of Gleason Park to IU for the Gary campus. The first classes were held at the Gleason Park location in 1959 after the completion of Tamarack Hall. The IUN campus now includes thirty-six acres and a physical plant of sixteen buildings.

IU offered extension classes in South Bend in 1922. Encouraged by Frank E. Allen, superintendent of schools in South Bend, who offered free classrooms and secretarial help, IU opened a part-time office in the city in 1933 and a full-time office in 1940. Classes offered in both South Bend and Mishawaka were at the freshman and sophomore levels. In 1950 civic leaders campaigned for a full degree program, but four-year degree programs were not approved by the Indiana Higher Education Commission until 1965. The first undergraduate degrees were awarded in 1967. Since then the IUSB campus has grown to forty-one acres and thirty-five buildings. In 1991 IU purchased twenty-three acres south of the St. Joseph River for future construction of student housing and athletic fields.

Indiana University Southeast (IUS) began as the Falls City Area Center in 1941 in Jeffersonville. Floyd I. McMurray, who had served as state superintendent of public instruction, was director from 1941 to 1956. Initially classes were taught at Jeffersonville and New Albany high schools. In 1945 IU acquired the National Youth Administration building in Warder Park, Jeffersonville. During the next five years, five more buildings were acquired. With the Jeffersonville site too restricted for anticipated growth, civic leaders of New Albany raised $500,000 to purchase land for a new campus. In 1973 IUS moved to a beautiful new campus just north of New Albany. It contains 177 acres and a physical plant of sixteen buildings.

Indiana University at Kokomo (IUK) grew from the Kokomo Junior College, established in 1932. The small college asked IU to take over its educational program in 1945. Growth led to the purchase of the Kingston-Seiberling mansion in 1946 and later the Mark Brown residence next door. Still later, land was acquired on South

Washington Street, and the main classroom building there was occupied in 1965. At present the IUK campus contains forty-eight acres and sixteen buildings.

IU East, Richmond, began in 1946 as a joint program of IU and Earlham College. Ball State and Purdue joined the program in 1967, and courses from all four institutions were offered in space provided by Earlham. Richmond citizens undertook a successful campaign in 1969 to raise funds to purchase a campus site. In 1970 IU, by agreement of the participating institutions, assumed administrative control of the educational program. In 1975 a new building was dedicated on the campus site on the north edge of Richmond. Today the campus includes 194 acres and six buildings. The regional Indiana Vocational Technical College is located on the IU East campus in a separate building.

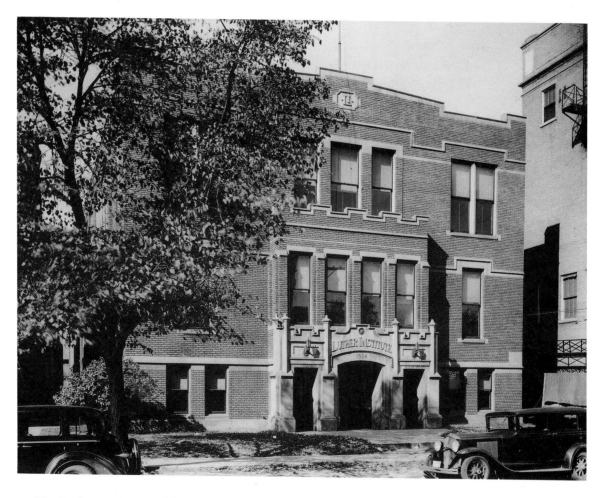

The Luther Institute Building, purchased by IU in 1939, was the site of IU's Fort Wayne Center until the new campus was opened in 1964 on Coliseum Boulevard.

162

Book moving day at Fort Wayne. Students, faculty, and staff carried books from their old quarters to the new Walter E. Helmke Library in 1972. IPFW student body president Brock Able leads the student book walkers from his wheelchair.

The library was named to honor Walter E. Helmke, a Fort Wayne attorney and an IU trustee, 1954-56. Helmke played a leading role in the formation of the joint Indiana University–Purdue University at Fort Wayne.

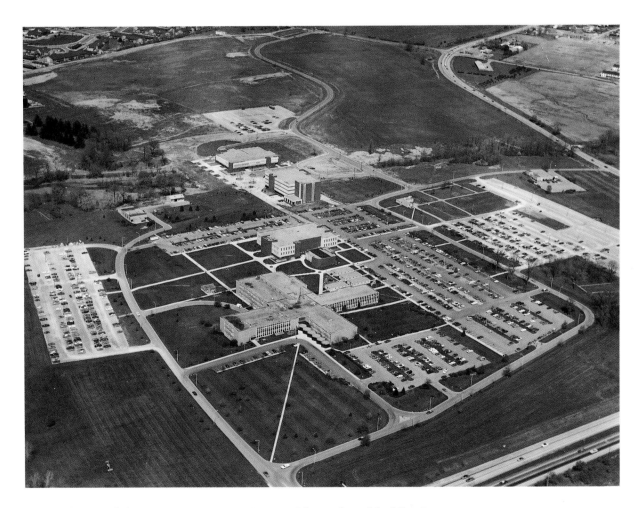

Aerial view of the Fort Wayne campus in 1974. The X-shaped building in the foreground is Kettler Hall, dedicated in 1964. It was named to honor Alfred W. Kettler, Fort Wayne businessman and civic leader. Kettler worked tirelessly for the unification of IU and Purdue educational programs in the city. The photograph was taken by Gabriel R. Delobbe of Fort Wayne.

Commencement time at IU Northwest (Gary), 1988.

The main building on the
Washington Street campus of IU
Kokomo, dedicated in 1965. The
building contains administrative
offices, classrooms, the library, and
the computer center. Havens
Auditorium, to the left, is attached
to the main building. It may be
entered either from the main
building or from the outside
entrance.

The Kingston-Seiberling mansion, purchased in 1946 to house the activity of the Kokomo Center, now IU Kokomo. The fine old mansion was the home of IUK for eighteen years before the move to the new campus on South Washington Street.

Commencement at IU Kokomo in 1988. The academic procession marched toward Havens Auditorium, where 269 students received degrees. The auditorium was named to honor Mrs. Cressy Thomas Havens, A.B. 1910. A gift from her estate went toward construction of the auditorium, which is a combined community and university facility. The auditorium seats more than nine hundred. It is used frequently by IUK and community groups for musical and dramatic productions and programs relating to public issues.

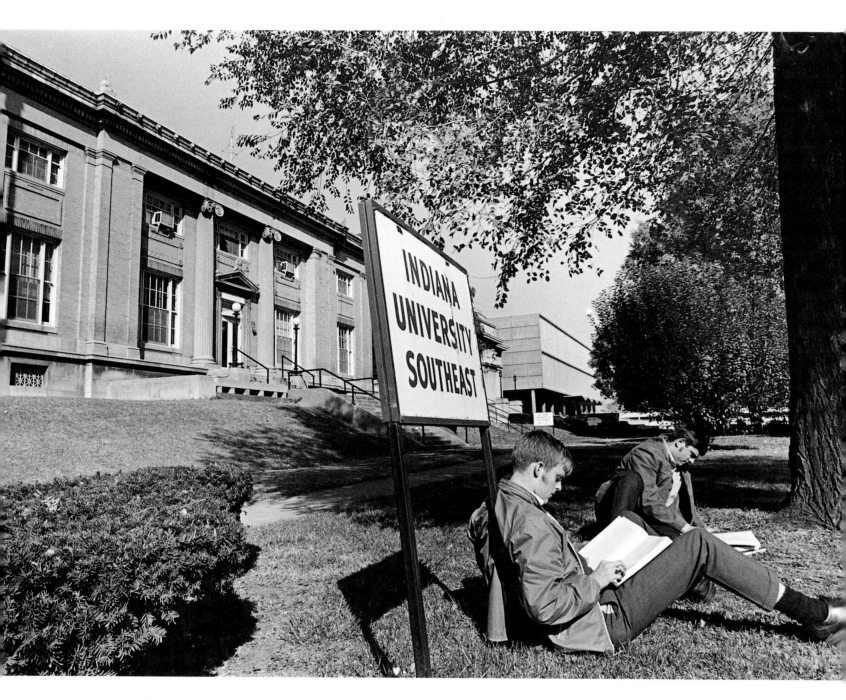

The first campus of IU Southeast in Warder Park, Jeffersonville. In 1973
the school moved to its present campus just north of New Albany.

IU East at Richmond is the most recent campus of Indiana University. Founded in 1971, IUE was first located on the campus of Earlham College. It was moved to a new campus just north of Richmond in December 1974. The new building was dedicated in February 1975.

Commencement at Richmond, 1988. President Thomas Ehrlich personally greeted each of the 103 graduates in an outdoor ceremony at IUE.

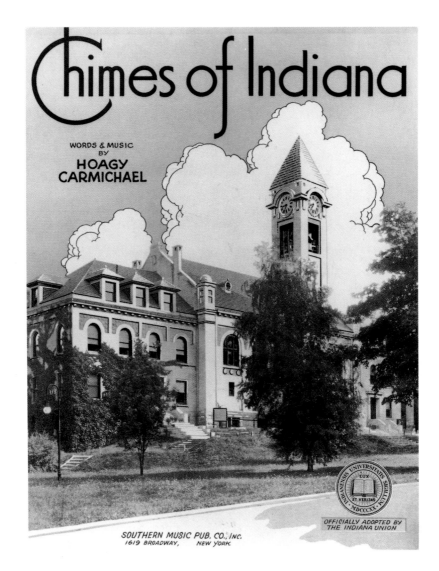

Chimes of Indiana

WORDS & MUSIC
BY
HOAGY CARMICHAEL

SOUTHERN MUSIC PUB. CO., INC.
1619 BROADWAY, NEW YORK

OFFICIALLY ADOPTED BY
THE INDIANA UNION

Hoagy Carmichael's "Chimes of Indiana" was played and sung by Hoagy on an IU Founders Day program broadcast over the Blue Network of NBC Radio in May 1937. Hoagy kept tinkering with the song, changing some of the lyrics and the music, and published a revised version in 1953.

Some of Hoagy's friends, who had urged him to write such a composition, thought that "Chimes" would become his alma mater's hymn, and several efforts have been made by admirers of the composer and the song to have "Chimes" designated IU's official song. The most notable efforts were an extensive campaign by the *Indiana Daily Student* in 1953 and a petition by the Board of Managers of the Alumni Association to the Board of Trustees in 1977. The trustees took no action on the request. "Hail to Old IU," by consensus and continuance, remains the alma mater song.

As first published in 1937, "Chimes" included these lyrics:

Sing these chimes of Indiana,
Hail to the crimson hue!

Sing her praise to Gloriana
Hail to old IU!

Lift thy voices joined in loyal chorus
Let thy hearts rejoice in praise of those before us.
Sing these chimes of Indiana
Ever to her be true.

In the second edition published in 1953, two stanzas were revised:

Lo, the chimes of Indiana
Follow the crimson tide
Loyal chimes of Indiana bursting with
Hoosier pride.

Proud of our campus on Jordan
Hail to old IU
Join in praise of Indiana
Ever to her be true.

168

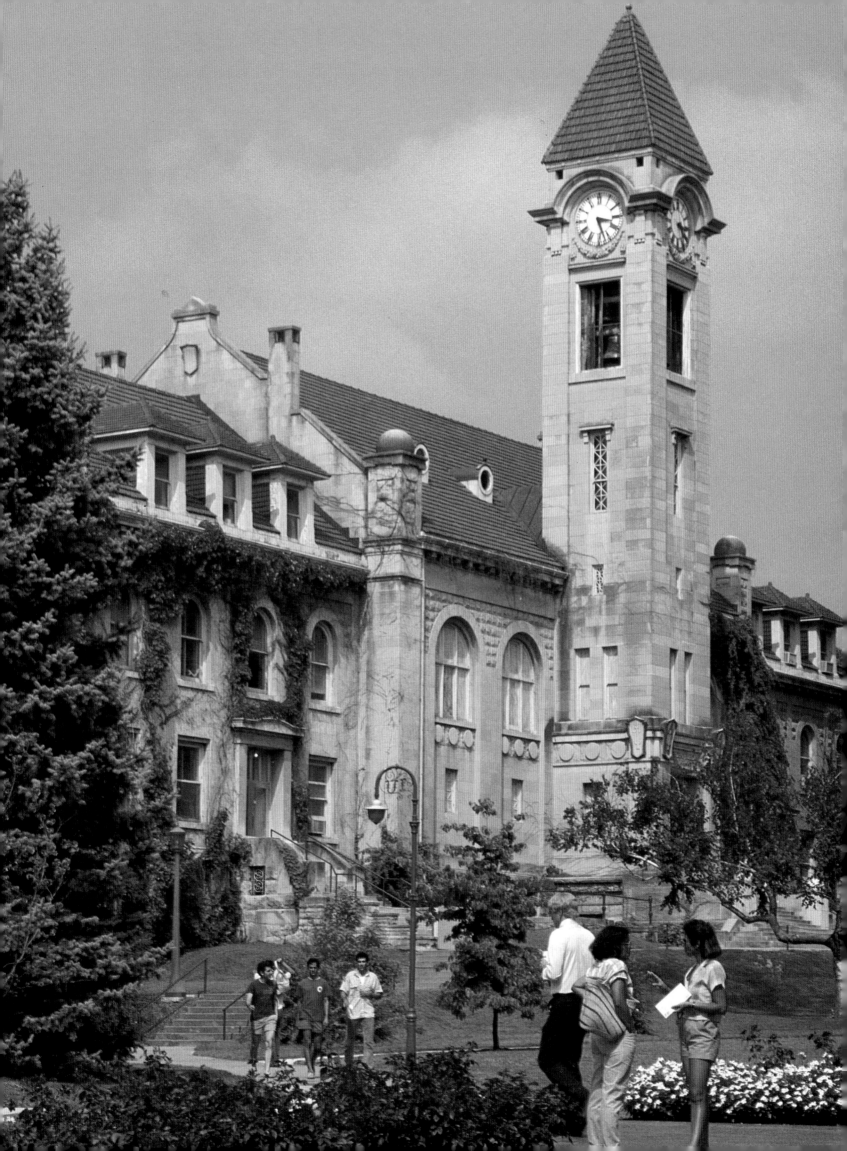

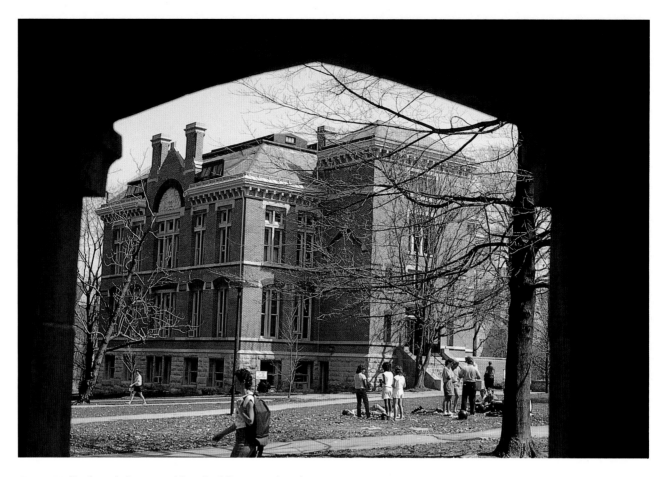

Owen Hall, one of the two oldest buildings on the Bloomington campus.

The Student Building, completed in 1906 (preceding page). The chief promoter of the building, intended primarily for use by women, was Mrs. Joseph Swain, wife of President Swain. The building was financed by public subscription. The largest single donation, $50,000, came from John D. Rockefeller on a matching basis. Four classes, 1899 to 1902, subscribed a small sum for the purchase of chimes, a clock was added to the want list, and the architects were instructed to plan a tower to house these most notable features of the structure.

The tower containing the chimes and the clock was ravaged by fire during building renovation in December 1990. It was rebuilt, and the clock and chimes were replaced thanks to loyal alumni who contributed more than $165,000 for restoration. The eleven original bells were replaced with fourteen. The building, renovated throughout, was rededicated in an impressive ceremony at homecoming, October 11, 1991.

The atrium in the Art Museum, looking toward the Indiana Memorial Union.

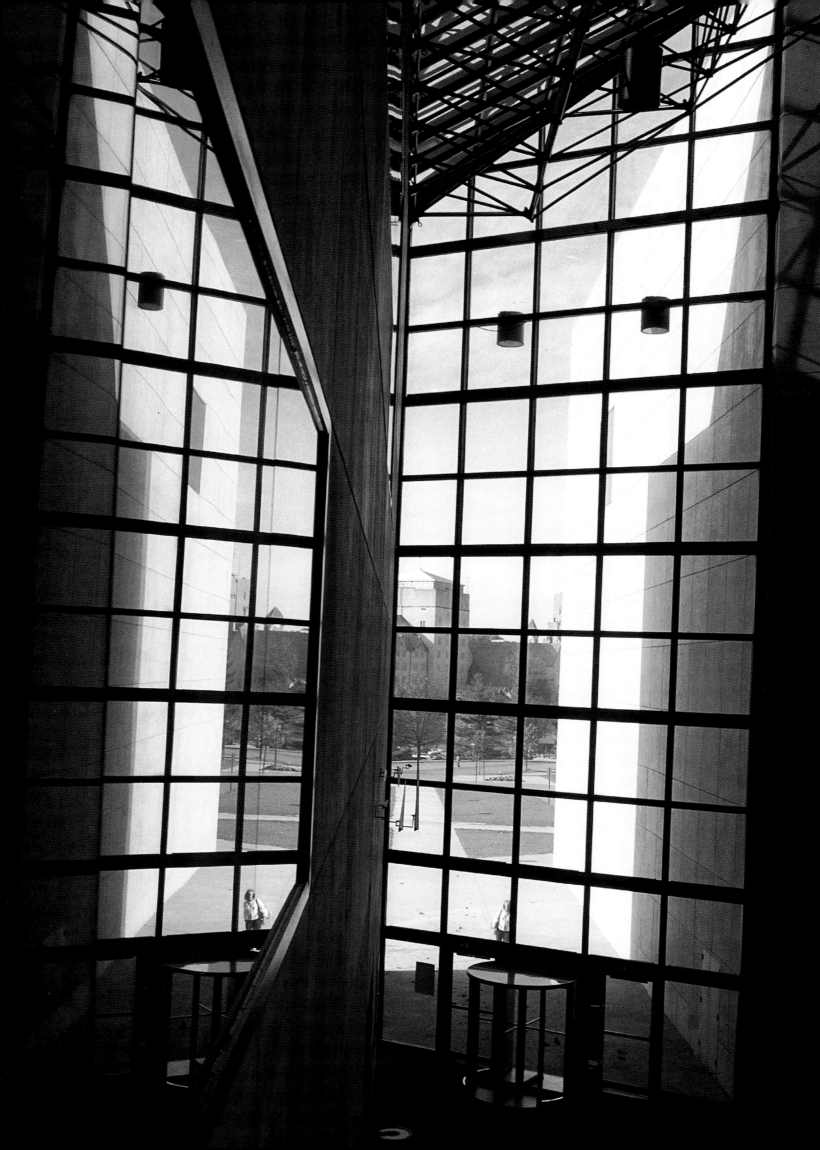

The Metz Carillon Tower, off Lingelbach Lane, was constructed on the highest spot on the Bloomington campus. The carillon, with its sixty-one cast bells, was a gift of the Arthur Metz Foundation during the sesquicentennial year, 1970. It was given in memory of Dr. Arthur Metz, A.B. 1909, distinguished Chicago physician and IU benefactor. A carillon concert is given each Sunday evening at 5:00 during the regular academic year. The present carillonneur is Brian Swager.

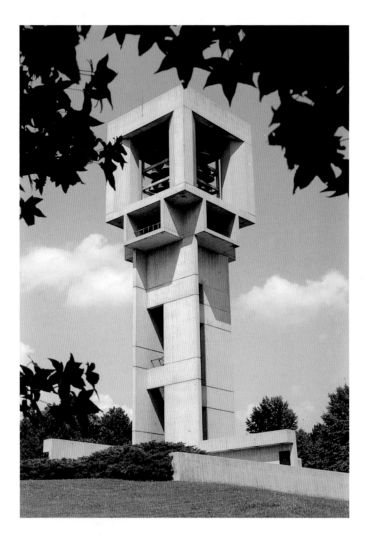

The atrium in the Chemistry Building. Since the building was completed in 1931, two major additions have altered the original building almost beyond recognition. Both additions were the result of an expansion of chemistry programs and the need for more laboratory, library, and classroom space.

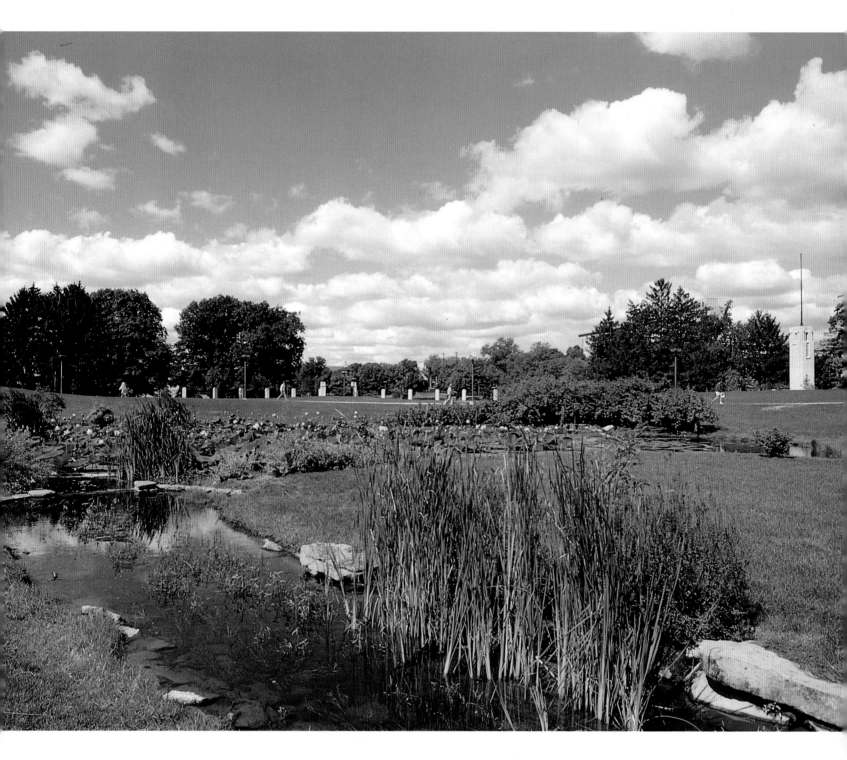

The Board of Trustees approved the design for the Arboretum on the nine-acre site of the Tenth Street Stadium in 1983. Trees, shrubs, and a comprehensive beautification program converted the acreage into one of the most beautiful parts of the campus. Charles W. Hagen, professor emeritus of biology, was chairman of the planning committee, which included landscape architect Fritz Loonsten. The plan called for planting trees that would not duplicate those found elsewhere on campus, thus bringing new species to the campus. Numerous trees have been donated in commemoration of IU faculty, staff members, and friends. The Arboretum also features a pond, waterfall, rock garden, and gazebo, the latter a gift of Jesse H. Cox, Class of 1942. Preserving a bit of tradition, the cornerstone of the old stadium was used as the cornerstone of the new Memorial Stadium. Other features of the old stadium were kept in place: the two limestone ticket booths, the stone flagpost towers, and the iron fence at the west end of the field.

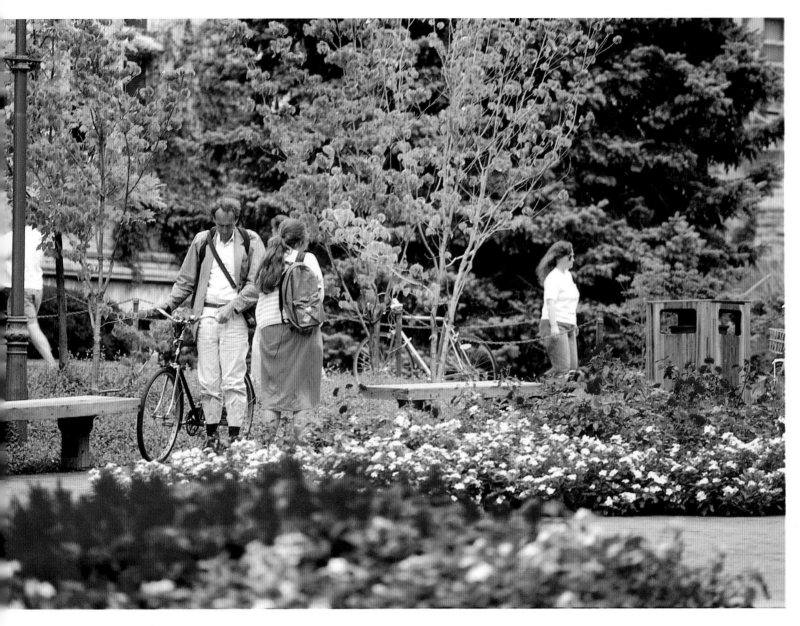

Flower beds heighten the beauty of the Sample Gates.

Early snowfall on the Bloomington
campus.

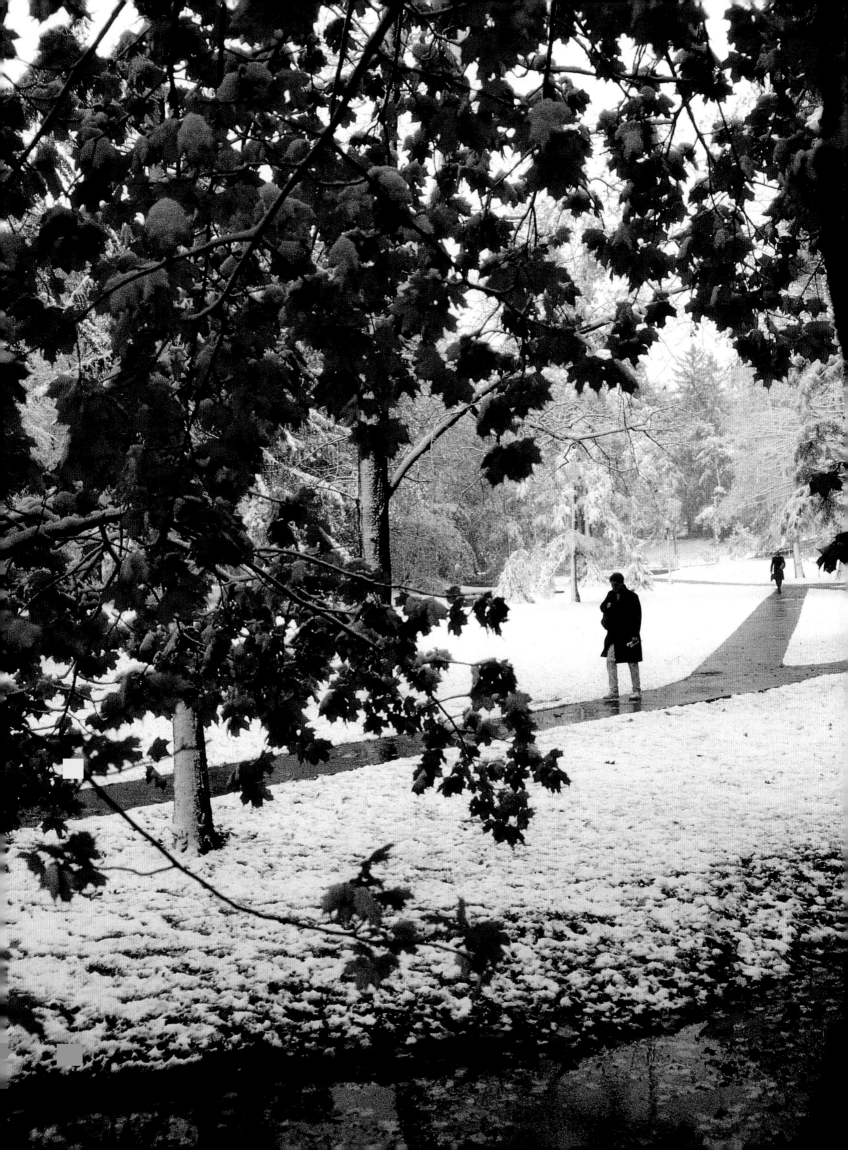

A graduating scholar returning books to the library and a professor holding a globe: limestone carvings at the southwest entrance to the Memorial Union Building.

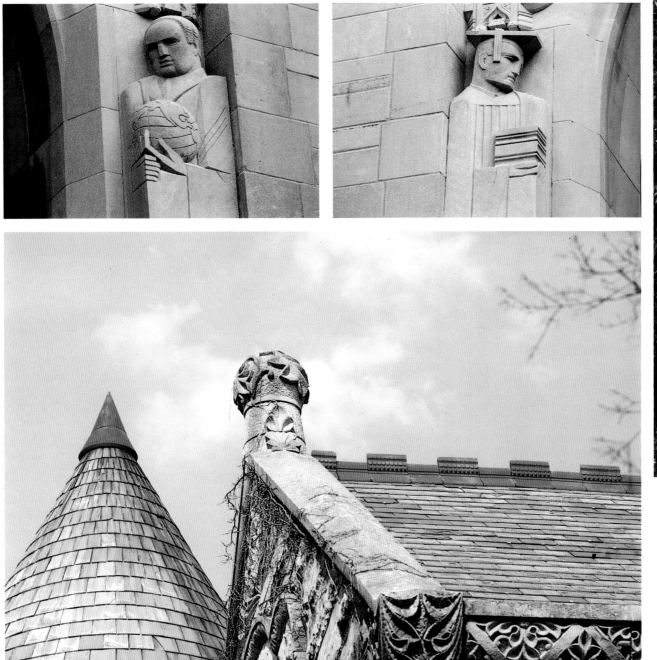

Tower and roof of Maxwell Hall.

The Bloomington campus in the fall boasts a profusion of colors.

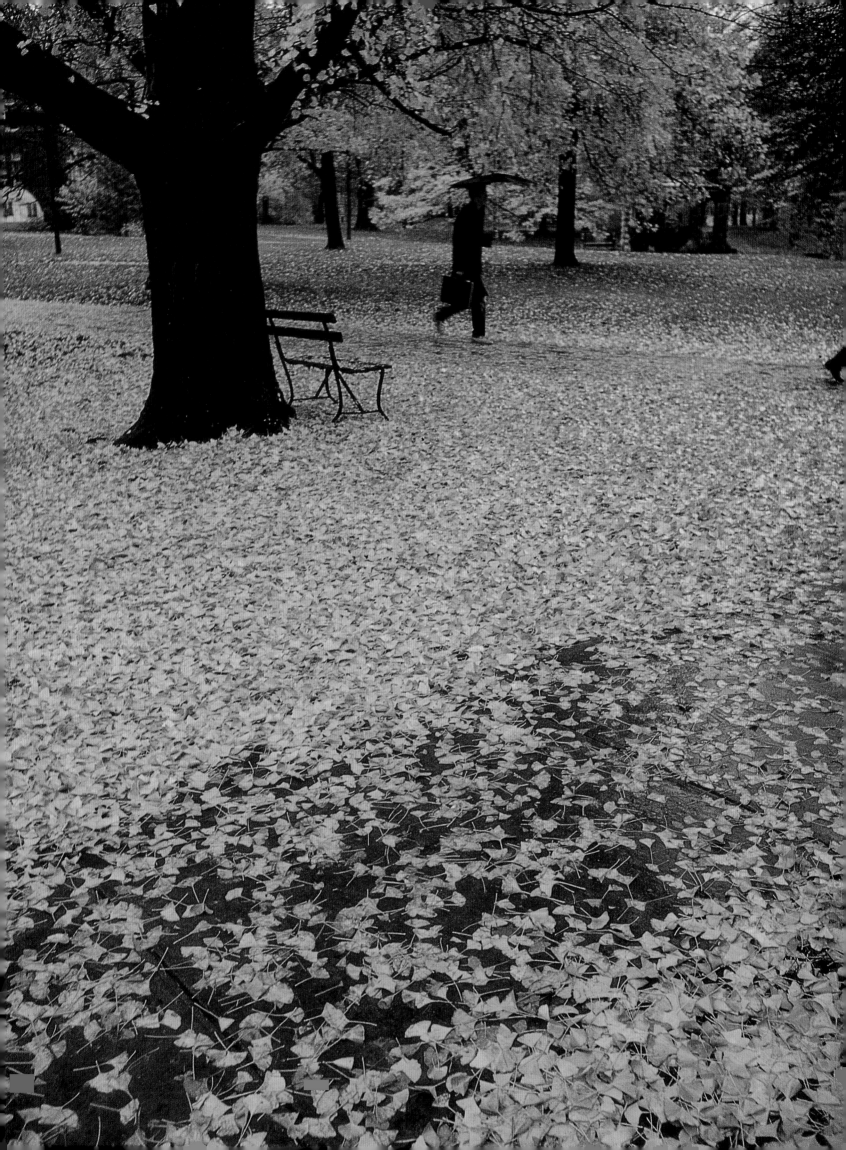

The fanlike leaves of the ginkgo tree annually carpet the ground east of Maxwell Hall.

An aerial view of the Bloomington campus in early fall, Franklin Hall in the foreground, Ballantine Hall in the distance.

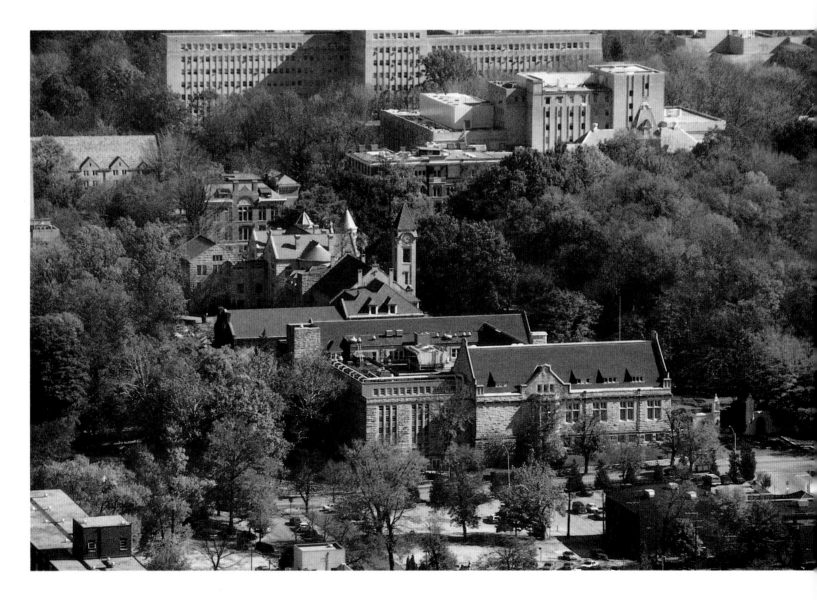

A trio of presidents—Ryan, Wells, and Ehrlich—at the unveiling of the portrait of Ryan.

Interior of the Indiana University Cyclotron Facility (IUCF). IUCF contains equipment for basic and applied research in nuclear physics. It is available for use by scientists worldwide. Approximately half the use has been by IU scientists and the rest by scholars from the United States and seventeen foreign countries. Because IUCF serves as a national resource, most of the operating funds are provided by the National Science Foundation.

The building was occupied in 1971, and the system began operation in 1975. Since then, additions have been made to the building and its equipment.

Studying in summer.

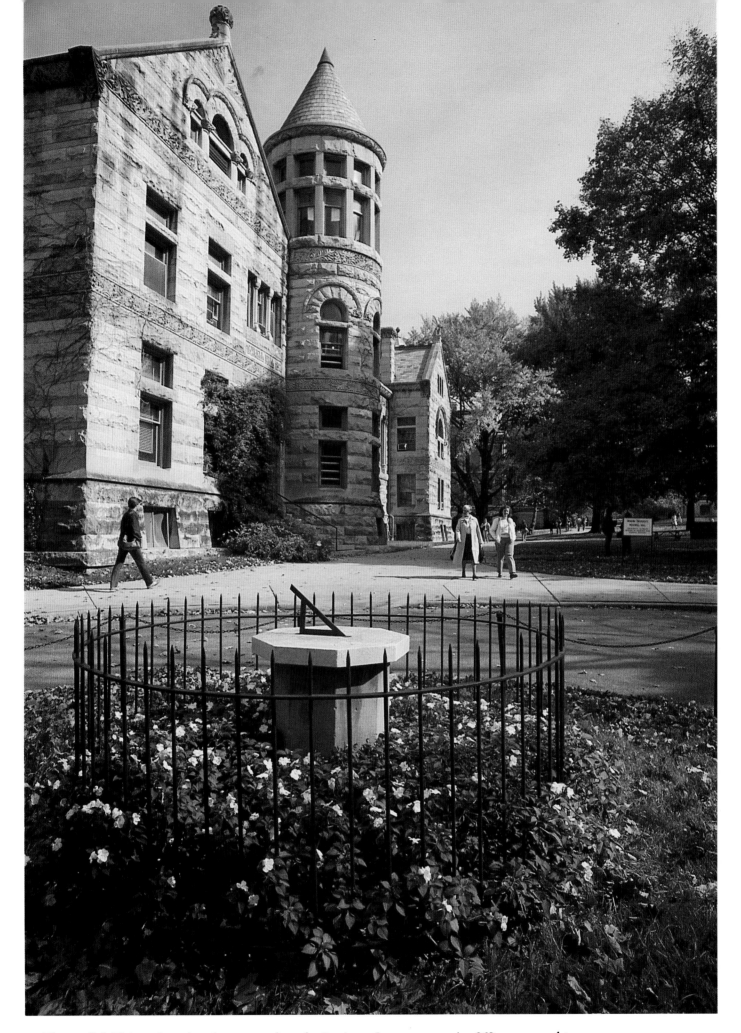

The sundial. This ancient timepiece, erected on the Seminary Square campus in 1868, was moved to its present location adjacent to Maxwell Hall in 1896. The ashes of Otto Paul Klopsch and Matilda Zwicker Klopsch, who became acquainted on campus, were scattered at the sundial by their son in 1935. A brass plaque, green with age, commemorates the devoted couple, both graduates in the Class of 1895. An endowment was left to the university for planting flowers there annually.

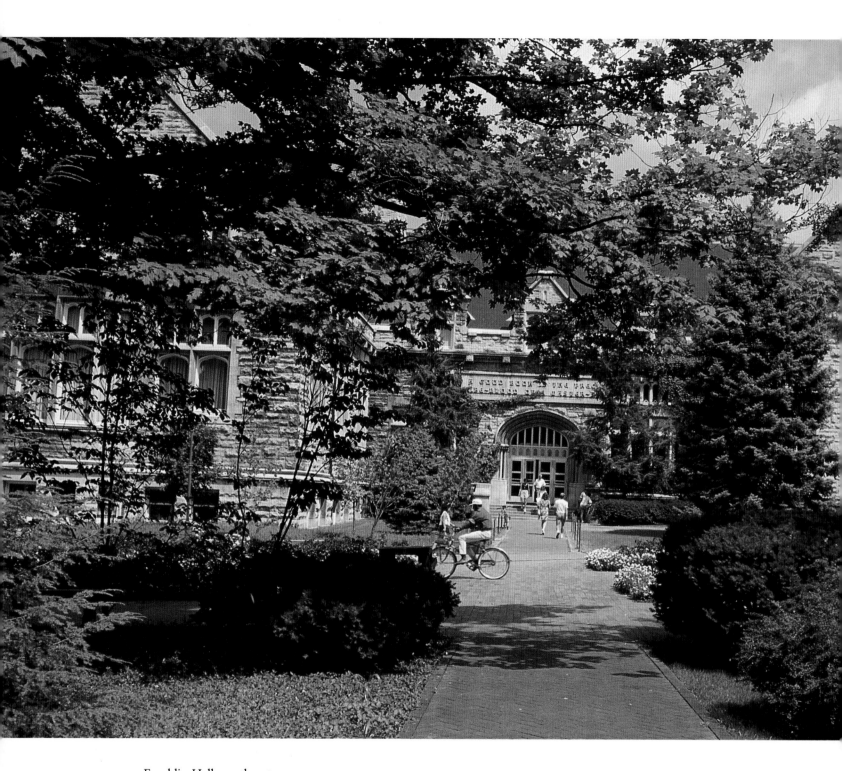

Franklin Hall, south entrance.
Constructed as the second library
building in 1907, it was named in
1988 to honor Joseph Amos Franklin
(1904-80), who served successively as
IU accountant, treasurer, and vice-
president. The inscribed tablet in
Franklin Hall testifies that "few have
served Indiana University longer, and
none more faithfully, than Joe
Franklin."

Students and bicycles in front of Ballantine Hall.

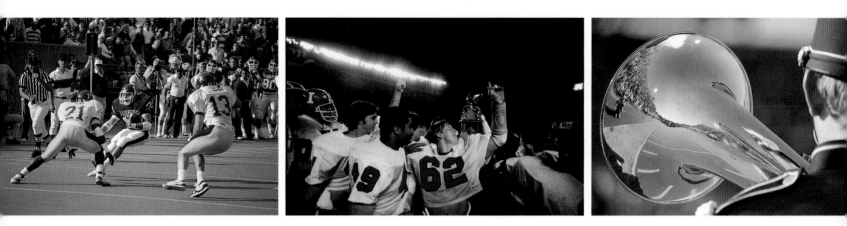

Football and its associated attractions: the fans, the band, and the Red Steppers. The color at a football game has been called "a worthy competitor to the fall colors on the campus."

A student protest in Dunn Meadow
against the Gulf conflict, 1990.

Fire hydrant near the east entrance to Bryan House,
home of the president of IU.

A rainy day on the Bloomington
campus calls forth umbrellas of
various colors and sizes.

The Wellhouse was erected in 1908 over a campus cistern. Designed by Professor Arthur Lee Foley of the Physics Department, it has a foundation in the shape of the Beta Theta Pi fraternity pin. The structure was a gift to the university by a member of the fraternity, IU trustee Theodore F. Rose, in the name of the alumni. It contains the portals of the Old College Building from Seminary Square. In campus lore, no woman student can become a "coed" until she has been kissed at midnight within these portals.

Showalter Fountain in the Fine Arts Plaza was the gift of Grace Showalter in memory of her husband, Ralph. It was dedicated in 1961. The figure of Venus and the dolphins that adorn the fountain are the work of Robert Laurent, longtime professor of sculpture in what is now the Henry Radford Hope School of Fine Arts.

Statue of Eve from the pair *Adam and Eve* in Dunn's Woods, executed by Jean Paul Darriau, member of the faculty in the Henry Radford Hope School of Fine Arts.

Under Coach Jerry Yeagley, IU's soccer team won NCAA championships in 1982, 1983, and 1988.

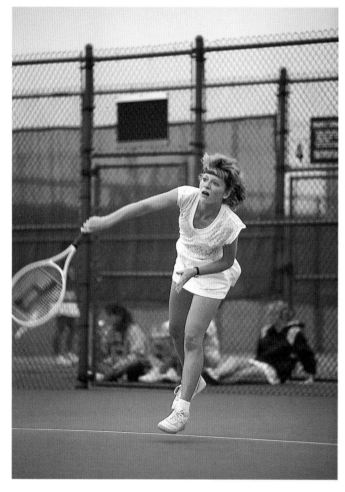

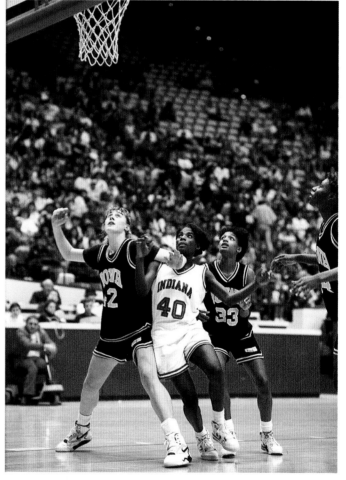

Brenda Hacker was a four-year member of the Hoosier women's tennis team, which dominated Big Ten championships in the 1980s and early 1990s.

In scoring and rebounding, freshman Shirley Bryant led the IU women's basketball team in 1991-92.

Swimmers work out at the Natatorium on Indianapolis campus.

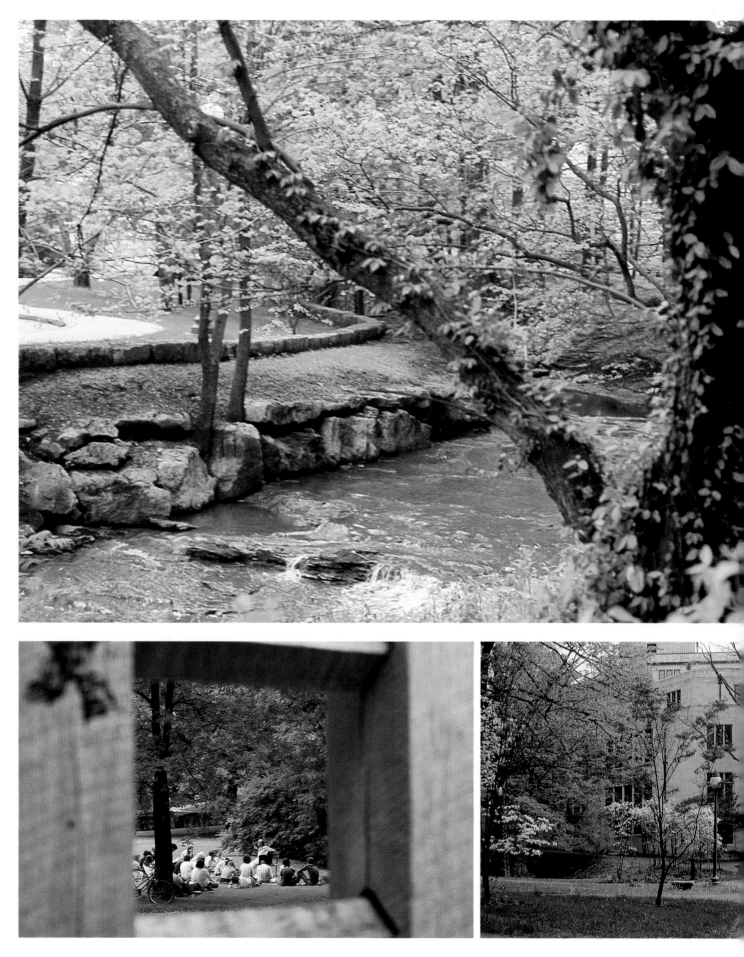

The outdoors provides a classroom without walls during clement seasons.

Spring along the banks of the Jordan River, near Beck Chapel. This tiny brook, which flows through the campus, was once called Spanker's Branch. It was renamed to honor David Starr Jordan after he resigned as president of IU to become the first president of Stanford University. A building, Jordan Hall, and a street, Jordan Avenue, attest to Jordan's impact on both IU and the City of Bloomington.

Dogwood and redbud in bloom at the north entrance to the Law Building, which houses the oldest state university law school west of the Alleghenies. In spite of its age, the school had no building especially designed for its educational mission before construction of the Law Building in 1956. It had been housed in Maxwell Hall. By the late 1970s, the need for enlarged library space and extensive renovation of the 1956 structure led to an addition, which was dedicated in 1986.

The Arboretum.

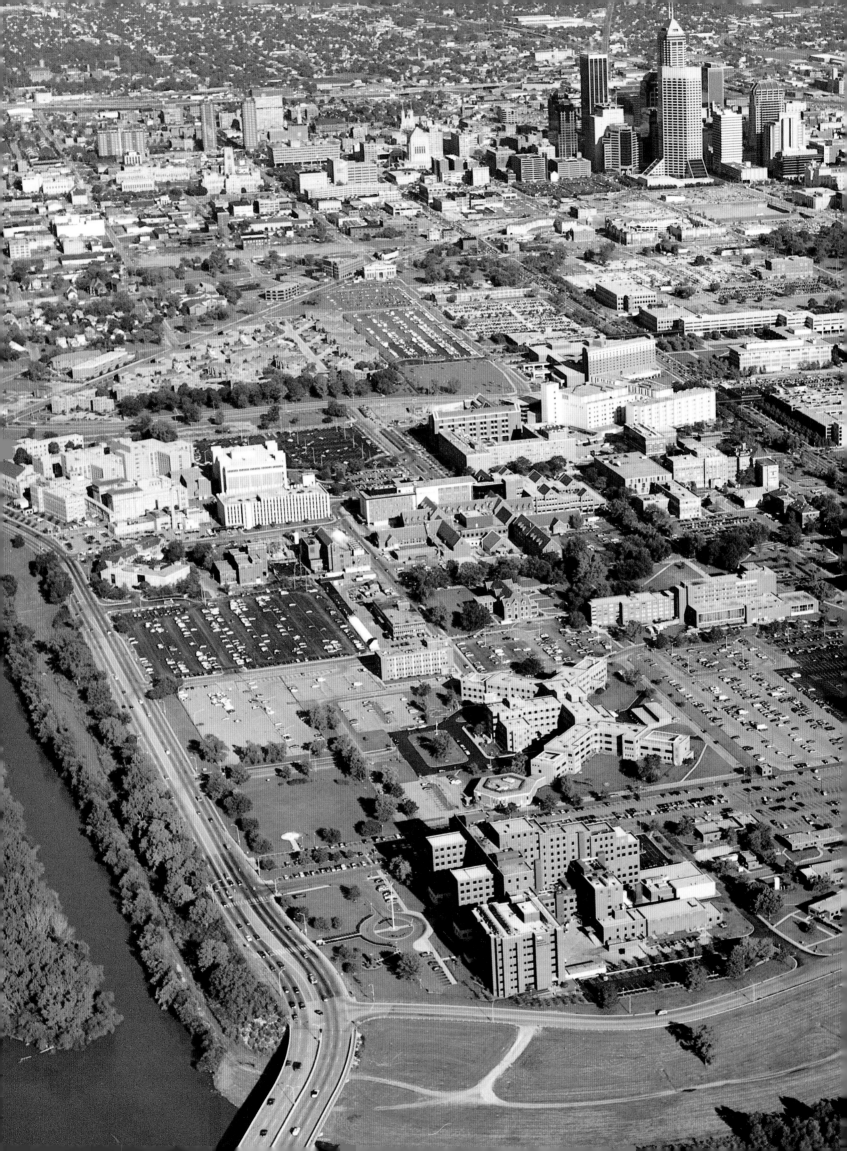

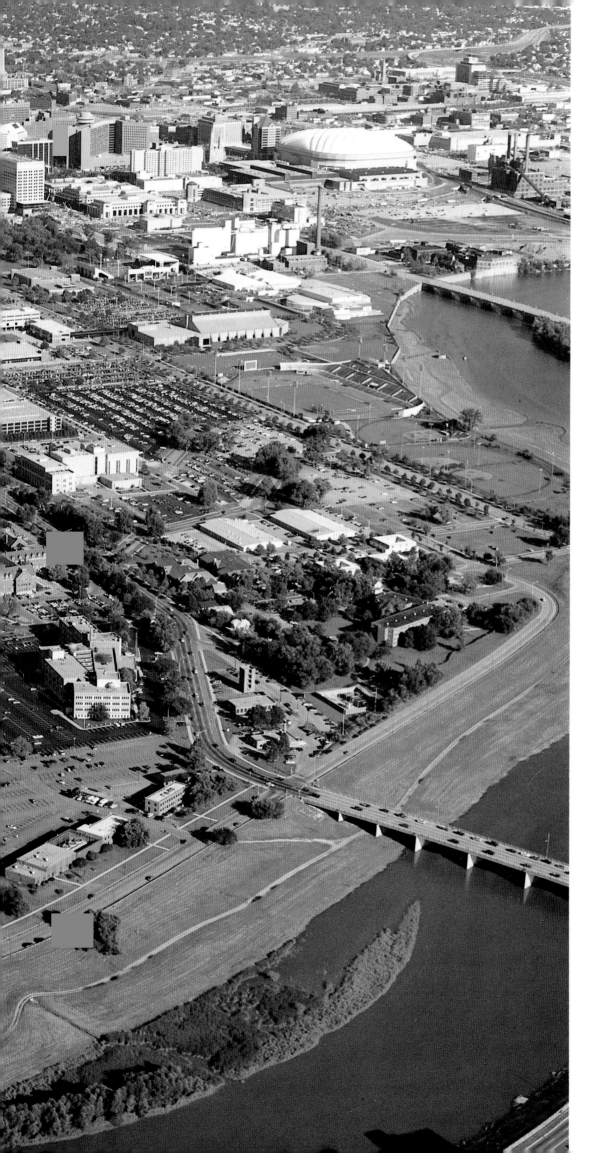

Recent aerial view of the IUPUI campus looking east toward Indianapolis skyline.

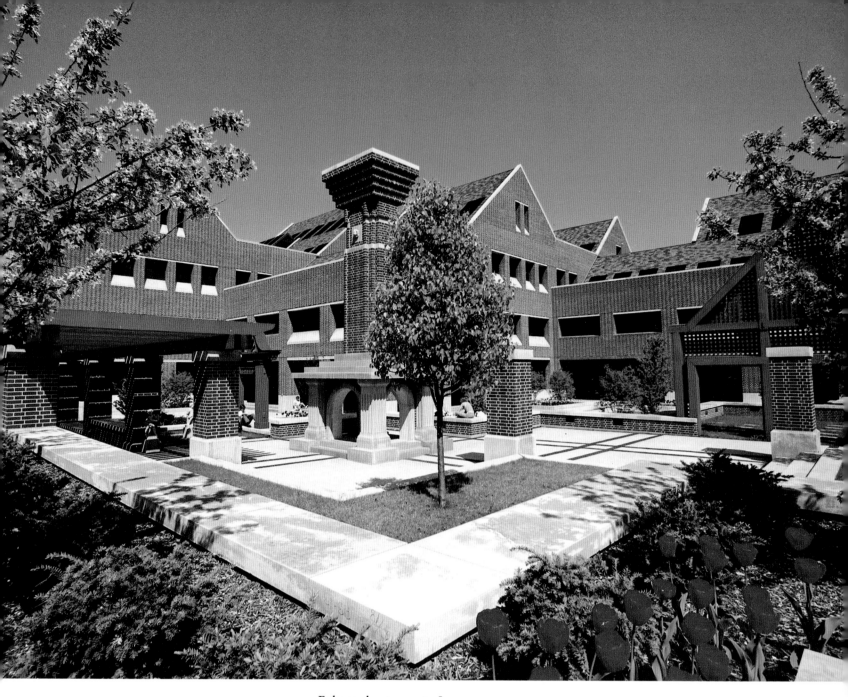

Enhanced entrance to James
Whitcomb Riley Hospital on IUPUI
campus.

A view of part of the Medical
Center, Indianapolis.

The skywalk over Michigan Street
connecting the University Hospital
and the parking garage, IUPUI.

Medical Research and Library
Building, Medical Center,
Indianapolis, dedicated in 1989.

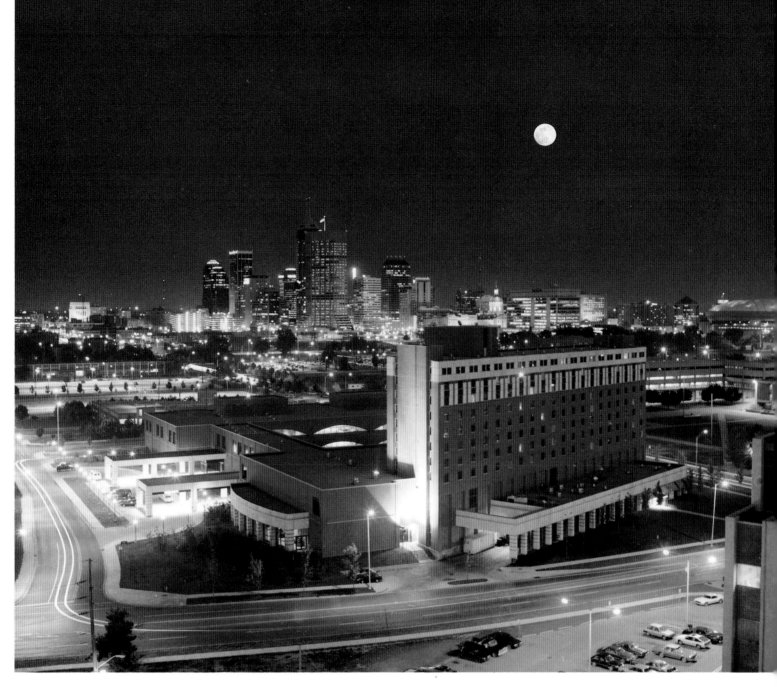

The University Place Executive Conference Center and Hotel at IUPUI. The Conference Center is owned and managed by IU. The hotel is owned by investors known as University Development Group I. IU and Group I jointly own the underground parking garage. The land is owned by IU and is leased long-term to Group I. The Conference Center was dedicated in 1987, and the hotel opened the same year.

Commencement at IU East (Richmond).

A view of the campus at IU East (Richmond).

East Building on the Washington Street campus of IU Kokomo, constructed in 1979-80.
It is the major classroom and laboratory building at IUK.

Inside East Building looking down, IU Kokomo.

Northside Hall, IU South Bend.

Outside the University Center at IU South Bend.

The Franklin D. Schurz Library at IU South Bend, named to honor the South Bend publisher, civic leader, and friend of education. He played an important part in acquiring the land for the present IUSB campus.

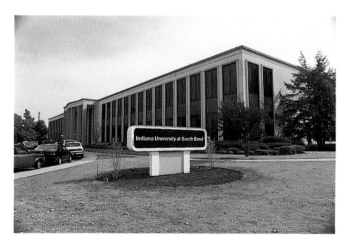

Administration building at IU South Bend.

University Center at IU
Southeast (New Albany).

McCullough Plaza at IU Southeast.
The plaza with its clock and chimes
was a gift of Dr. and Mrs. James Y.
McCullough, Sr. Dr. McCullough, a
distinguished physician of New
Albany and a stalwart friend of IU
Southeast, contributed funds for
scholarships for science students.

A view of the campus from
inside Hillside Hall, IU Southeast
(New Albany).

Courtyard near Library and
University Center, IU Southeast
(New Albany).

Hawthorn Hall, IU Northwest (Gary).

Fountain behind the Library, IU Northwest (Gary).

Raintree Hall at IU Northwest (Gary).

The plaza behind the Library and Hawthorn Hall of IU Northwest (Gary).

Side view of Gym and Multipurpose Building, Fort Wayne.

Bicycle parking space, Fort Wayne.

Sundial set in the middle of a geogarden consisting of igneous, sedimentary, and metamorphic rocks with shrubs, Fort Wayne.

Beck Chapel was completed in 1956, the gift of Frank O. Beck, IU alumnus, and his wife, Daisy Woodward Beck. Known as the "chapel of all faiths," it is used for individual worship, meditation, and wedding ceremonies, with occasional memorial services and christenings. The chapel is governed by a committee in accordance with the terms of the bequest. The committee names the chaplain and curator of the chapel. The lych-gate that gives distinction to the entrance to the chapel yard was a gift of Robert R. Sturgeon in memory of his wife, Miriam Meloy Sturgeon, A.B. 1938, A.M. 1940.

View of the Arboretum through the old iron fence.

Part of the south wall, Maxwell Hall.

Foyer, Musical Arts Center. A commemorative plaque on the wall of the foyer informs the reader: "The Grand Foyer Contributed by Hoagland Carmichael." The MAC, a superlative structure for musical performances, was completed in 1971. Leighton Kerner wrote in the *New York Post*: "Indiana University's School of Music and its combined opera house and concert hall, the spacious and admirably equipped Musical Arts Center, constitute one of the country's major musical assets."

Peau Rouge Indiana by Alexander Calder. Standing in front of the Musical Arts Center, the stabile was a gift of Oscar R. Ewing, A.B. 1910, LLD. 1970.

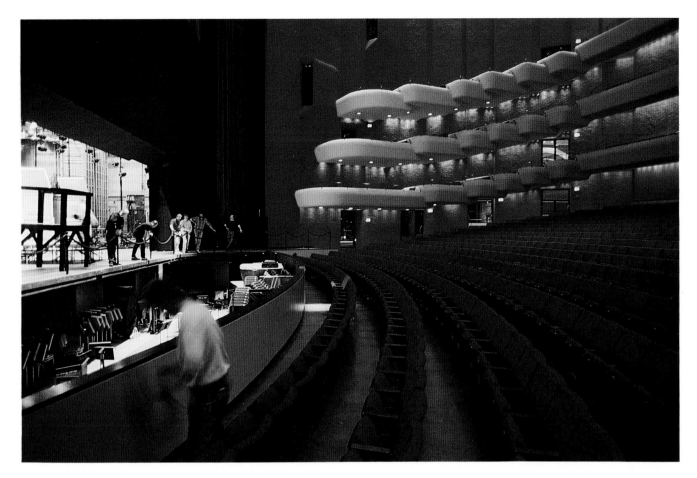

Auditorium of the Musical Arts Center.
Many of the seats bear the names of their donors.

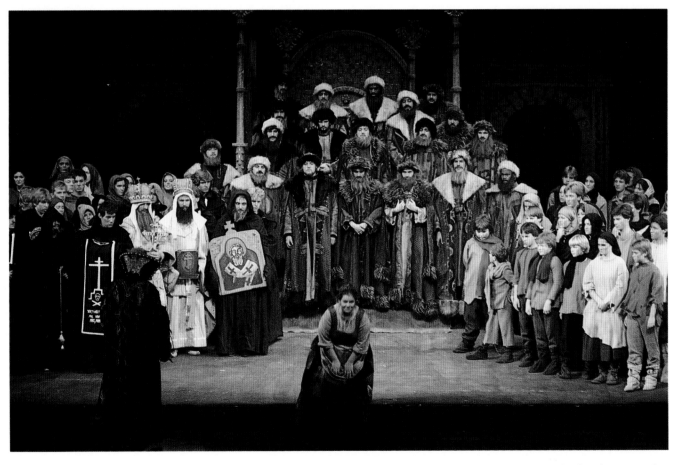

Two scenes from *Boris Godunov* (above and overleaf). This opera by
Modest Mussorgsky was performed in the Musical Arts Center in 1979.

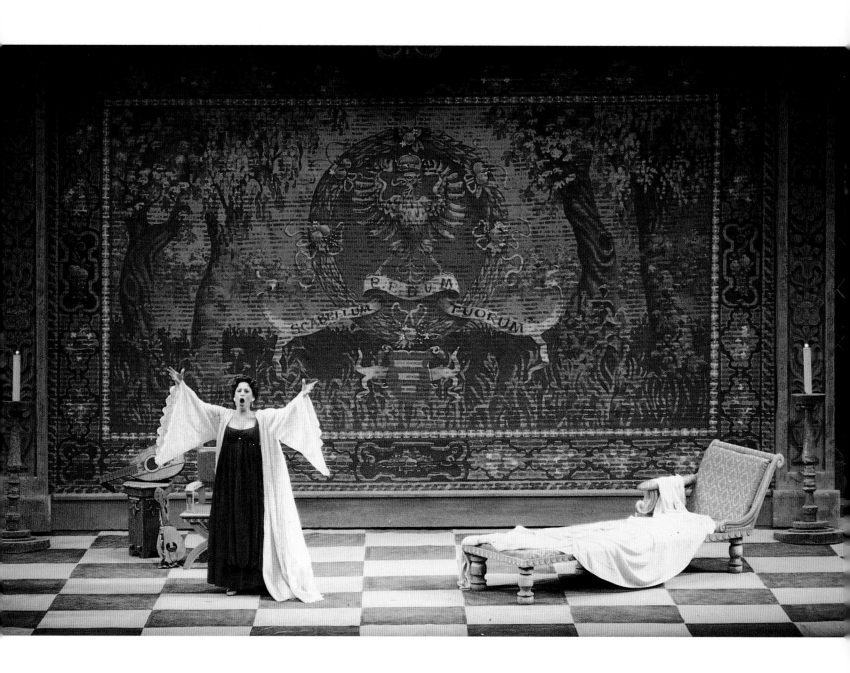

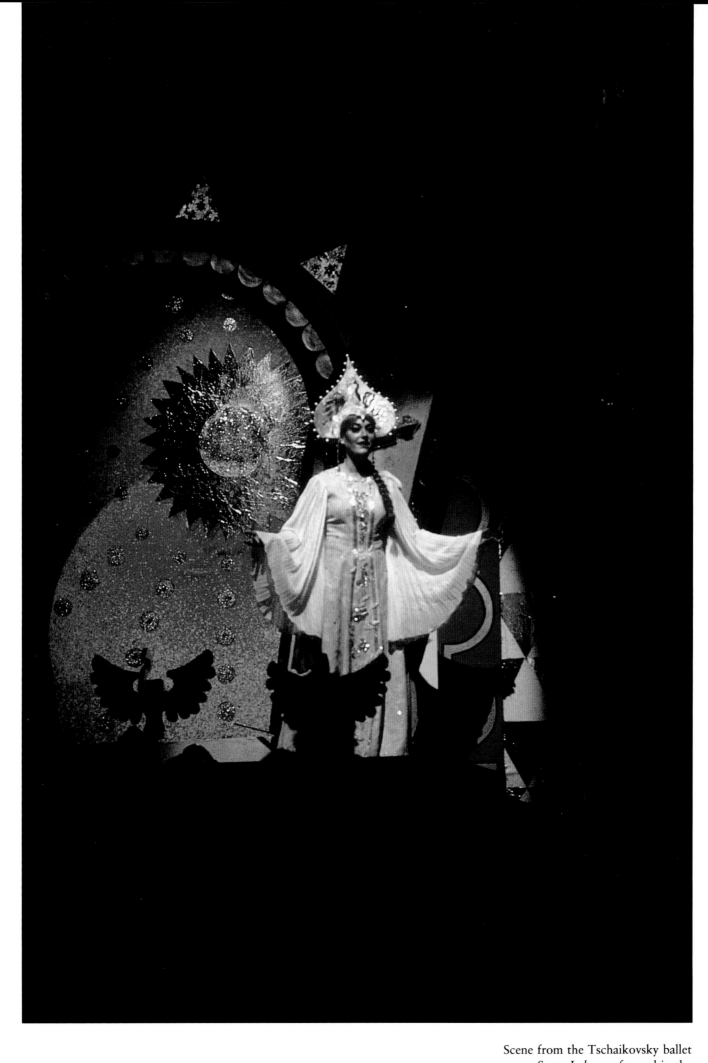

Scene from the Tschaikovsky ballet
Swan Lake, performed in the
Musical Arts Center, 1987.

Atrium of the Art Museum. The museum, designed by I. M. Pei and
Partners, was completed in 1981 and dedicated in 1982. It represents a cultural
resource of regional importance, containing more than 25,000 paintings,
sculptures, artifacts, and art objects in its collections.

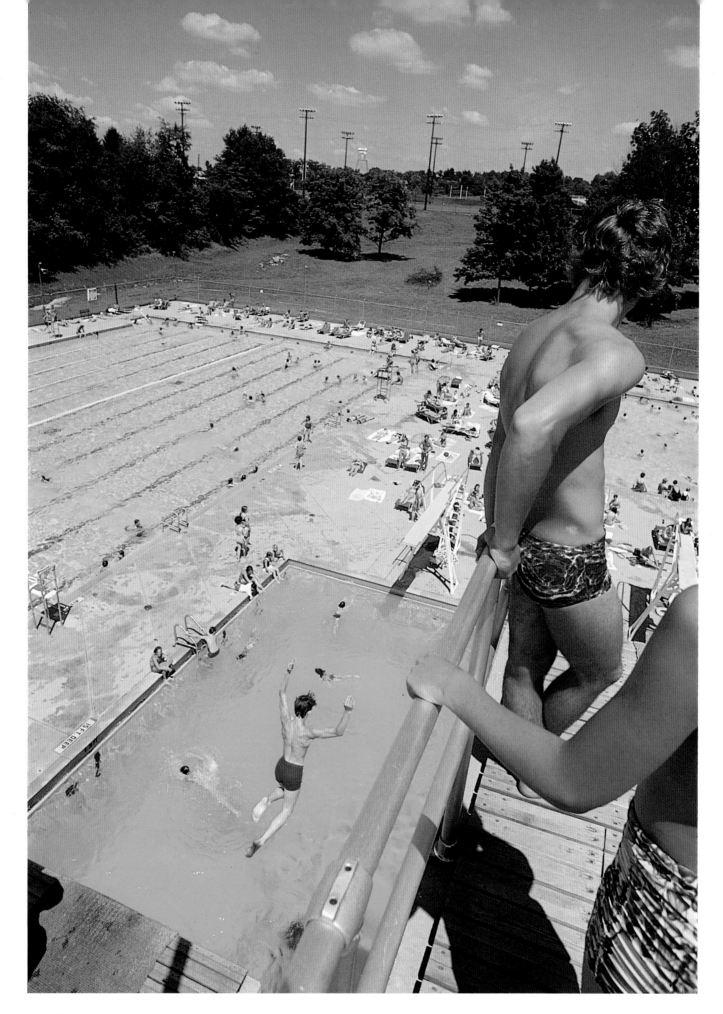

The outdoor pool in Bloomington, open to faculty families, staff members, and visitors.

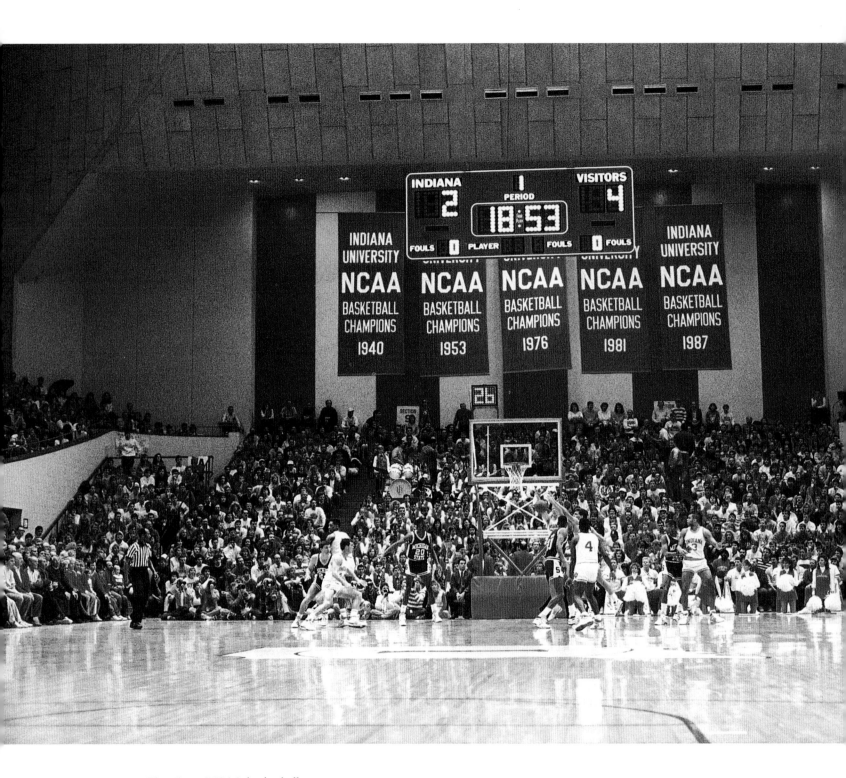

Five times NCAA basketball
champions, two under Coach
Branch McCracken, three under
Coach Robert M. Knight.

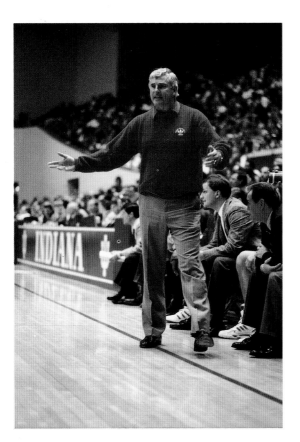

IU 74, Syracuse 73! Players Steve Alford and Dean Garrett and Coach Bob Knight celebrate in New Orleans after winning the NCAA basketball title in 1987. It was Knight's third championship at IU and the fifth for the university.

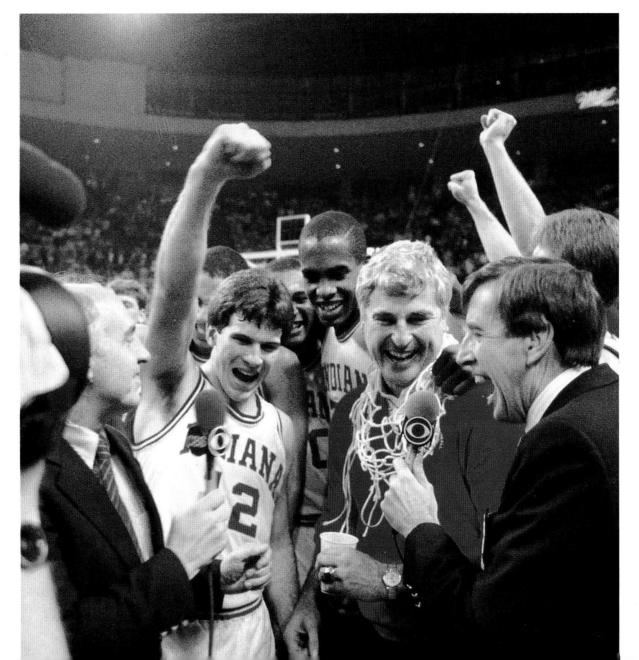

Dedication of renovated Student
Building with restored clock tower,
October 1991. The tower burned
during renovation work in
December 1990.

Fall on the Bloomington campus.

Wilmer Baatz in the Black Culture Center Library assisting students. Baatz, a longtime IU librarian with a special interest in African-American library collections, compiled and published numerous bibliographical lists relating to African-American topics and paid special attention to the acquisition program for the Black Culture Center Library. After his retirement he continued his interest as a volunteer.

Woodburn Hall in the foreground, Wildermuth Intramural Center and the Art Museum in the background. The hall, constructed in 1940 to house business and economics, was named in 1971 to honor James Albert Woodburn, longtime professor of history and author of *History of Indiana University 1820-1902*. It is now home to the Department of Political Science and African Studies.

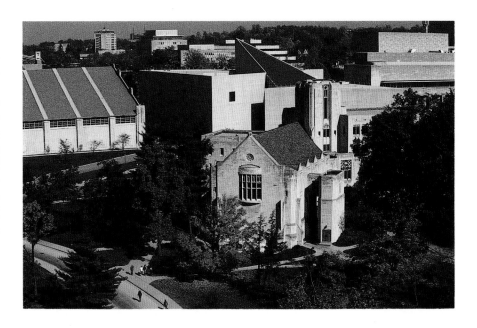

Crossing the Jordan River in winter.

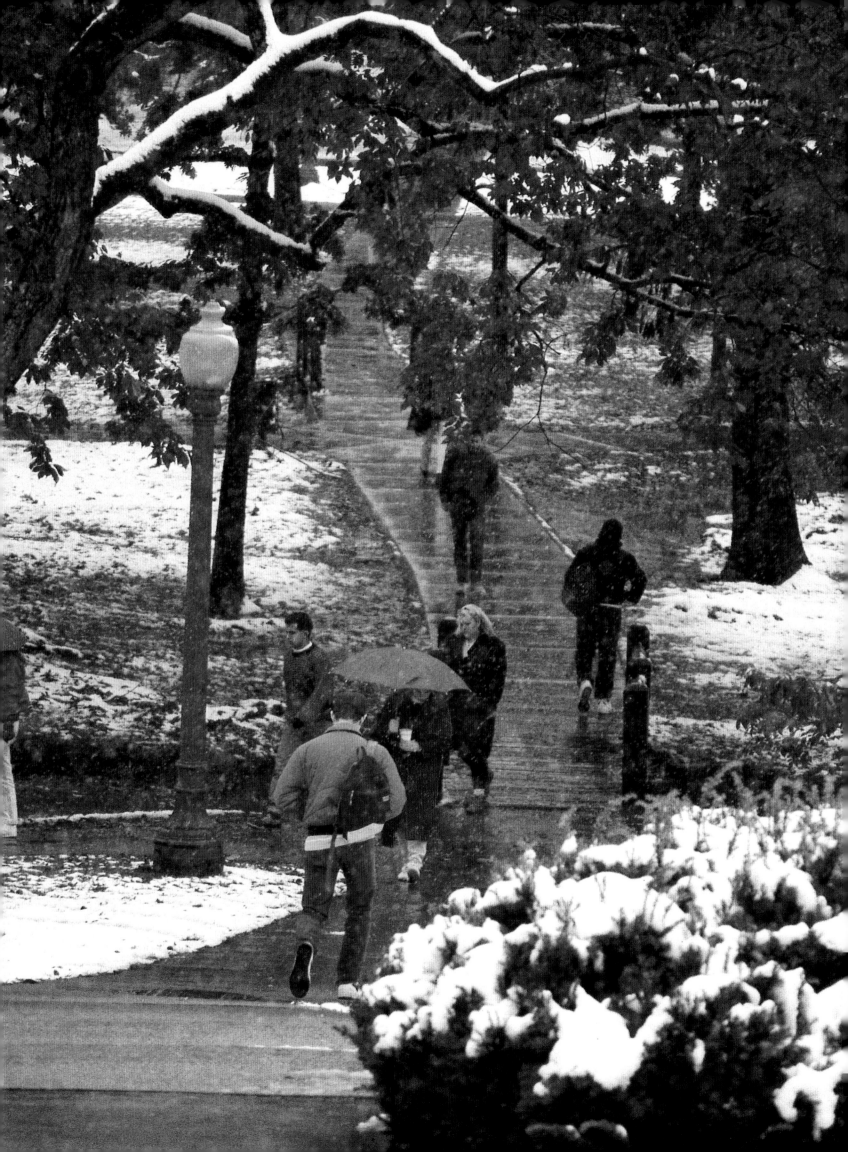

The Student Building clock and bell tower at Christmas time.

Madrigal dinners featuring the School of Music Madrigal Singers and Brass Quintet have been held annually in the Memorial Union Building since 1948. This traditional revelry, enchantment, and feasting derived from the sixteenth century includes the wassail bowl, boar's head, and flaming plum pudding.

Tuba-tooting Santas, students of Harvey Gene Phillips, distinguished professor of music. Phillips and his tuba students gained an international reputation as participants in musical events, often for charity, and did much to improve the musical image of the tuba.

The Singing Hoosiers in formal concert.

World premiere of *Breaking Away* at the IU Auditorium.

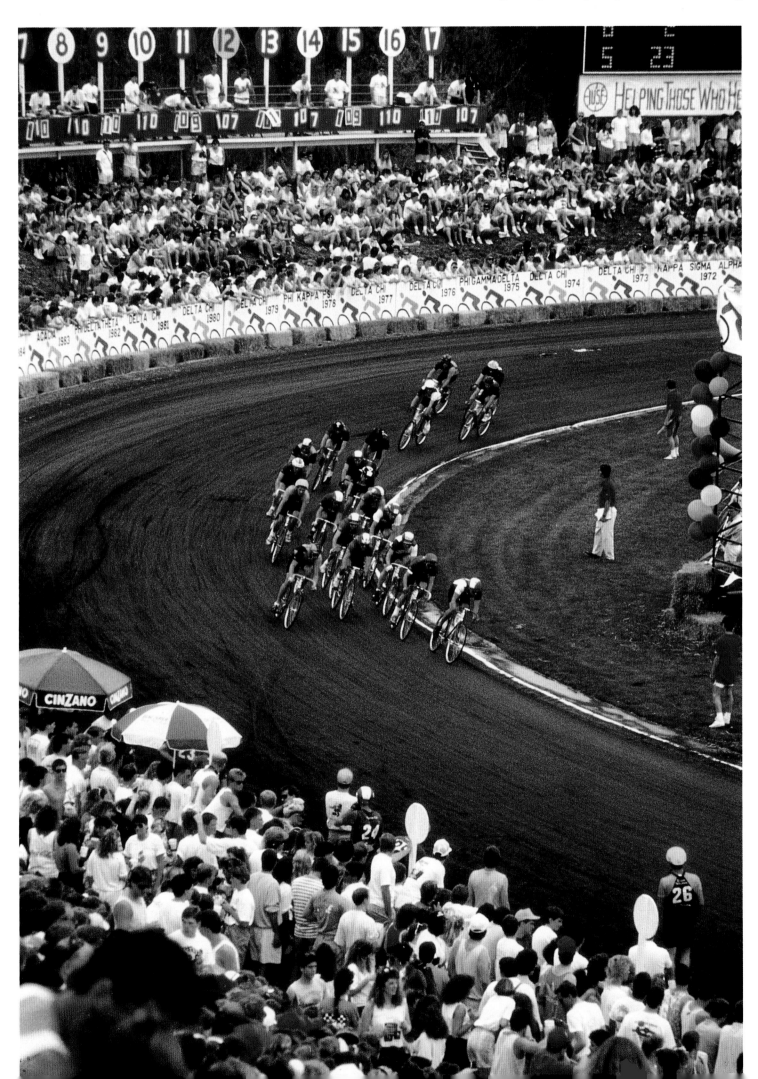

Little 500 bicycle race, always colorful and exciting.

Crossing the Arboretum on a winter day.

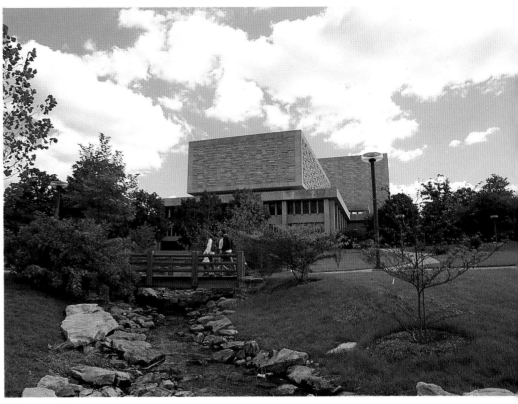

The main University Library as viewed from the Arboretum. The building was occupied in June 1969 and dedicated in October 1970 as part of the IU sesquicentennial celebration. A three-in-one structure, the library has a five-floor tower housing collections for undergraduate use, a twelve-story tower housing collections for graduate use, and a third general area containing a central lobby linking the ground floors of the towers.

Students walk through the Arboretum on their way to classes (overleaf).

The academic procession circles
Showalter Fountain on the way to
the inauguration of President
Thomas Ehrlich in the IU
Auditorium, October 12, 1987.

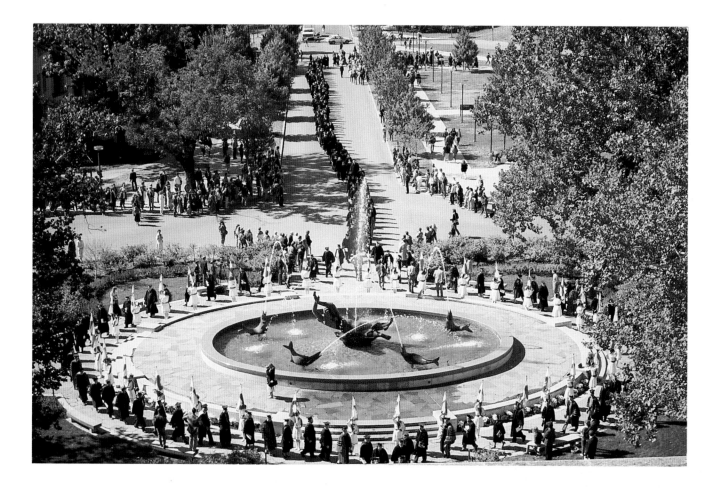

The investiture of Thomas Ehrlich
as the fifteenth president of Indiana
University.

DOROTHY COLLINS
has been a special assistant
to several presidents of
Indiana University.

CECIL K. BYRD
is professor and librarian emeritus,
with long service to Indiana
University as a teacher and
administrator.

BOOK AND JACKET DESIGNER · SHARON L. SKLAR

COPY EDITOR · KENNETH GOODALL

PRODUCTION · HARRIET CURRY

TYPEFACE · SABON

TYPESETTER · SHEPARD POORMAN

PRINTER AND BINDER · C & C PRINTERS